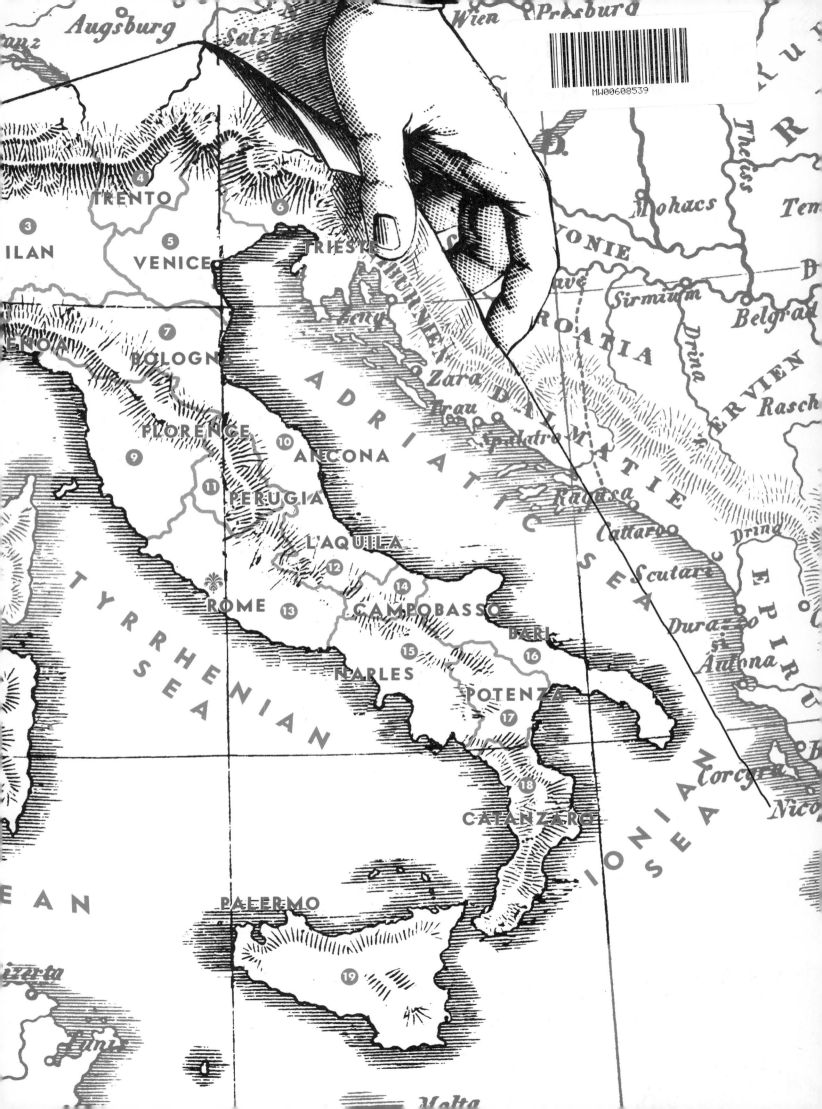

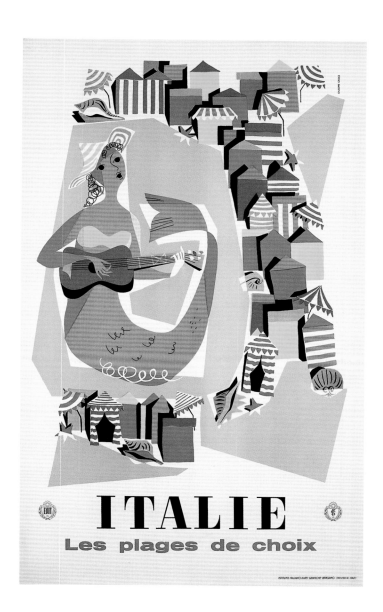

ITALIE
Les plages de choix

ITALIE

EN

LORENZO OTTAVIANI

TRAVEL ITALIA
THE GOLDEN AGE OF ITALIAN TRAVEL POSTERS

Posters from
the Collection Alessandro Bellenda
Alassio, Italy

ABRAMS, NEW YORK

This page:
Detail from
Procida L'Isola di "Graziella," 1952
(Featured on page 116)

Previous page:
Detail from
La Riviera Italienne, ca. 1927
(Featured on page 72)

Page 1:
Italie, les plages de choix, ca. 1955
Giuseppe Croce
ENIT, FS
24 ⁵⁄₁₆ x 39 ¾ in.
(61.7 x 101 cm.) Offset
Istituto Italiano D'Arti Grafiche,
Bergamo

Editor: Eva Prinz with Marina Garcia-Vasquez
Designer: Lorenzo Ottaviani
Production Manager: Anet Sirna-Bruder

Cataloging-in-Publication data has
been applied for and is available from
the Library of Congress.

ISBN 13: 978-0-8109-9441-6

ISBN 10: 0-8109-9441-0

Published in 2007 by Abrams,
an imprint of Harry N. Abrams, Inc.

Printed and bound in China
10 9 8 7 6 5 4 3 2 1

HNA ▮▮▮▮▮
harry n. abrams, inc.
a subsidiary of La Martinière Groupe

115 West 18th Street
New York, NY 10011
www.hnabooks.com

TRAVEL ITALIA
THE GOLDEN AGE OF ITALIAN TRAVEL POSTERS

Contents

Posters: The Italian Beginning

En Italie, 1953
Alfredo Lalia
24 ⁵⁄₁₆ x 39 ³⁄₈ in.
(61.7 x 100 cm.) Offset
FS, ENIT
Stab. L. Salomone, Rome

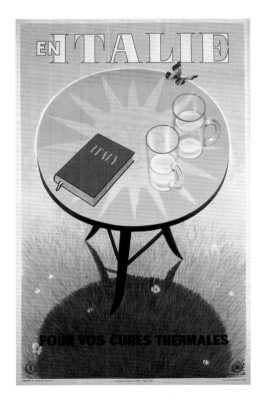

Opposite

Italy, 1935
Ruggero Alfredo Michahelles
24 ³⁄₈ x 39 ⁵⁄₁₆ in.
(62 x 99.8 cm.) Lithograph
FS, ENIT
Barabino & Graeve, Genoa

To talk about the history of Italian posters we begin our journey in Paris.

It was in the French capital that in 1860, Jules Chéret a French artist, uncovered the full potential of a new printing technology: lithography.

Invented by Alois Senefelder in Bohemia, Germany, in 1798, lithography was the most important evolution of printing since the invention by his fellow countryman Johannes Gutenberg some four hundred years earlier. Although less revolutionary than Gutenberg's press with moveable type, stone lithography was equally groundbreaking, as it was the first print-making technology that allowed artists to work using traditional techniques and to create prints that could rival an original painting in terms of detail and tone.

Within a few years, the lithographic press Chéret ran at Imprimerie Chaix was able to create multicolored printed images or "chromolithographs" where separate stones were used for each color. This technique made it possible to print images with large areas of flat color, a key ingredient in the creation of advertising posters.

In the 1870s, Chéret's posters took Paris by storm with the same social impact as cinema in the 1930s, television in the 1950s and most recently the Internet. Just imagine it: One day, over the gray bleak walls of a Paris lit by smoky gas lamps and suffocated by the noxious fumes of coal-burning stoves, large bright and colorful posters depicting music and dance and beautiful women at the Olympia, the Folies Bergères, the Théâtre de l'Opéra, and the Moulin Rouge suddenly appear. What a shock that must have been. The entire city of Paris became an open-air art gallery.

The new art form was so successful that even the lofty circles of the French Impressionists could not ignore it. Many established artists were at first reluctant to consider advertising posters an art form; however, it paid the bills between one masterpiece and another. It also provided immediate exposure in front of a very large audience. It was even too tempting for Édouard Manet and Georges Seurat, who also experimented with this new media.

In a few years an entire design and printing industry was established and new talent came to the scene, with a new generation of artists that

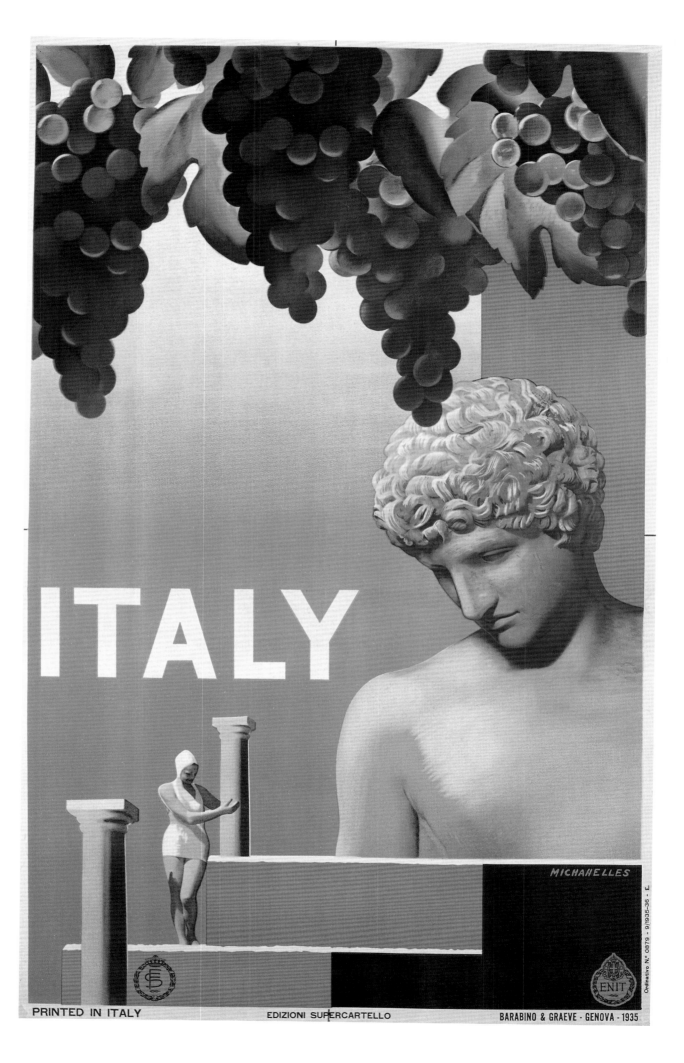

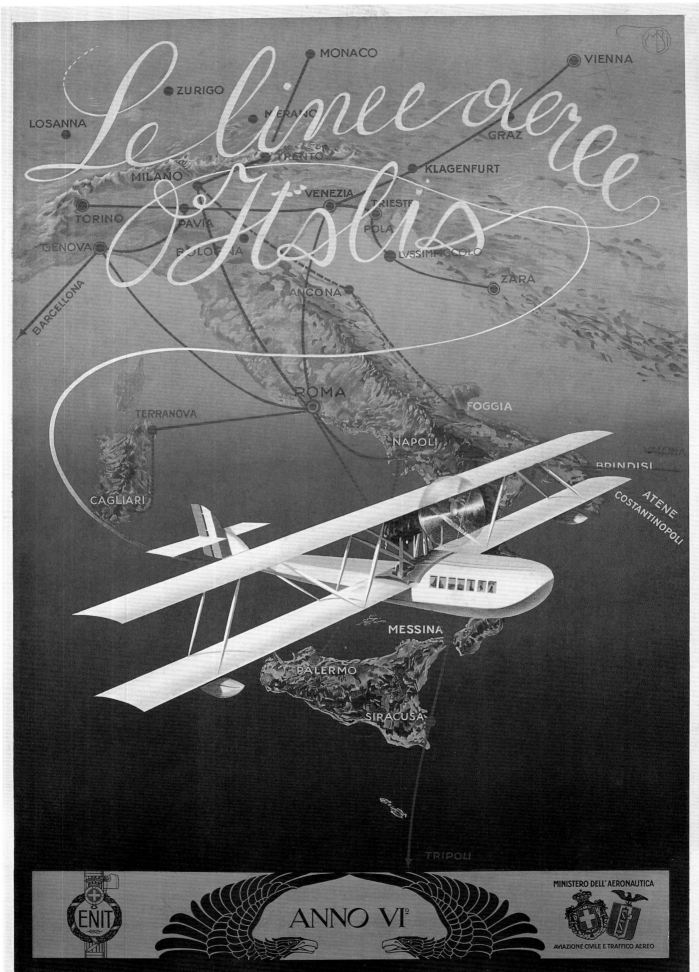

included Henri de Toulouse-Lautrec. He was called "the soul of Montmartre," after the Parisian quarter where he made his home and drew a great deal of inspiration for his compositions. In his brief life Lautrec managed to leave behind an indelible mark, characterized by a modern and incisive style that didn't follow any accepted formula. While the history of French posters is vast and it includes many other important artists, Lautrec's work anticipated the profound social changes that were occurring in French society and Europe at large.

G. Ricordi & C.

In Italy, during the early 1890s, this social and commercial phenomenon made a strong impression on the entrepreneurial mind of Giulio Ricordi. Giulio was the grand-nephew of violinist Giovanni Ricordi (1785-1853), who in 1808 had founded the music publishing company G. Ricordi & C. The company was synonymous with Opera, since Ricordi was the music publisher of composers such as Verdi and Puccini.

Giulio Ricordi, now at the helm of the family company, soon realized that there was a tremendous business opportunity in designing and printing posters to promote its music properties.

Ricordi acquired the latest German lithographic equipment and hired Adolfo Hohenstein (1854–1928) a brilliant German Art Nouveau artist, who was working as a set designer at La Scala in Milan, as Ricordi's artistic director. Hohenstein's 1895 poster for Puccini's *La Bohème*, a contemporary story that takes place in the same Paris depicted by Chéret, became the benchmark of Italian poster design. Under Hohenstein, the Officine Grafiche Ricordi served as a training ground for the next generation of Italian artists such as Leopoldo Metlicovitz (1868–1944) and Marcello Dudovich (1878–1962). An artist from Trieste, Metlicovitz came to Ricordi as a lithographer's assistant in 1891 and shortly after he was promoted to technical director. Metlicovitz went on to become Ricordi's most prolific artist and eventually replaced Hohenstien as Ricordi's artistic director.

His winning design for the 1906 International Exposition is a splendid poster depicting "Science" and "Progress" riding a steam engine through the Simplon Tunnel on its maiden voyage. Dudovich was Metlicovitz's greatest pupil, and his inimitable style propelled him into the Pantheon of poster designers.

Marcello Dudovich was also born in Trieste, the pearl of the Austro-Hungarian Empire—not yet part of Italy. After his studies at the Real-Schule of Trieste, Dudovich continued his education in Munich, Germany. Dudovich's father was a friend of Leopoldo Metlicovitz, and in 1897 he arranged a meeting between Marcello and Leopoldo, who by this time was already a technical director at Ricordi in Milan.

That encounter was a pivotal moment for Dudovich's artistic future. He began working at Ricordi as a graphic technician under the direction of Metlicovitz and Hohenstein in an atmosphere that fostered artistic excellence.

Dudovich's talent became so evident that he was soon promoted from his initial job of "chromolithographer"—a technician whose sole task was to transfer the original design onto the lithographic stone. Offered design assignments, he was able to work side by side with other young artists such as Aleandro Villa, Giovanni Mataloni, and Duilio Cambellotti.

Italy This Winter, 1935
Ruggero Alfredo
Michahelles
24 ¾ x 39 ⅛ in.
(62.8 x 99.3 cm.)
Lithography and Offset
FS, ENIT
Barabino & Graeve, Genoa

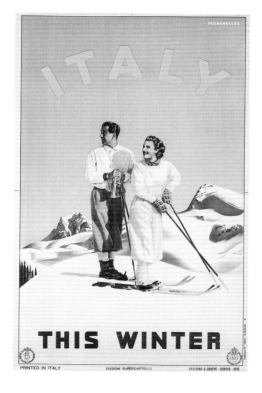

Opposite
Le Linee Aeree d'Italia, 1927
Mario Borgoni
27 ⁹/₁₆ x 39 ⁹/₁₆ in.
(70 x 100.5 cm.) Lithograph
FS, ENIT
Richter & C., Naples

Winter in Italy, 1951
Alfredo Lalia
24 1/4 x 39 1/16 in.
(61.5 x 99.2 cm.) Offset
FS, ENIT
Stab. Luigi Salomone,
Rome

Kennst du das land?
Italien, ca. 1935
Ruggero Alfredo
Michahelles
24 13/16 x 39 7/16 in.
(63 x 100.2 cm.)
Lithography and Offset
ENIT, FS
Gros Monti & C., Turin

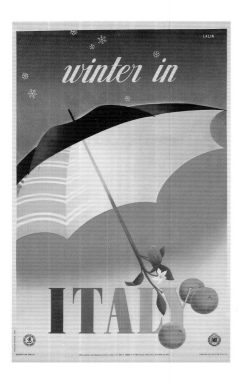

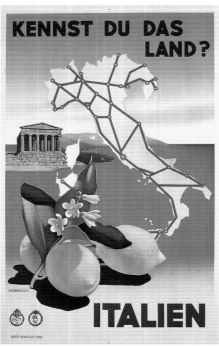

During the first years of his design career one could already pinpoint the essential characteristics of his work: a lean, sober style with a mature and dynamic sense of composition. His figures, drawn with quick lines, were never forced; on the contrary they appeared natural and seductively fashionable. Undoubtedly, the seeming ease of execution in his posters was due to Dudovich's meticulous preparation, which often included using a photographic camera to document those details and situations that he would then elaborate with his pencil.

Between 1912 and 1918 Dudovich illustrated many of the covers for the monthly travel magazine *Rivista Mensile del Touring Club Italiano* (the monthly magazine of the Italian Touring Club).

The travel posters by Dudovich that appear in this book further demonstrate his versatile talent and chronicle his personal artistic development. The posters were commissioned by ENIT (Italian Government Tourism Board) and FS (Italian State Railways) as part of an ongoing state-sponsored advertising program. "Ercolano," (page 126) designed circa 1928, is likely the most "political" because its subject matter is particularly in line with rhetoric of the Fascist regime. A muscular, larger-than-life arm clothed in a *camicia nera* (the black shirt that was required as part of the Fascist uniform), gives the ubiquitous Roman salute while uncovering the town of Herculaneum buried in ashes by Mount Vesuvius's deadly volcanic eruption of 79 AD.

Also in 1928, ENIT and FS commissioned Dudovich to create a poster for the town of Padova (page 60). In it, Dudovich celebrates Donatello's bronze equestrian monument dedicated to Erasmo of Narni, a famous military leader, better known as "Gattamelata," or "The Honeyed Cat." The expert pencil drawing accurately, encapsulates the architectural details while retaining the dynamic, quick lines of a sketch. The subtle color scheme appears to pin the dark overtones of military might against the light convoluted architectural background of a society largely under the influence of the Church.

ENIT and FS had also the foresight to hire Dudovich for the 1933 poster "Grado" (page 65), a less political and more comfortable subject for the artist. In it, we can easily recognize the defining characteristic of Dudovich's work: a natural drawing ability that captures women and their elegance. This unique talent could be seen earlier in his work for Magazzini Mele of Napoli, one of the most famous and prized series of Italian posters of all time.

From the "Grand Tour" to Mass Travel

To fully appreciate the enormous impact of a state policy devoted to increasing tourism in Italy, we have to begin with a brief history of Italian tourism itself.

Since the Middle Ages there has been a continuous stream of travelers voyaging to Italy. While all roads led to Rome—by far the preferred destination for pilgrims, artists, academics and merchants—soon the cities of Milan, Bologna, Florence, and Venice also began receiving their fair share of visitors. Since the Renaissance many European nations had established brotherhoods in Rome to welcome and assist their fellow countrymen, pilgrims, and businessmen. In 1666, the French government instituted the Academy of France in Rome, acknowledging the importance

of Italy's cultural and artistic roles and, in fact, appointing Rome as the place where artists from all over Europe should converge and interact.

The expression "Grand Tour" was first used by the Roman Catholic priest and travel writer Richard Lassels (ca. 1603–1668). In his book *Voyage or a Complete Journey through Italy* (ca. 1670) Lassels recommended that any "young gentlemen" should learn through direct experience about culture, architecture, history, and art by traveling through France and Italy, in what Lassels refers to as the Grand Tour. Six months or more in France and Italy on the Grand Tour soon became a required part of a young gentleman's education. The abundant classical antiquities, museums, and monuments were the focal point of this early form of tourism and was also embraced by older men and occasionally by women travelers.

The Italian leg of the Grand Tour quickly gained popularity among adult and young travelers alike. It was commonplace to see the English, German, and French elite criss-crossing Italy in luxurious horse-drawn coaches accompanied by a full complement of medics, chefs, valets, painters, and couriers to ensure a safe and comfortable journey.

By the time the Grand Tour was embraced by the European bourgeoisie—certainly amidst some form of disdain and outrage by the upper classes—Italy had surpassed France as the favorite part of the voyage. Genoa and its splendid "Italian Riviera"—an attractive alternative to the Côte d'Azur—became a preferred destination for English tourists enchanted by the sunny and favorable climate, breathtaking landscapes, friendly hospitality, and superb gastronomy.

Italy By Train

The industrial revolution had proven fatal for the horse-drawn carriage. In his book *The Carriage Trade: Making Horse-Drawn Vehicles in America*, Professor Thomas A. Kinney notes,

> In 1926, the Carriage Builders' National Association met for the last time signaling the automobile's final triumph over the horse-drawn carriage. Only a decade earlier, carriages and wagons were still a common sight on every Main Street in America. In the previous century, carriage-building had been one of the largest and most dynamic industries in the country.

On another front, steam locomotives had begun appearing in the early 1800s. A few decades later the entrepreneur and travel agent Thomas Cook would use this new form of transportation to bring the English tourists to Italy with an "all inclusive" formula whereby travelers were charged a fixed price on designated routes. Thanks to the high degree of comfort, speed, and moderate cost, the train would soon transform tourism into a mass phenomenon.

The first Italian train line was built in 1839, thirty-one years before the unification of Italy. It connected Naples to the nearby town of Portici. Other privately owned short train lines began appearing mostly in the north-central regions.

At the inception of rail transport Italy didn't have the economic means or the know-how to develop a railroad system. Instead it adopted a policy of granting licenses to qualified private companies, often foreign, to build and operate train lines on its territory. Five years after the unification

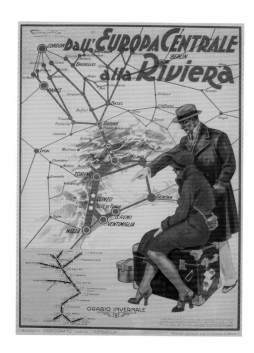

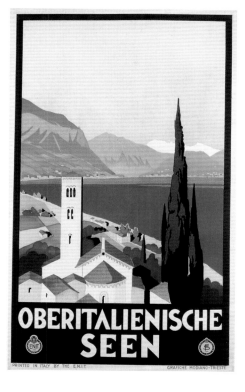

Pola, ca. 1925

Leopoldo Metlicovitz
39 ⅜ x 27 ⅟₁₆ in.
(100 x 68.7 cm.) Lithograph
ENIT, FS
Officine Grafiche
G. Ricordi & C., Milan

of Italy in 1870, the Italian state exercised the option to not renew the licenses to the private companies and began the process of consolidating the fragmented railway lines into a single network.

By the time FS—Ferrovie dello Stato (Italian State Railways)—was finally created in 1905, existing tracks totaled about 9,000 miles and connected most of the territory. Now organized into one comprehensive national network, the Ferrovie dello Stato had the characteristic of being completely integrated with the urban layout according to a "romantic" sensibility. Trains would emerge from under the hills' brick-lined tunnels and run along coast-jumping gulfs and coves across breathtaking bridges. It was a spectacular and entertaining ride that showcased memorable panoramas and vistas, with passengers glued to the windows of the *carrozze*, or carriages. Train tickets were affordable and prompted an exponential growth in ridership. Mass tourism was finally becoming a reality. Moving people from one place to another also meant the need to create infrastructure such as hotels, and restaurants, as well as the need to provide seaside and mountainside activities.

When the Ferrovie dello Stato began to promote its travel destinations with the help of marketing campaigns, the key element was the poster. The Ferrovie dello Stato travel posters would beautify railroad stations while advertising picture-perfect destinations throughout Italy.

One of Ferrovie dello Stato's notable posters is the historically relevant ca. 1925 poster for "Pola–Venezia Giulia" by Leopoldo Metlicovitz. Following the collapse of the Austro-Hungarian Empire in 1918, Pula and the whole of Istria was annexed to Italy. Renamed Pola by the Italians, this Adriatic

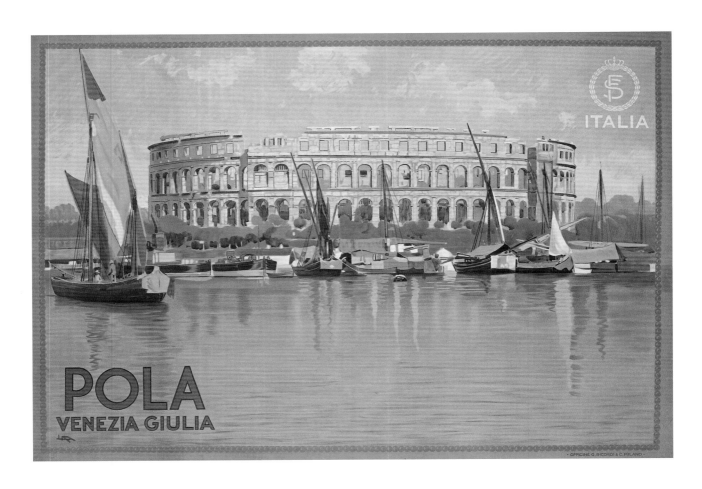

seaport town became a new territory to be discovered by tourists. Metlicovitz painted a serene atmosphere with colorful boats against the backdrop of the town's first-century Roman amphitheatre, certainly suggestive of the idea that the Pola was destined to become part of Italy. The sans-serif typography is not typical of Metlicovitz, who usually chose to work with more decorative typefaces, but it does reflect his preference for text being arranged in multiple lines, forming a block. Twenty-five years later the annexation of the new territory would be sadly reversed when Italy, defeated in World War II, was stripped of its sovereignty over Istrian Pola and Dalmatia.

Another fine example of a Ferrovie dello Stato promotion is the 1925 poster of Santa Caterina del Sasso–Lac Majeur by an unknown artist (page 33). The image depicts the hermitage of Santa Caterina del Sasso—founded in the 1300s by a rich local merchant named Alberto Besozzi. The story goes that after having survived a heavy storm while crossing the lake, he decided to retreat to that rocky ledge on the Lombardia side of Lago Maggiore. In order to engage the tourist's imagination, the artist captured the mystic atmosphere of the site, bathing the scene in a warm, heavenly light. The typography is hand-drawn and discretely integrated with the painting in terms of color, texture, and placement. Even the words "Lac Majeur" are only as wide as the stone wall so as not to intrude on the scene.

Marketing A Country

The other forces behind marketing Italy as a tourist destination were the TCI—Touring Club Italiano and ENIT—Istituto Nazionale per il Turismo (Italian Government Tourism Board). Originally established as a national association of cyclists with the aim of fostering the social and cultural values of tourism, TCI soon embraced other modes of tourism contributing to the development of Italy's tourism industry. Still in existence today, TCI's mission was eventually redirected with the birth of ENIT.

Soon after the end of World War I, foreign tourism in Italy was challenged by emerging European destination alternatives. Having fought a long and expensive war that cost more than 600,000 lives and an enormous amount of money, Italy needed the economic benefits of a healthy foreign tourism trade which would bring valued currencies. On October 12, 1919, a royal decree by King Vittorio Emanuele III established the creation of a state tourist board. It was named ENIT–Ente Nazionale per le Industrie Turistiche. ENIT was structured under the Ministry of Industry, Commerce, and Labor and was given the urgent task to secure a steady stream of foreign tourism to Italy.

ENIT's strategic plan included setting up a network of tourist offices abroad to more effectively promote Italy through education within each foreign market. During its infancy, ENIT's short-term goals focused on driving tourists to Italy's existing private infrastructures such as hotels and resorts. This initial approach would soon evolve into a less commercial state policy of promoting the entire Italian territory and its treasures. The strategy adopted by ENIT was to break down the overwhelming vastness of Italy's offerings according to specific travel themes such as antiquity, religion, health and spas, winter sports, the mountains, and the sea.

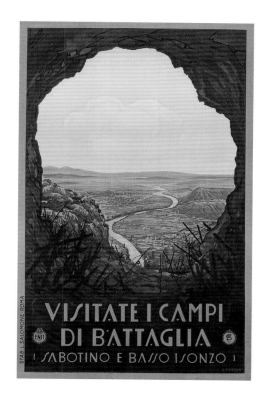

Visitate i Campi di Battaglia, ca. 1928
Amos Scorzon
25 x 39 in.
(63.5 x 100 cm.) Lithograph
ENIT, FS
Stab. L. Salomone, Rome

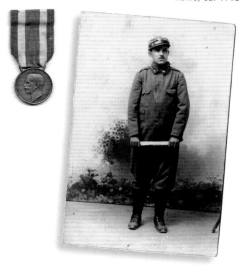

Pietro Venturini
Caporal
2° Reggimento Bersaglieri
Royal Italian Army
Rome, ca. 1916

Italia, 1935
A. M. Cassandre
24 ⁷⁄₁₆ x 39 ³⁄₈ in.
(62 x 100 cm.) Lithograph
ENIT, FS
Off. Graf. Coen & C., Milan

Abbazia, 1937
Walter Molino
27 ⁹⁄₁₆ x 39 ⁹⁄₁₆ in.
(70 x 100.5 cm.) Lithograph
ENIT
Ediz. F.I.A.R., Milan

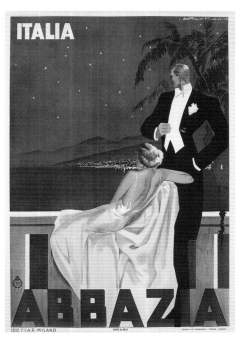

As anyone could easily deduce, all of these offerings combined with glorious weather, salubrious air, and the appeal of a more relaxed lifestyle made Italy an irresistibly attractive destination. In any single year ENIT produced hundreds of millions of brochures, postcards, and posters to advertise major cultural centers and small and unknown towns alike.

ENIT's poster campaigns were often realized in collaboration with the Ferrovie dello Stato. Despite car manufacturers Isotta Fraschini and FIAT's introduction of Italian automobiles at the turn of the century, railroads remained the premier transportation system for tourists. The introduction of the so called *treni popolari* or affordable trains, helped increase ridership even more by providing reduced-fare tickets. Tourism had indeed taken hold as a mass phenomenon.

Another notable contribution to the tourism industry was the government's ideological input. In 1925 it created the association Opera Nazionale Dopolavoro. The goal of the Dopolavoro was to tend to the free time of workers by: "elevating the moral and physical strength of the population with sport, art, tourism, health care and professional training."

Travel posters were designed to be easily printed in multiple editions in different languages for both domestic and foreign markets by using what we now call a "plate change"—in this case a lithographic stone change. The splendid subject of "La Riviera Italienne" (circa 1927) by Mario Borgoni best illustrates this technique. Borgoni skillfully integrated in the foreground, at the bottom of the composition, a large empty area painted with the same color scheme of the poster. All of the posters were printed with that area empty. Once divided in lots, one for each language, the posters went back on press and the empty area was overprinted with the language of choice. One basic design leading to all language versions is a classic example of the close relationship between art and commerce still relied upon by today's graphic designers.

In 1931, ENIT became a state administration solely focused on tourism and under the direct control of Fascist leader Benito Mussolini. During Mussolini's regime the Ministero della Cultura Popolare (MinCulPop) was created to strictly control all information. Any kind of publication had to be approved in advance by the MinCulPop. Travel posters were not exempt from the stern scrutiny of the regime and soon became an instrument of propaganda. Travel posters were required to celebrate the rhetoric of the Fascist regime as an underlying theme: youth, self-reliance, physical body strength, the past glory of the Roman Empire, and civic order. Mussolini, a journalist and firm believer in the power of communication and graphic identity, often acted as a creative director himself, establishing guidelines that had to be strictly followed across all media.

In these years, typography became bold and masculine. Borrowed from the Roman Empire's idiom, the letter V was used instead of U—see Simonetti's 1927 poster for the Umbrian town of Spoleto (page 92). Umberto Noni's 1934 poster for L'Aquila (Italian for "eagle") is also a fitting example of symbolism borrowed from previous empires: an imposing royal eagle with a golden crown stands against the Spanish Fortress, its wings spread to protect the town. L'Aquila's more picturesque civil or religious landmarks are completely foregone in favor of a strong militaristic image.

Of particular interest is Mario Puppo's 1938 poster for Cortina (page 57) where it appears the artist cleverly complied with the rules of the regime. The poster shows a healthy and dynamic couple of competitive

skiers standing on a ski slope in front of the Dolomites. The man's arm is stretched forward at shoulder level and with a flat hand he is pointing at the horizon. However, because Puppo rotates the entire composition clockwise, thereby raising the man's arm to a 45-degree angle, the man actually appears to be giving the Fascist's Roman salute.

Imperial expansion was another very important theme of Mussolini's regime. He successfully argued Italy's needs to colonize new territories to provide for its demographic growth and boost economic prosperity. The 1928 poster by an unknown artist, for the northern African town of Tripoli in Libya, is thought to advertise what appears to be an exotic and tranquil destination. The view from an arched courtyard opens onto the old town of Tripoli, the white buildings and slender minarets are set against a deep blue sea and turquoise, cloudless sky. The perspective of the composition leads a viewer first to a green luscious palm tree with a reddish bark (a subtle reminder of the colors of the Italian flag) and then to the sea, leading one's eyes toward the Southern Italian coasts. The sense of heat in the tropical town is conveyed by the deep yellow tint of the beautifully arranged deco-style lettering.

A New Life

After the widespread destruction of World War II and the tragic loss of human life, Italy began a path of reconstruction and transformation that would deeply affect the country and drive its growth for the next two decades. As argued by Germano Celant in an essay from The Italian Metamorphosis, 1943–1968, "The collapse of the regime, the military defeat, and the Resistance swept away nationalistic-rhetorical models of culture in favor of an open, liberal national identity. Intellectuals embarked on a search for the modern that had developed in democratic countries…" Creativity had been liberated again. The Italian filmmaker Renzo Rossellini began shooting his signature movie, *Open City,* in 1944 while the German Army was still lingering in Rome. In 1946, just two years after the war ended, the industrialist Enrico Piaggio launched the Vespa scooter—the first truly popular motorized vehicle and an iconic masterpiece of industrial design. Artists such as Renato Guttuso, Alberto Burri, Lucio Fontana and Emilio Vedova returned to their respective towns from voluntary exile or from having joined the Resistance, the partisan fighting force that contributed to the liberation of Italy.

At the end of the war, the tourist industry found itself having to address the tall order of restoring its damaged infrastructures. Railroads were hit especially hard, with destroyed bridges, collapsed galleries, and train stations that needed extensive rebuilding. However, amidst the fervor of the Italian rebirth, it took the FS less than seven years to restore the entire railroad network.

ENIT redoubled its marketing efforts, as tourism was once again considered one of the pillars of the resurgent Italian economy. Posters now advertised popular beaches with a renewed joy of life, as seen in Filippo Romoli's 1949 poster "Marina di Massa" (page 83). Here an exuberant young lady—who incidentally regained the delicate feminine proportions that the Fascists censured in favor of the muscular prototype of a hard working mother—is happily rowing a pattino raft by herself along the crowded and democratic beaches of Tuscany.

Tripoli, ca. 1930
Anonymous
24 9/16 x 39 7/16 in.
(61.7 x 100.2 cm.) Lithograph
ENIT, FS
S.T.E.N., Turin

Rodi, 1937
Erberto Carboni
26 7/8 x 39 5/8 in.
(68.2 x 100.7 cm.) Offset
ENIT, FS
Pizzi & Pizio,
Milan - Rome

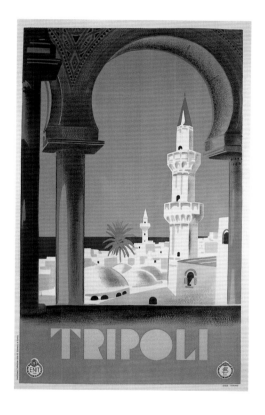

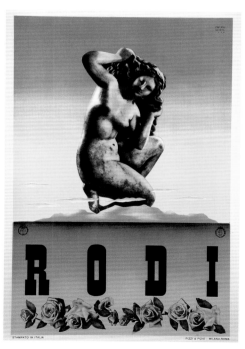

Finale Ligure, 1950
Mario Puppo
27 ⁹⁄₁₆ x 39 ³⁄₈ in.
(70 x 100 cm.) Lithograph
ENIT
SAIGA, già Barabino &
Graeve, Genoa

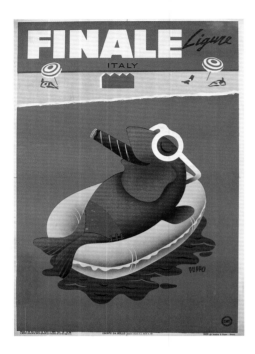

Posters of this period also reflect the changing nature of tourism. Gone were the days of inquisitive tourists only interested in history and antiquity. Tourists often traded their Baedeker's travel guidebook tour for a more recreational Italian vacation.

The 1949 poster "Lido di Jesolo" by Dinon-Pellarin (page 64) and the 1950 poster "Finale Ligure" by Mario Puppo reflect this shift in demand by domestic and foreign tourists alike. The actual landscape and landmarks of these two renowned seaside resorts were not the focal message. The posters' intent was to establish a memorable and unique identity built on the benefits of choosing Finale or Jesolo for an Italian vacation. The metaphor of the child-size life preserver with its cute duck head positioned the sandy beaches of Jesolo as a safe, family-oriented destination. Finale's happy suntanning, cigar-smoking fish highlighted how the resort could provide even the adult male tourist—including busy northern Italian industrialists—a tranquil moment away from everything.

The 1950s would bring the international jet-set, celebrities, and intellectuals to discover the romantic Isle of Capri with its Blue Grotto, beaches and coves, abundant flora, and endless romance. The Ligurian artist Mario Puppo captured the simple Mediterranean beauty of the island in his 1952 watercolor poster "Capri" (page 115), where a vase of cheerful red geraniums in the foreground leads the eye to a dramatic drop down to the coastline below and the two "Faraglioni" rocks amidst a deep blue sea.

Ironically, I believe the decline of the poster as the primary tool for tourism advertising campaigns at the end of the 1950s was due in part to its ultimate success. Travel posters had successfully established Italy as one of the most desirable travel destinations. Even Hollywood took notice of that. American film director William Wyler's romantic comedy *Roman Holidays* (1953) starring Audrey Hepburn and Gregory Peck, filmed on location in Rome and at the Cinecittà studios, and David Lean's *Summertime* (1954) with Katharine Hepburn and Rossano Brazzi, set in Venice, became the new "posters." The filmmakers and their films took on the job as the spokesmen for an entire country. Perhaps it was in those moments that the Italian travel poster had arrived at the end of its own particular long journey and took a step into history.

The Poster Is Alive

As Stuart Wrede points out in *The Modern Poster*, "It is equally significant as a reproducible popular cultural medium that can be used by all—from large institutions to small cultural or political movements and individuals—to give visual expression to their ideas and beliefs. That cannot be said of television, radio, or the press."

While the advent of the Internet has in part eroded the poster's unique and democratic role described by Wrede only twenty years ago, posters today still retain an important social, artistic, and commercial function and are an essential part of how we communicate.

Opposite

Detail from:
**Oberitalienische
Seen, ca. 1928**
(Featured on page 11)

**The Valley
of Aosta, ca. 1930**
Giuseppe Magagnoli
24 ⅜ x 39 ½ in.
(62 x 100.3 cm.)
Lithograph
ENIT, FS
Maga, Milan

The Valley of Aosta

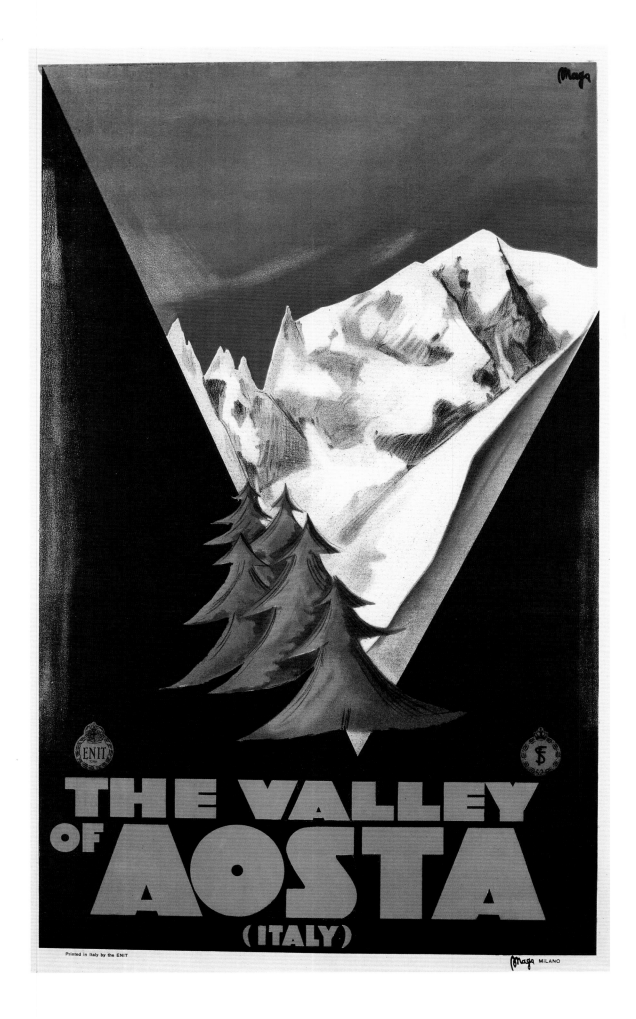

Valle d'Aosta, 1954
Mario Puppo
25 ½ x 38 ⅝ in.
(64.8 x 98.2 cm.)
Offset
Assessorato
Regionale per il Turismo
SAIGA, Genoa

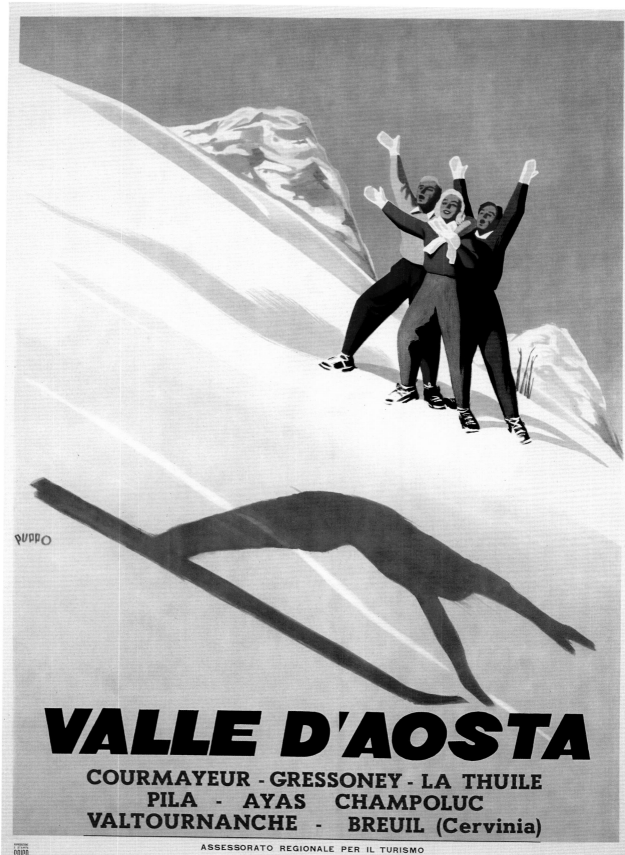

VALLE D'AOSTA
COURMAYEUR - GRESSONEY - LA THUILE
PILA - AYAS CHAMPOLUC
VALTOURNANCHE - BREUIL (Cervinia)

ASSESSORATO REGIONALE PER IL TURISMO

Val d'Aosta, 1947
Gino Boccasile
38 ³/₁₆ x 54 ¾ in.
(97 x 139 cm.)
Lithograph
Uffico regionale
per il Turismo
Stab. Pezzini, Milan

**Sports Invernali in
Val d'Aosta, 1937**
Mario Puppo
27 ⁵/₁₆ x 39 ⁷/₁₆ in.
(69.7 x 99.8 cm.)
Lithograph
Ente Provinciale
per il Turismo Aosta
Pizzi & Pizio, Milan - Rome

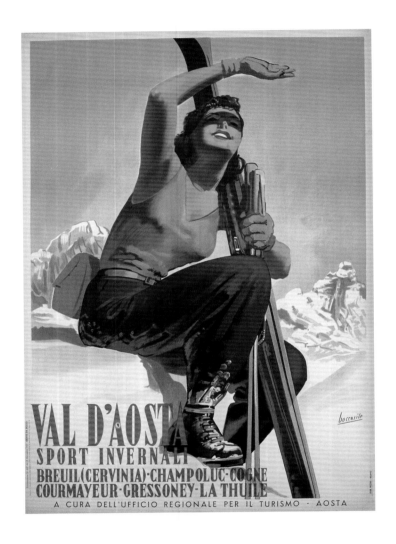

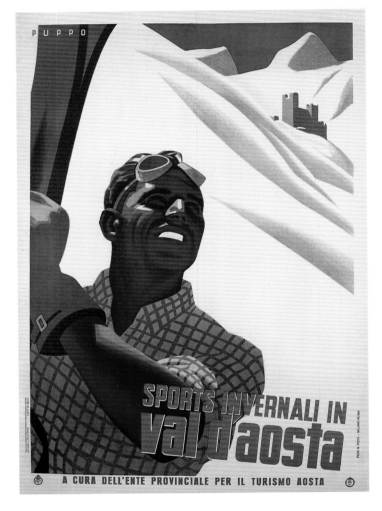

Vallée d'Aoste, 1950
Arnaldo Musati
27 ³/₁₆ x 39 ¾ in.
(70 x 100 cm.)
Offset
Bureau Regional
du Turisme
Grafiche I.G.A.P., Milan

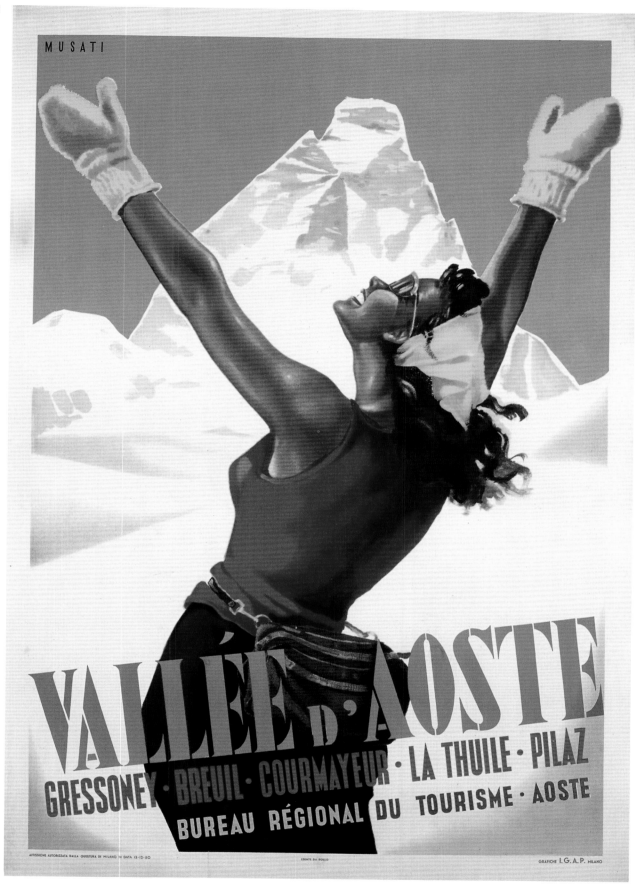

Val d'Aosta, ca. 1935
Anonymous
25 ⅞ x 39 ⅜ in.
(65.7 x 100 cm.)
Lithograph
ENIT, FS
Pizzi & Pizio, Milan - Rome

Bardonecchia, 1952
Anonymous
23 ⅝ x 39 in.
(60 x 99 cm.)
Offset
ENIT, FS
Roggero & Tortia, Turin

..
Piedmont Region

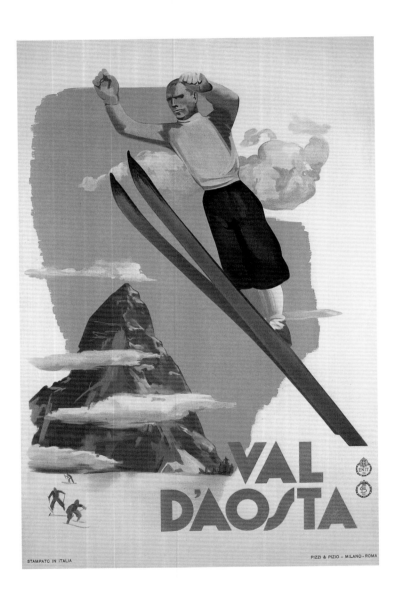

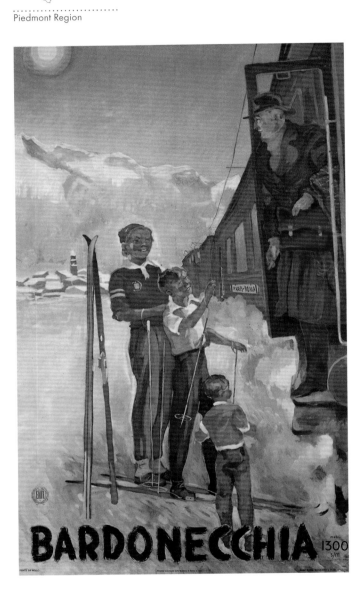

**Torino Capitale
delle Alpi, 1953**
Adalberto Campagnoli
23 ¾ x 38 ⅜ in.
(60.3 x 97.5 cm.)
Offset
ENIT
Gros Monti & C., Turin

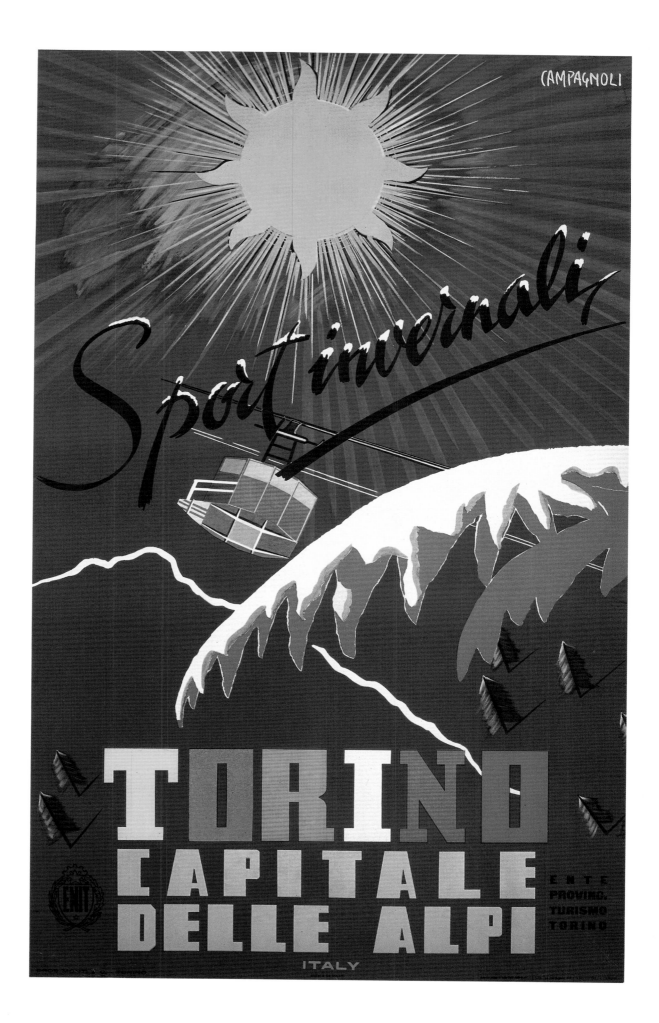

**Torino e le sue
valli, 1951**
Adalberto Campagnoli
24 ⅛ x 39 ⅝ in.
(61.3 x 100.7 cm.)
Offset
ENIT
Gros Monti & C., Turin

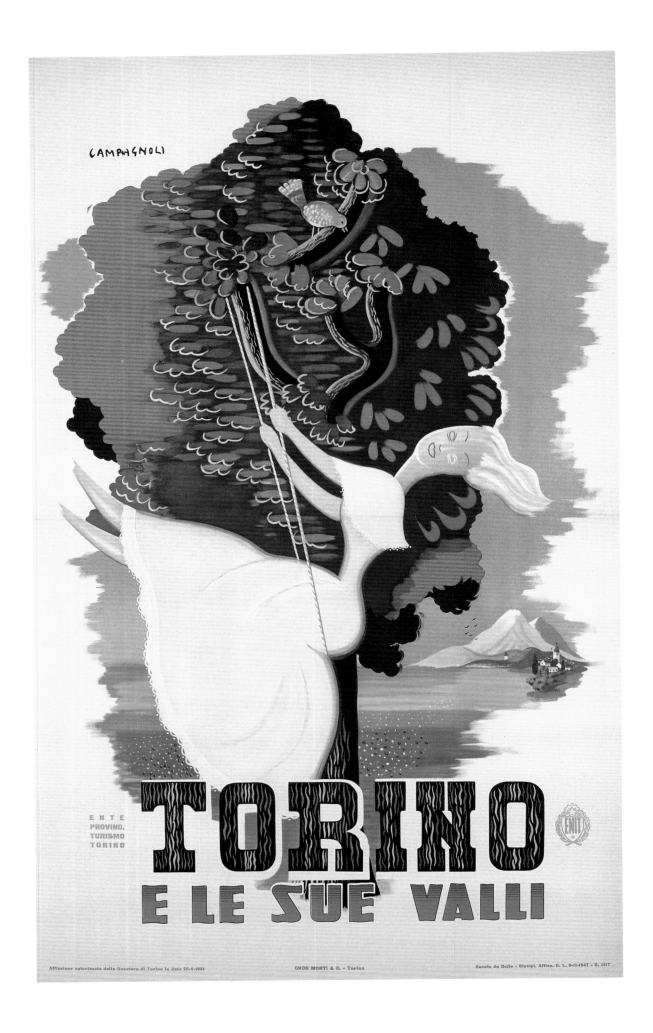

Torino, 1949

Tappa-Crea

24 ³/₁₆ x 39 ³/₈ in.
(61.4 x 100 cm.)
Lithograph
ENIT, FS
Gros Monti & C.,
Turin - Rome

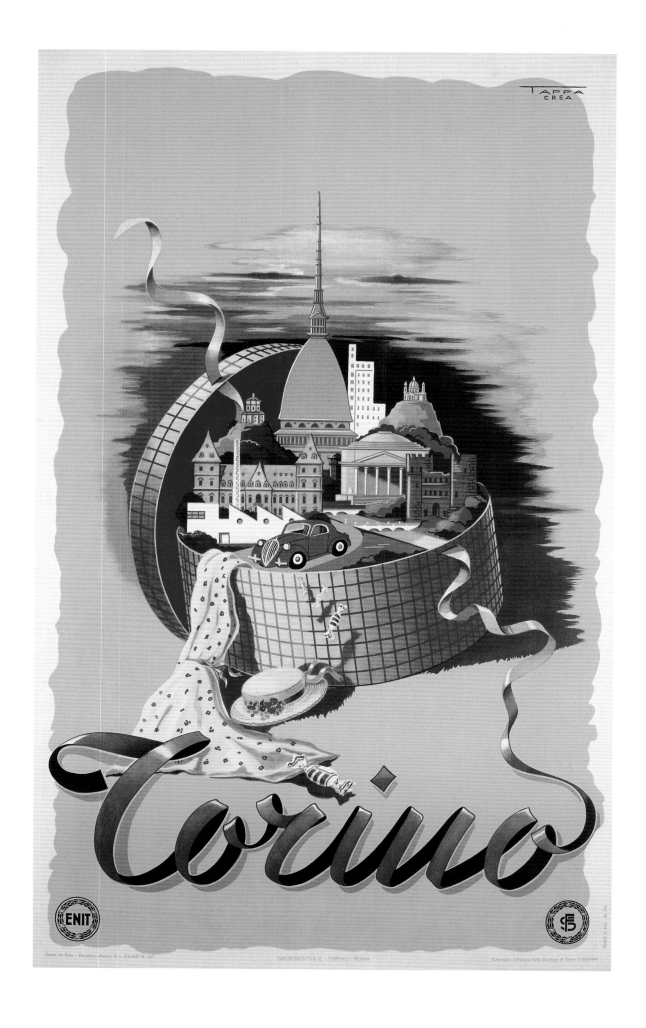

Varallo, 1936
Filippo Romoli
27 ⅝ x 39 ³/₁₆ in.
(70.2 x 99.5 cm.)
Lithograph
ENIT, FS
Barabino & Graeve,
Genoa

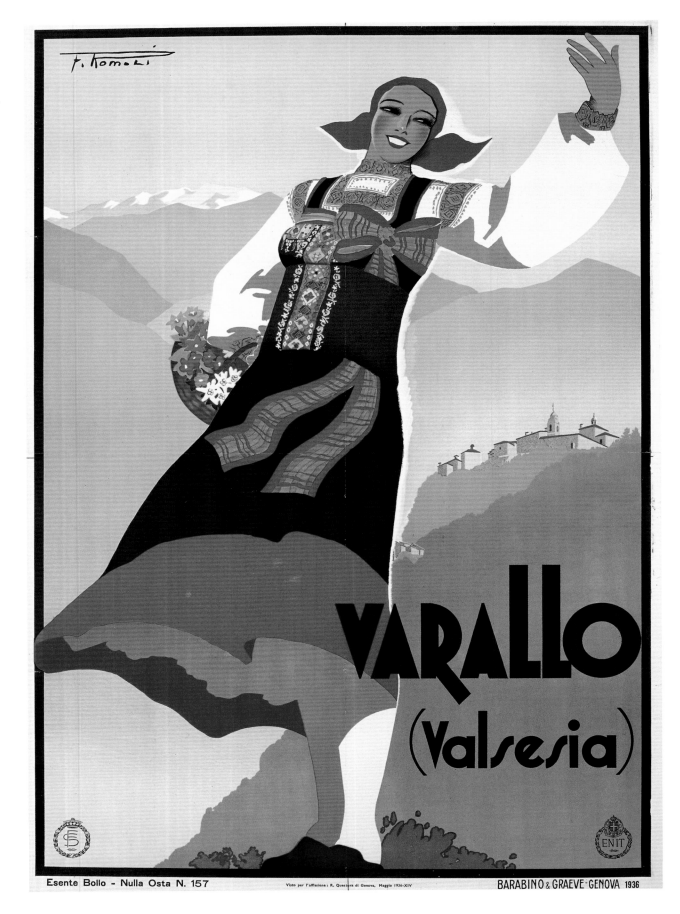

Valsesia, 1951
Filippo Romoli
24 ³⁄₈ x 38 ⁷⁄₈ in.
(62 x 98.8 cm.)
Lithograph
ENIT
SAIGA, già Barabino &
Graeve, Genoa

**Sports Invernali
in Italia, ca. 1926**
Paolo Paschetto
27 x 39 ³⁄₁₆ in.
(68.6 x 99.5 cm.)
Lithograph
ENIT, FS
Stab. A. Marzi, Rome

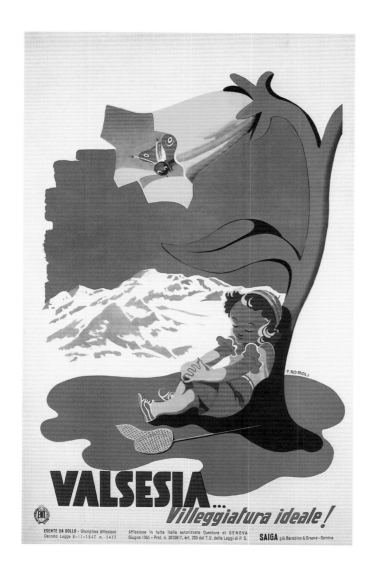

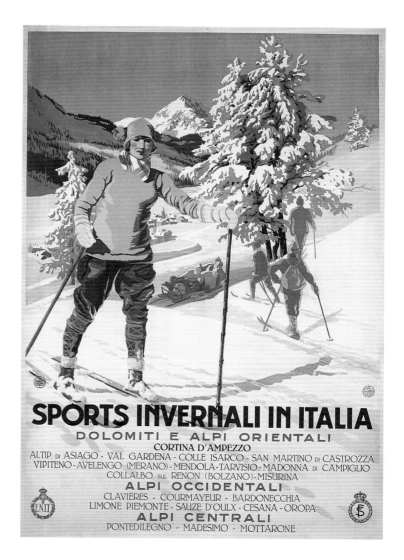

Mera, 1951
Arnaldo Musati
23 ⅝ x 39 in.
(60 x 99 cm.)
Offset
ENIT
SAIGA, già Barabino &
Graeve, Genoa

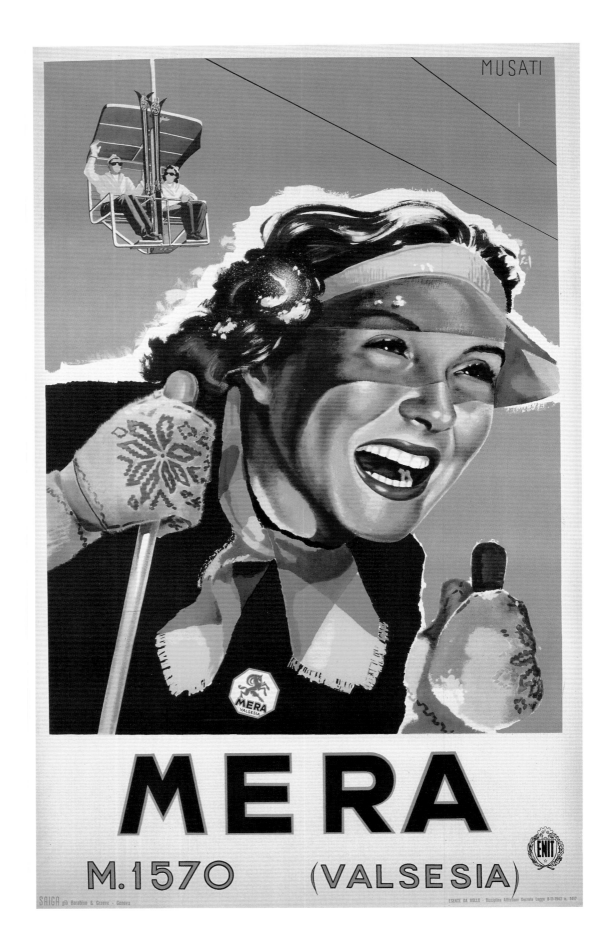

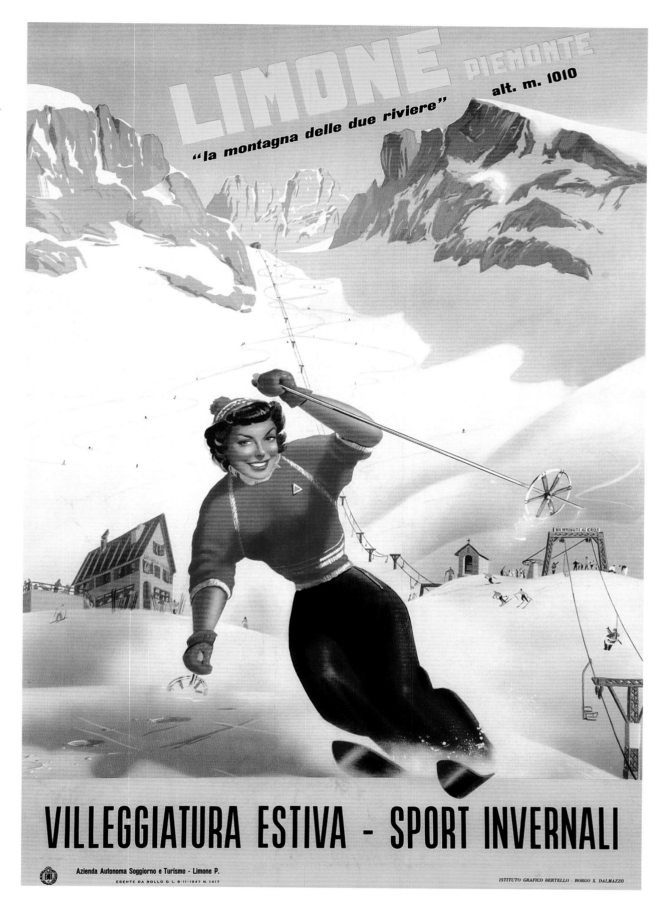

Stresa-Borromeo,
Lago Maggiore, 1927

Aldo Mazza

27 ⅝ x 39 ⅜ in.
(69.4 x 100 cm.)
Lithograph
ENIT, FS

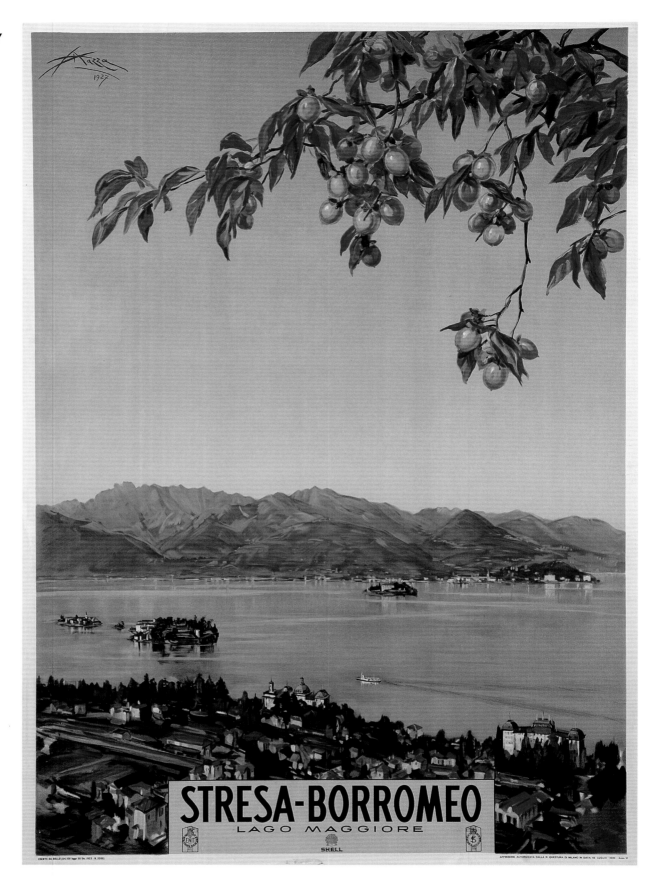

Le Lac Majeur, ca. 1925
Mario Borgoni
25 ³⁄₁₆ x 40 in.
(64 x 101.5 cm.)
Lithograph
ENIT, FS
Richter & C., Naples

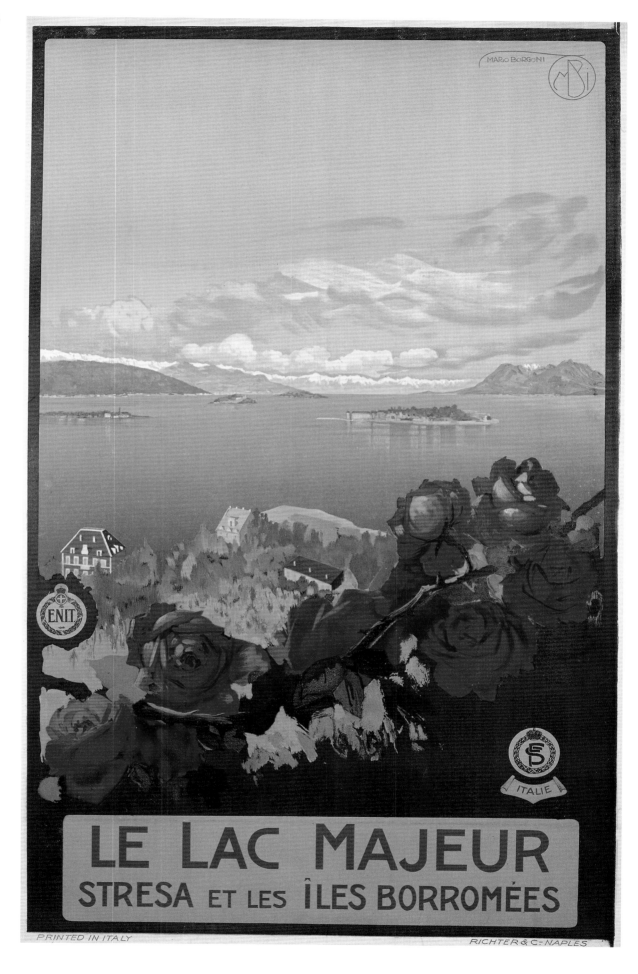

Baveno, 1949
Mario Puppo
27 x 39 in.
(68.5 x 99 cm.)
Offset
ENIT
SAIGA, già Barabino &
Graeve, Genoa

Lago D'Orta, ca. 1925
Anonymous
27 ¹¹⁄₁₆ x 38 ¼ in.
(70.4 x 97.2cm.)
Lithograph
FS, ENIT
Richter & C., Naples

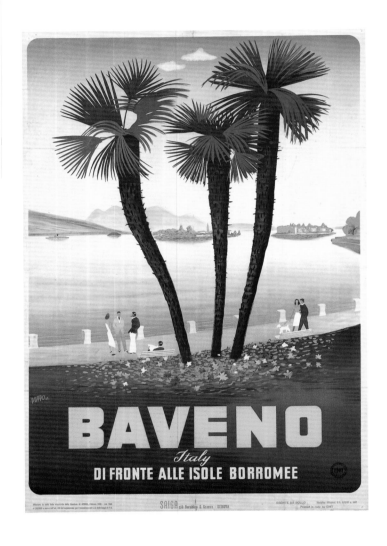

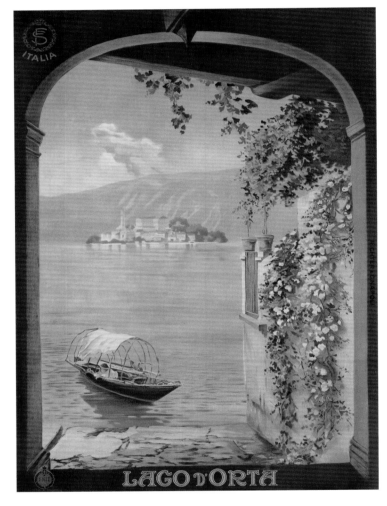

**Santa Caterina
del Sasso, ca. 1925**

Anonymous
27 ³/₁₆ x 39 ¹/₁₆ in.
(69 x 99.2 cm.)
Lithograph
FS
Richter & C., Naples

.............................
Lombardy Region

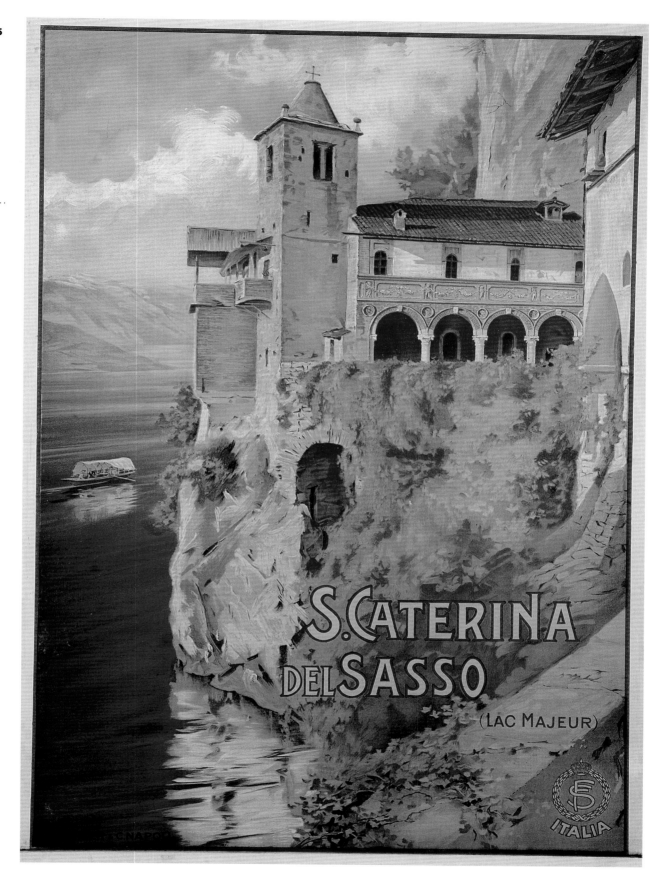

**Punta di Balbianello,
ca. 1925**

Anonymous

27 ⁹/₁₆ x 39 ³/₈ in.
(70 x 100 cm.)
Lithograph
ENIT, FS
Richter & C., Naples

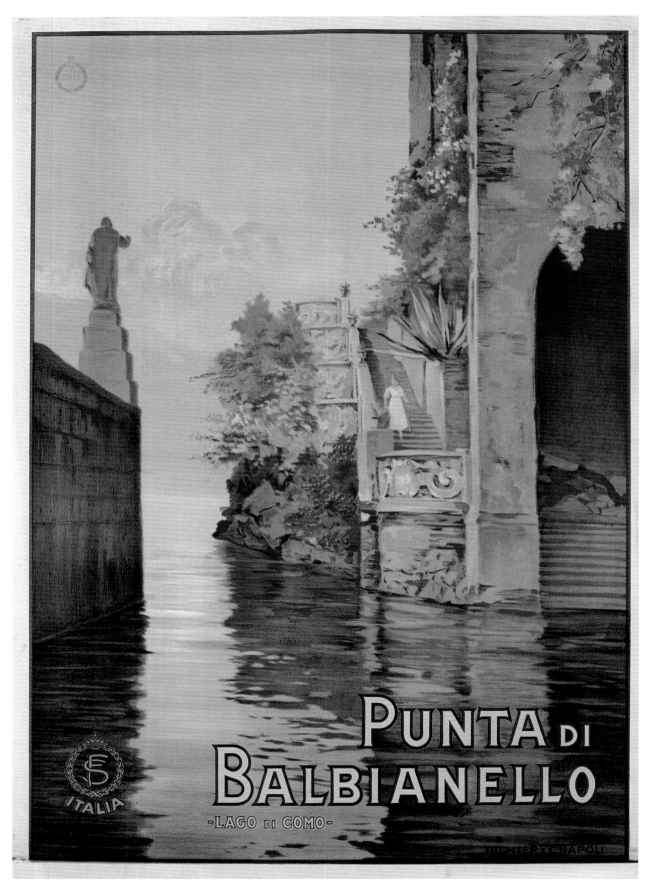

Bellagio, ca. 1926
Livio Apolloni
26 ¾ x 39 ⅜ in.
(68 x 100 cm.)
Lithograph
ENIT, FS
Novissima, Rome

Cadenabbia - Tremezzo, 1926
Livio Apolloni
27 ¼ x 39 ⅜ in.
(69.2 x 100 cm.)
Lithograph
ENIT, FS
Novissima, Rome

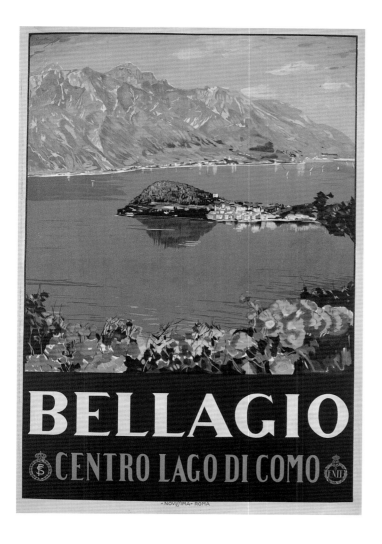

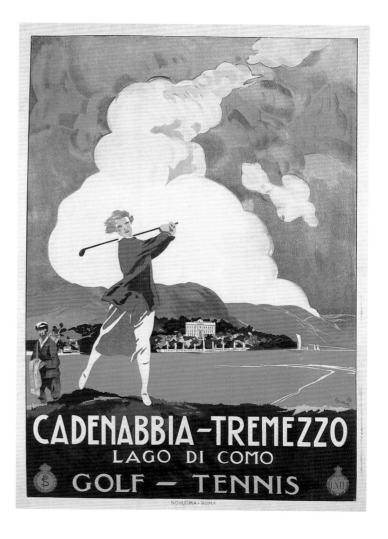

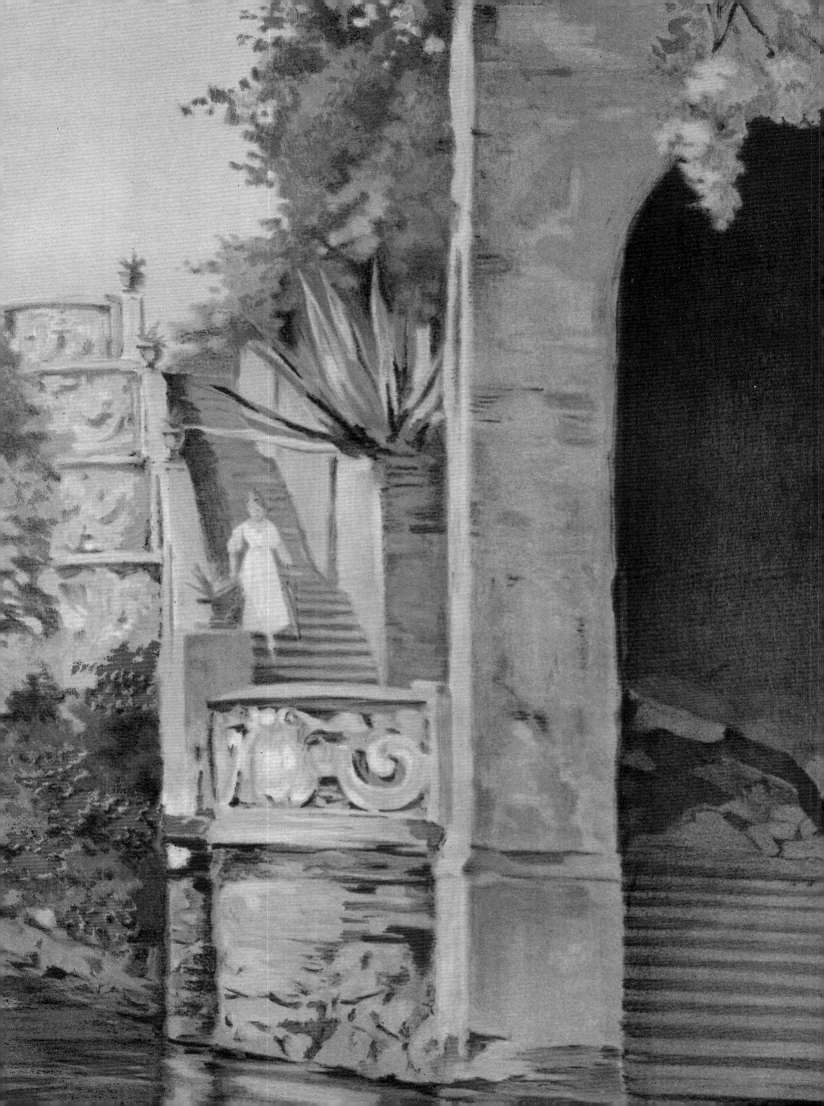

Brescia, ca. 1928
Vincenzo Alicandri
27 ⁹⁄₁₆ x 39 ⅜ in.
(70 x 100 cm.)
Lithograph
ENIT, FS
Richter & C., Naples

Milano, 1955
Marcello Nizzoli
24 ⅜ x 38 ⁹⁄₁₆ in.
(62 x 98 cm.)
Lithograph
ENIT, FS
Ind. Graf. N. Moneta,
Milan

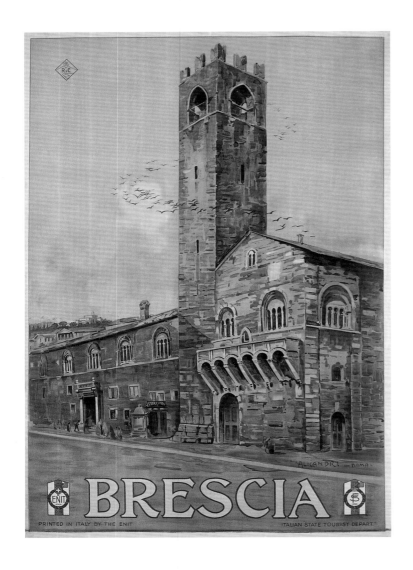

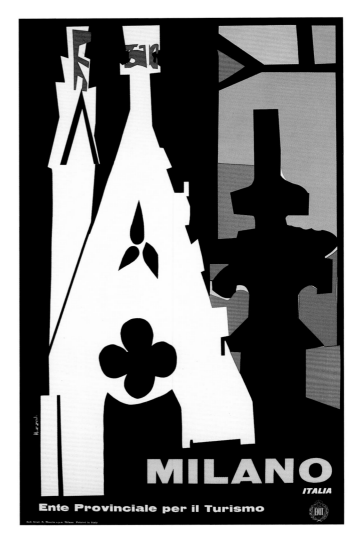

Milano, ca. 1928

Armando Pomi

24 ¹³/₁₆ x 39 in.
(63 x 99 cm.)
Lithograph
ENIT, FS
Studio Editoriale
Turistico, Milan

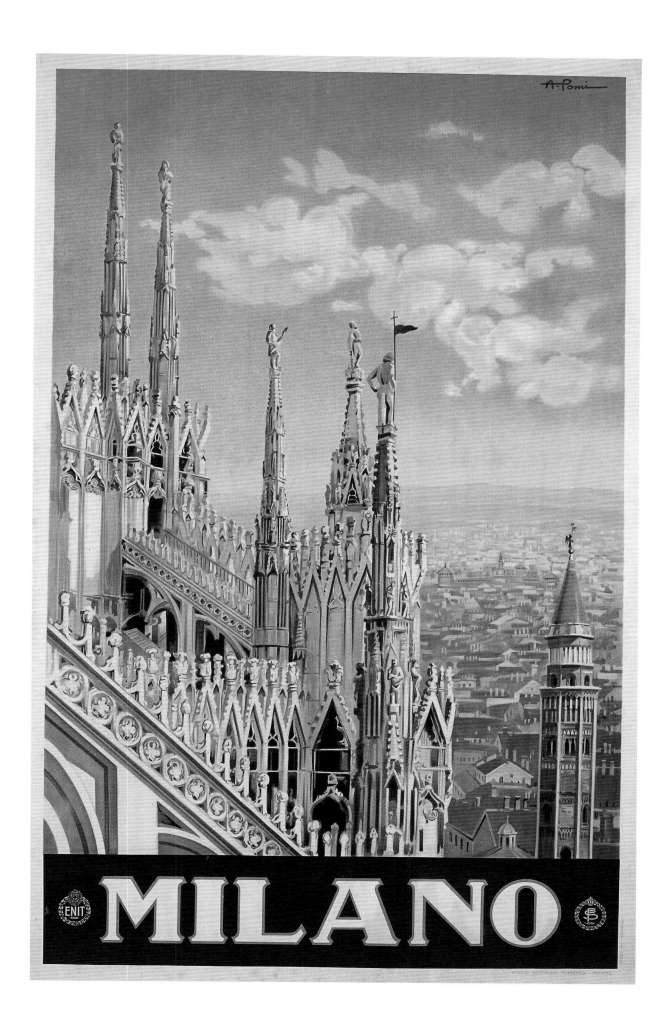

Bergamo, 1927
Marcello Nizzoli
27 ⁹⁄₁₆ x 38 ⁹⁄₁₆ in.
(70 x 98 cm.)
Lithograph
ENIT, FS
Edizioni STAR,
Milan

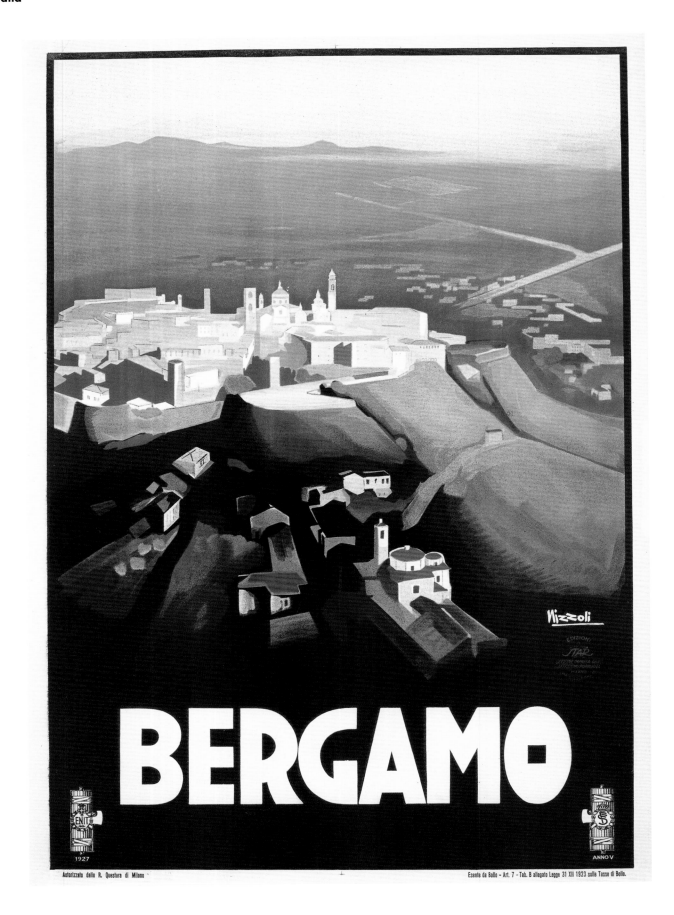

S. Pellegrino, ca. 1928

Fortunato Tami

24 ⅜ x 39 ³/₁₆ in.
(62 x 99.5 cm.)
Lithograph
ENIT, FS
Istituto Italiano d'Arti
Grafiche, Bergamo

Mantova, 1948

Giuseppe Riccobaldi

26 ⅞ x 39 ³/₁₆ in.
(68.3 x 99.5 cm.)
Lithograph
ENIT
SAIGA, già Barabino &
Graeve, Genoa

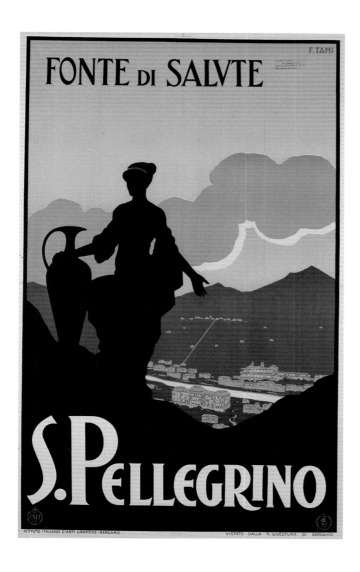

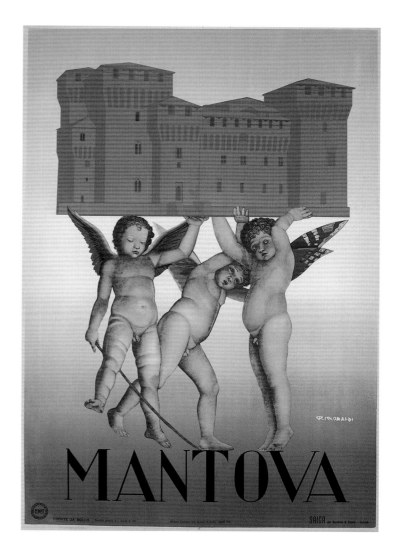

Gardone, 1934
Aldo Raimondi
24 ⁹⁄₁₆ x 39 in.
(62.4 x 99 cm.)
Lithograph
ENIT, FS
Barabino & Graeve,
Genoa

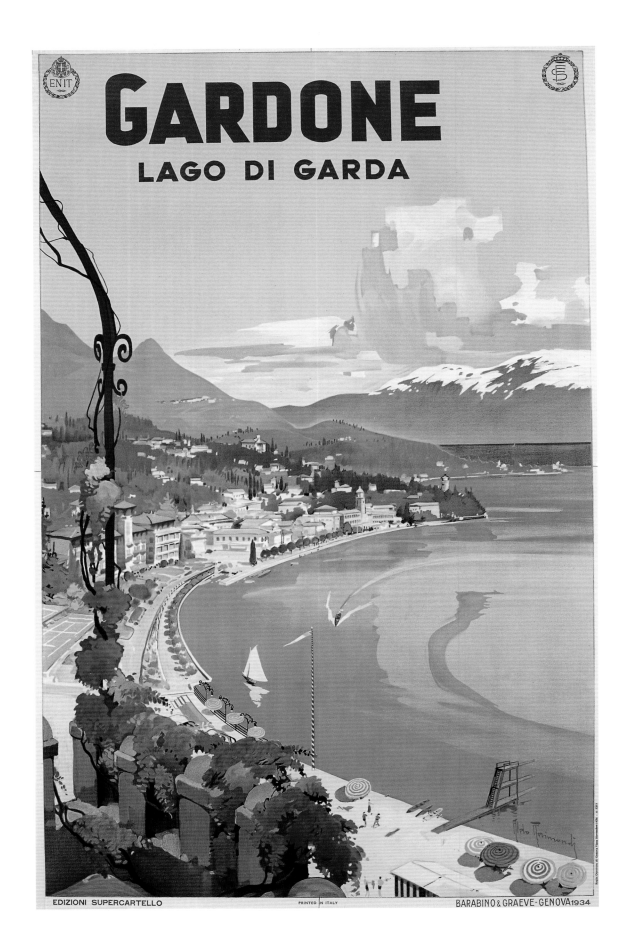

Le Lac de Garda, 1924

Severino Trematore

27 ³⁄₁₆ x 39 ³⁄₈ in.
(69 x 100 cm.)
Lithograph
ENIT, FS
Barabino & Graeve,
Genoa

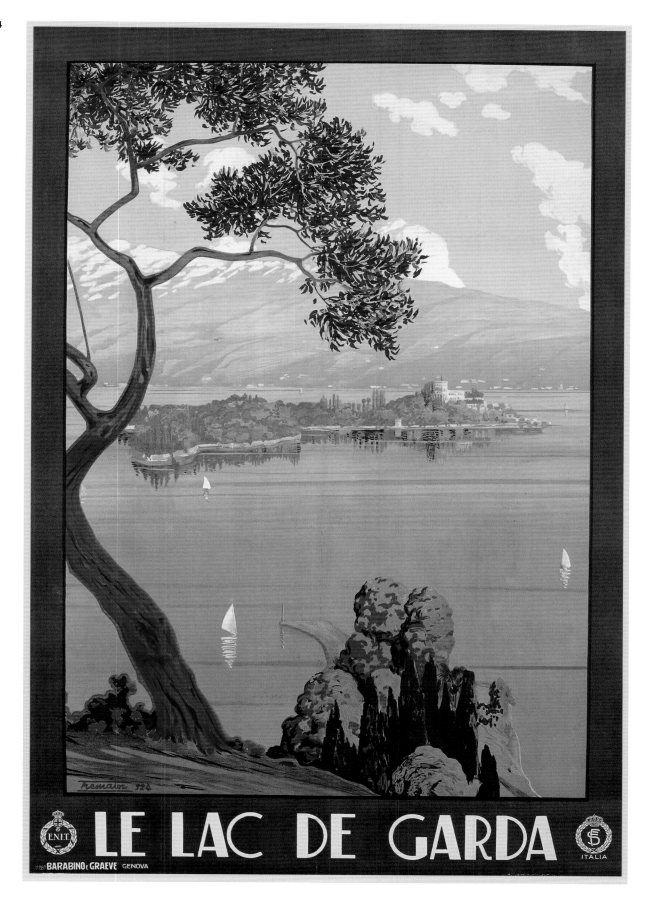

**Terme Sirmione
Lago di Garda, 1949**
Giuseppe Riccobaldi
27 x 39 ⅜ in.
(68.5 x 100 cm.)
Lithograph
ENIT, FS
SAIGA, già Barabino &
Graeve, Genoa

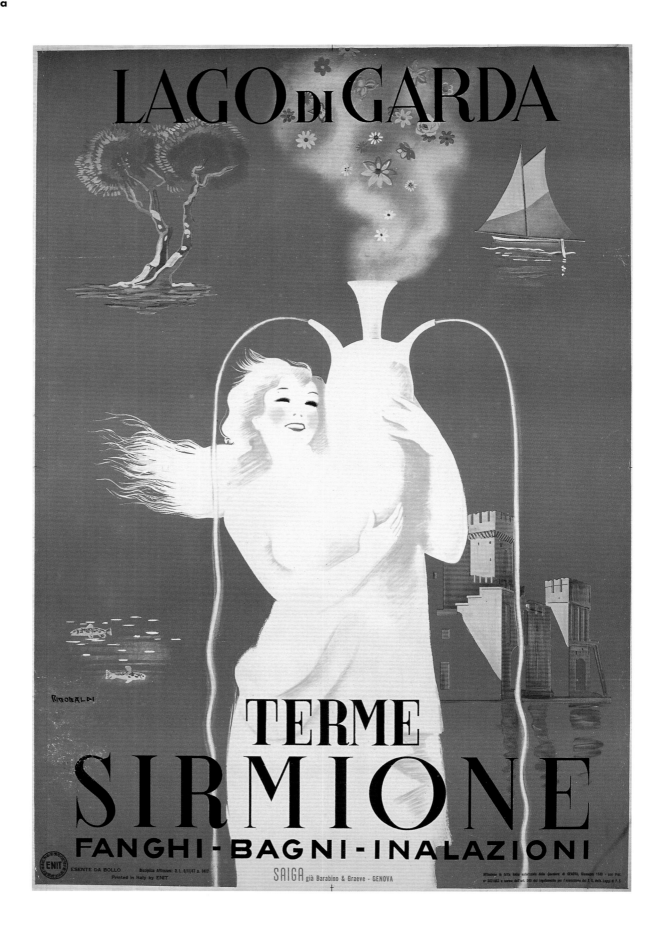

Lago di Garda, Riva, ca. 1926

Antonio Simeoni

27 9/16 x 39 3/8 in.
(70 x 100 cm.)
Lithograph
ENIT, FS
Barabino & Graeve,
Genoa

Trentino-Alto Adige
Region

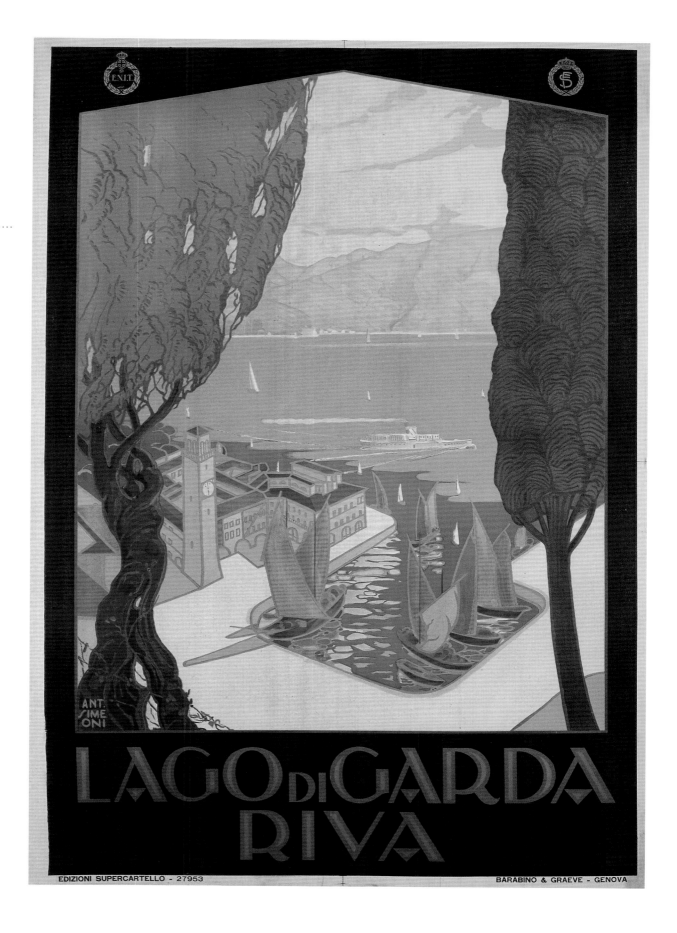

Riva Torbole, 1952
Mario Puppo
26 ⁹/₁₆ x 38 ⅜ in.
(67.5 x 97.5 cm.)
Lithograph
ENIT
Sigla Effe, Genoa

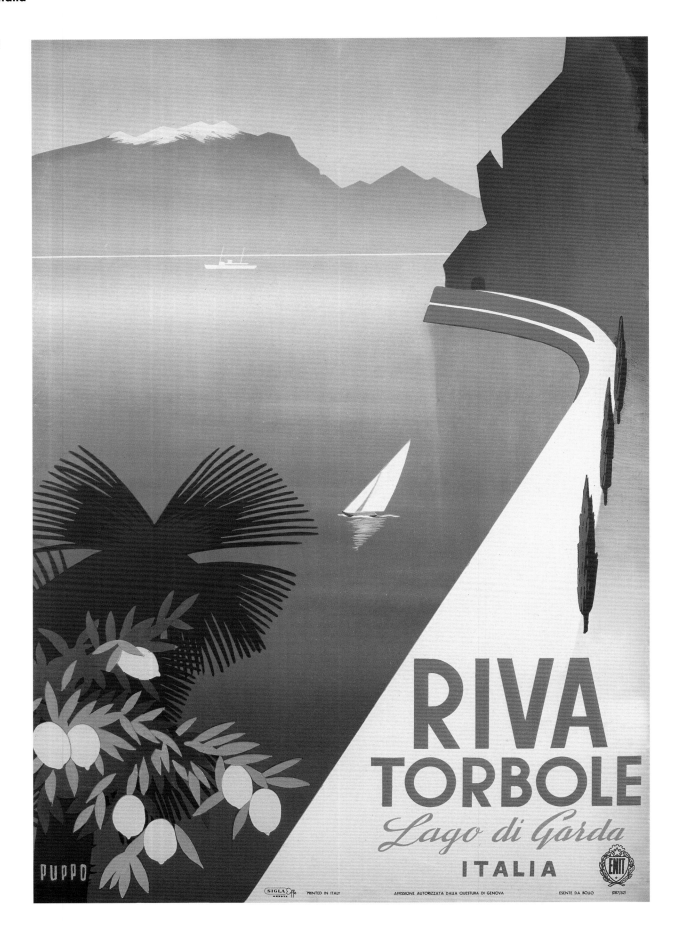

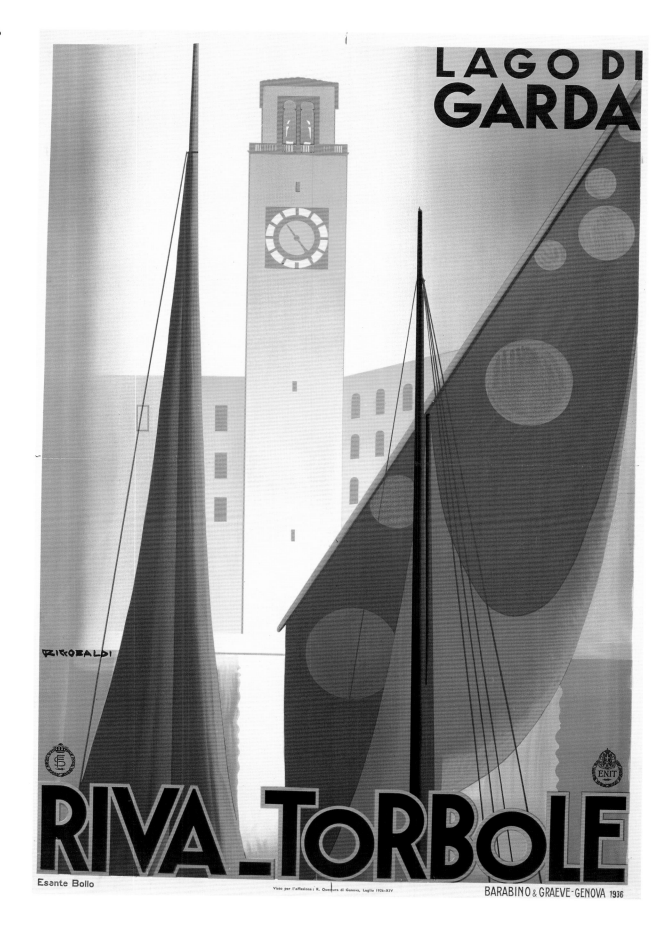

**Terme Levico
Vetriolo, 1950**
Giuseppe Riccobaldi
24 ⁵⁄₁₆ x 38 ³⁄₈ in.
(61.8 x 98.4 cm.)
Lithograph
ENIT
SAIGA, già Barabino &
Graeve, Genoa

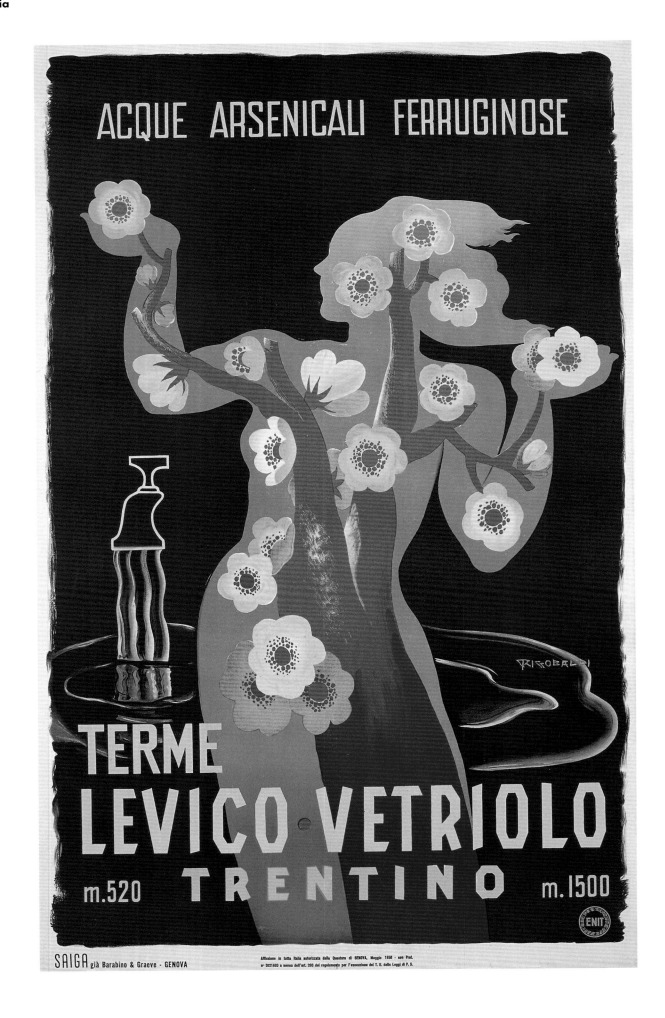

Trafoi, ca. 1920

Anonymous
26 ¾ x 39 ⅜ in.
(68 x 100 cm.)
Lithograph
ENIT, FS
Stab. L. Salomone, Rome

Merano, ca. 1927

Mario Borgoni
27 ¾ x 38 %6 in.
(70.5 x 98 cm.)
Lithograph
FS
Richter & C., Naples

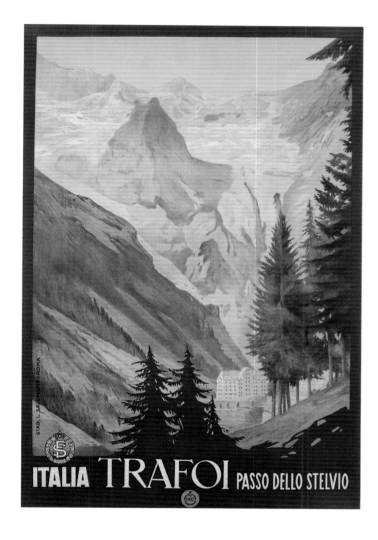

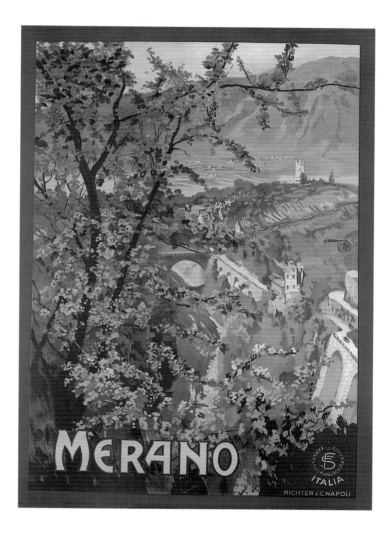

Merano, 1937
Sergio Franciscone
27 ¹¹⁄₁₆ x 39 ⅝ in.
(70.3 x 100.7 cm.)
Lithograph
ENIT, FS
Off. Graf. Coen & C.,
Milan

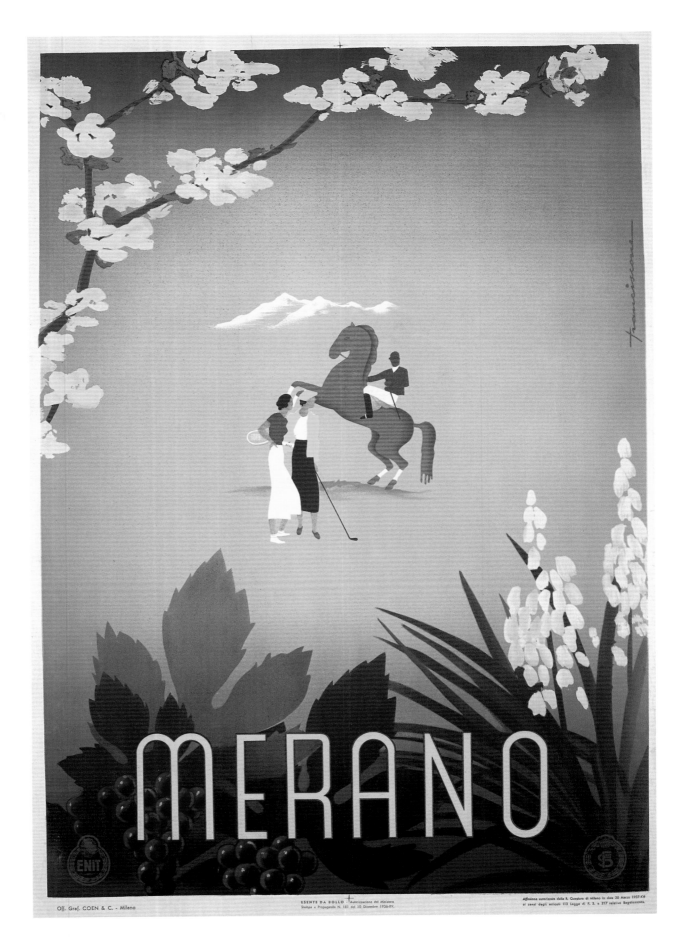

Bozen-Gries, 1934

Franz Lenhart

24 ⅜ x 37 ⅜ in.
(62 x 95 cm.)
Lithograph
ENIT, FS
Lit. G. Linke, Bolzano

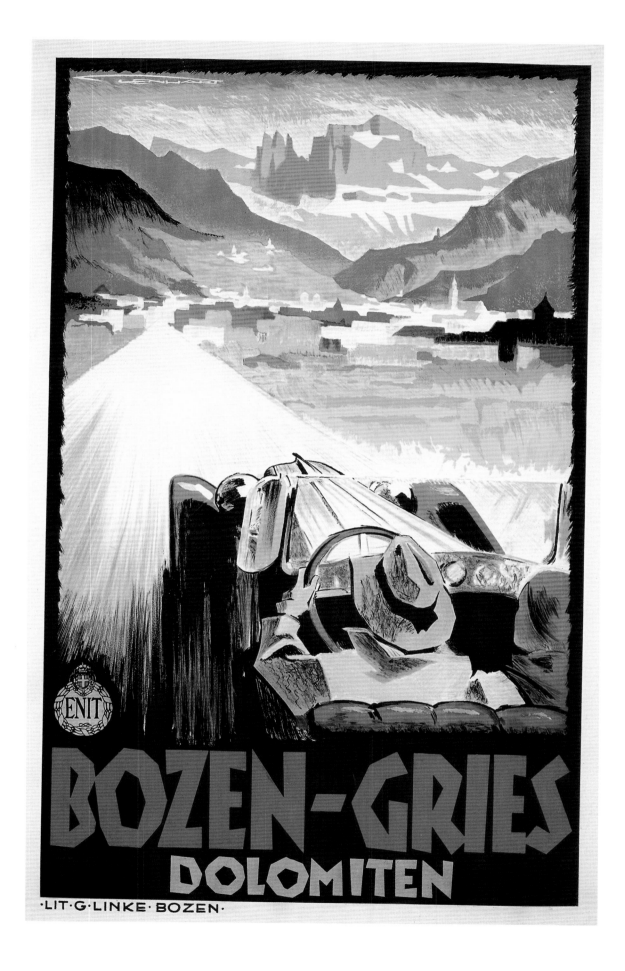

Solda, ca. 1928
Enrico Grimaldi
27 ⅛ x 38 ¹³/₁₆ in.
(69 x 98.6 cm.)
Lithograph
ENIT, FS
Richter & C., Naples

Dobbiaco, ca. 1928
Pio Solero
27 ⅜ x 39 ³/₁₆ in.
(69.5 x 99.5 cm.)
Lithograph
ENIT, FS
Stab. A. Manzi, Rome

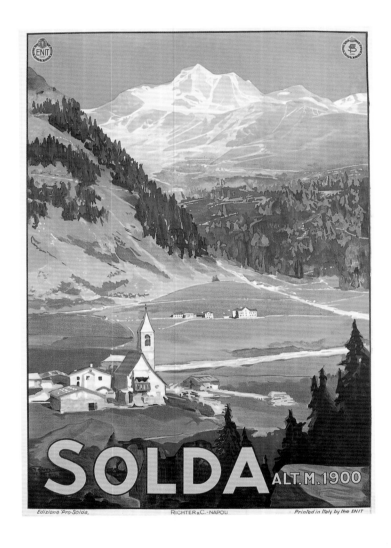

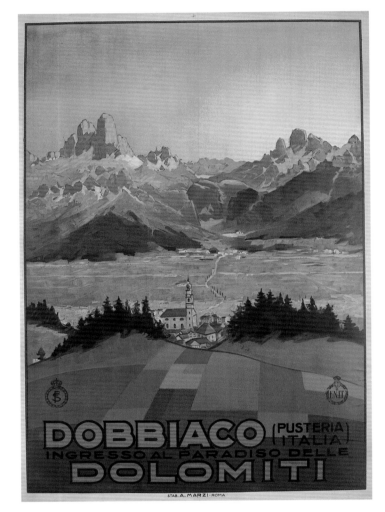

Dolomiti, 1938

Franz Lenhart

27 x 39 1/16 in.
(68.5 x 99.2 cm.)
Offset
ENIT, FS
Pizzi & Pizio, Milan - Rome

**Lago di Carezza e il
Latemar, ca. 1925**

E. R.

26 7/8 x 38 11/16 in.
(68.3 x 98.2 cm.)
Lithograph
FS
Stab. L. Salomone, Rome

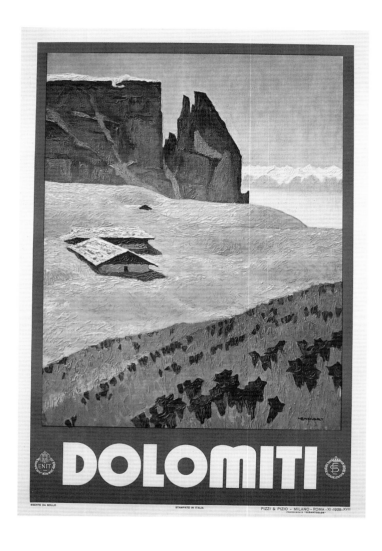

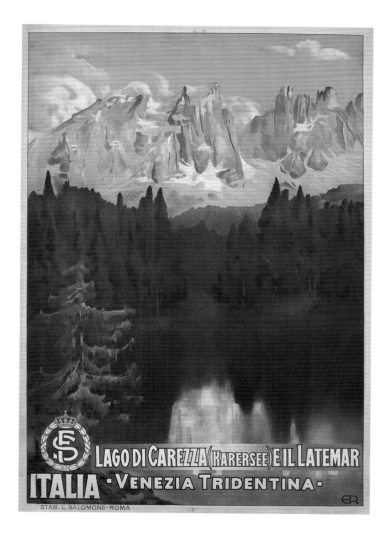

Alto Adige, 1940
Anonymous
27 ½ x 39 ⅛ in.
(69.8 x 99.3 cm.)
Lithograph
ENIT, FS
S.A.I.G.A. già Barabino &
Graeve, Genoa

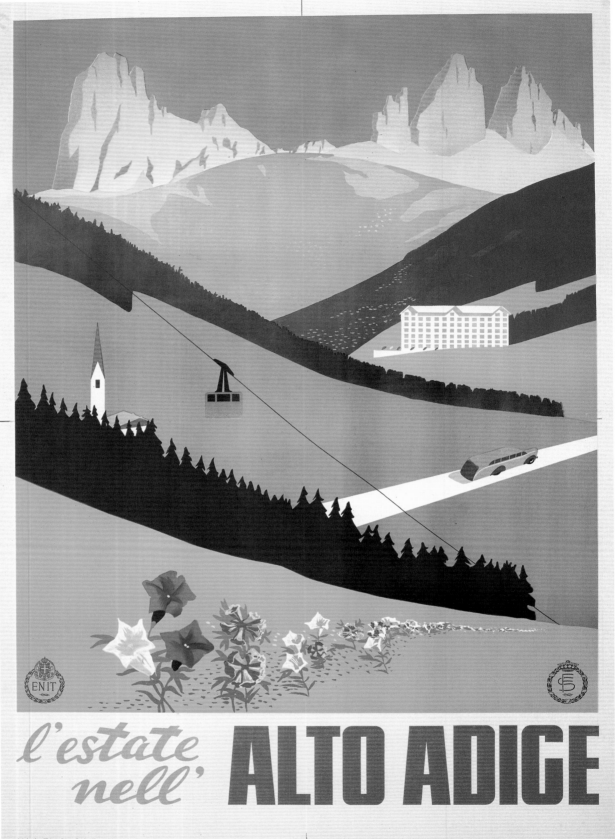

Trento, ca. 1926

Anonymous

24 ⅝ x 39 ½ in.
(62.5 x 100.4 cm.)
Lithograph
ENIT, FS
Off. Chappuis, Bologna

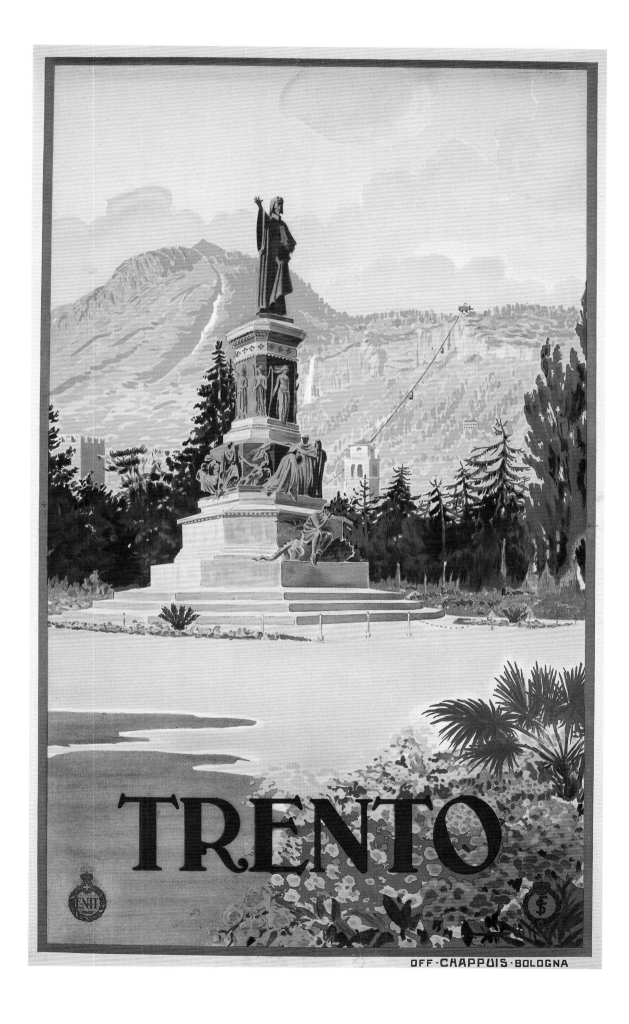

Cortina, 1937
Franz Lenhart
25 ³/₁₆ x 39 ⁵/₁₆ in.
(64 x 98 cm.)
Lithograph
ENIT, FS
Longo & Zoppelli, Treviso

Veneto Region

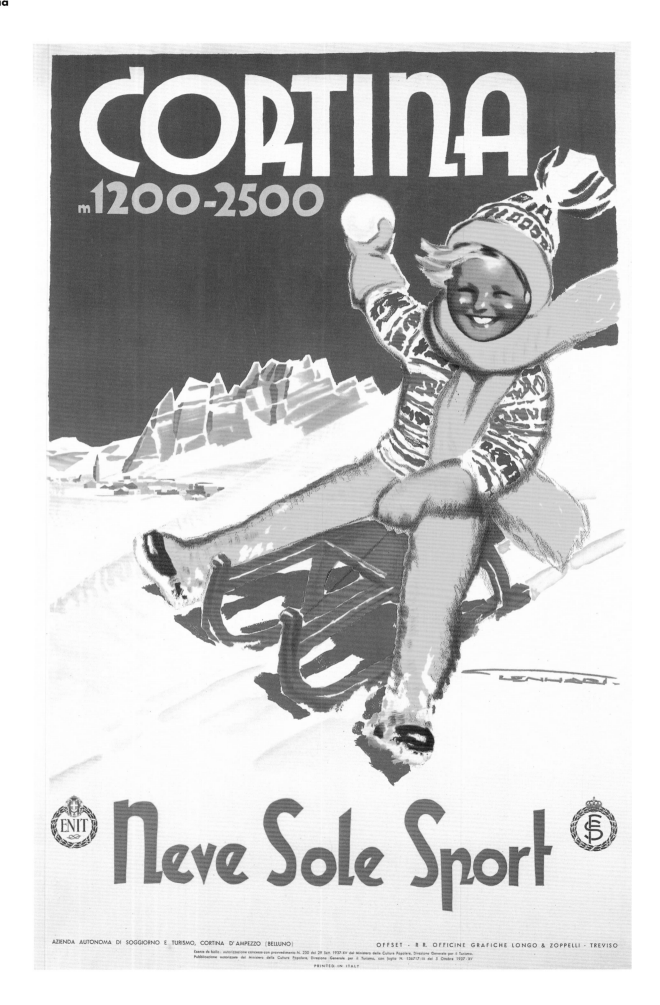

Cortina, 1938

Mario Puppo

26 9/16 x 39 7/16 in.
(67.5 x 100.2 cm.)
Lithograph
ENIT, FS
Pizzi & Pizio,
Milan - Rome

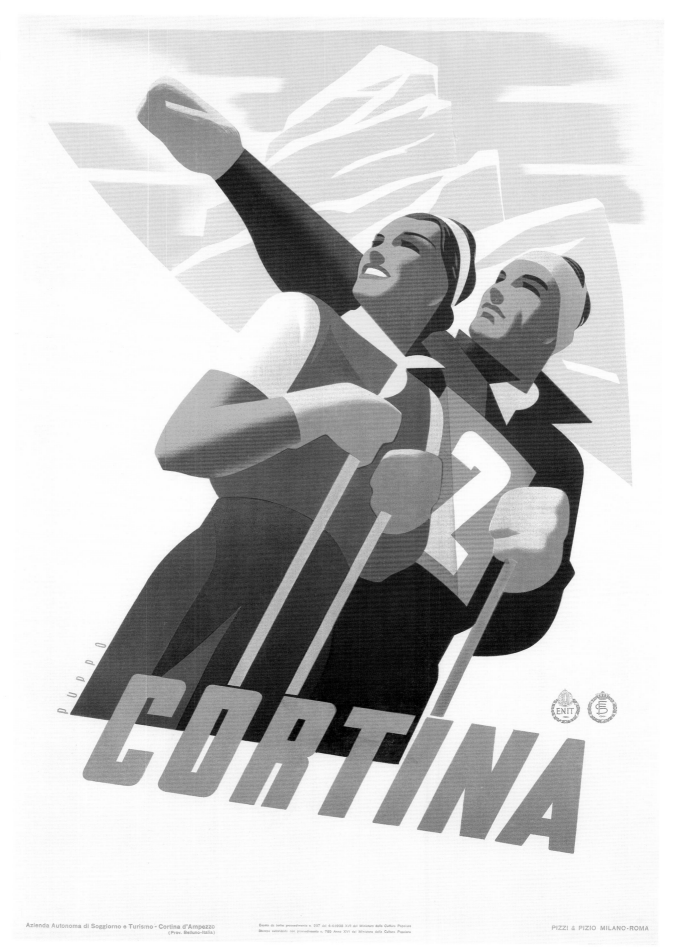

Cortina, 1938
Michele Ortino
27 ³⁄₁₆ x 39 ³⁄₁₆ in.
(69 x 99.6 cm.)
Lithograph
ENIT, FS
S.A.I.G.A., già Barabino &
Graeve, Genoa

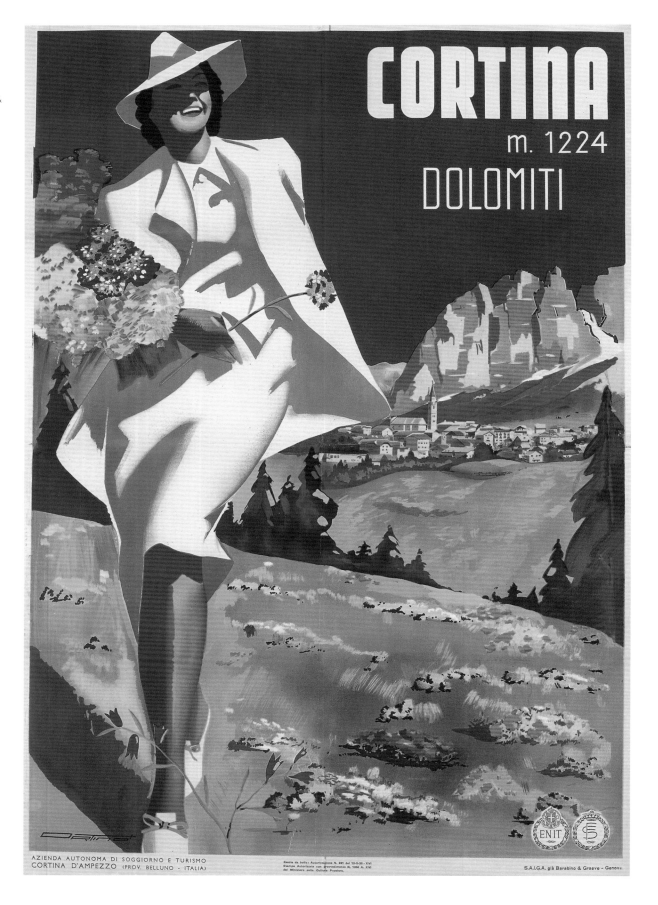

Vicenza, ca. 1926
Tullio Silvestri
26 ³/₁₆ x 38 ¾ in.
(66.5 x 98.5 cm.)
Lithograph
ENIT, FS

Vicenza, 1951
Giuseppe Riccobaldi
26 ¹/₁₆ x 38 ⅞ in.
(66.2 x 98.7 cm.)
Lithograph
ENIT, FS
Sigla Effe, Genoa

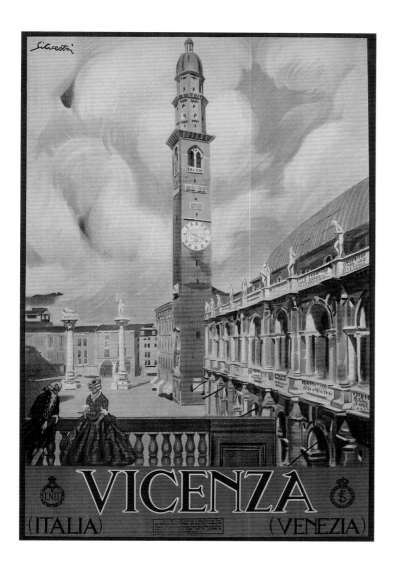

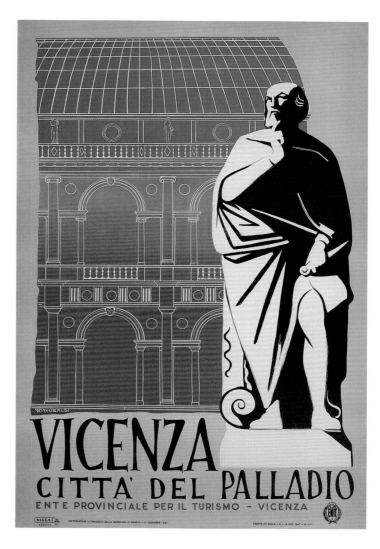

Padova, ca. 1928
Marcello Dudovich
25 ¾ x 40 ⁹∕₁₆ in.
(65.5 x 103 cm.)
Lithograph
ENIT, FS
Edizioni STAR, Milan

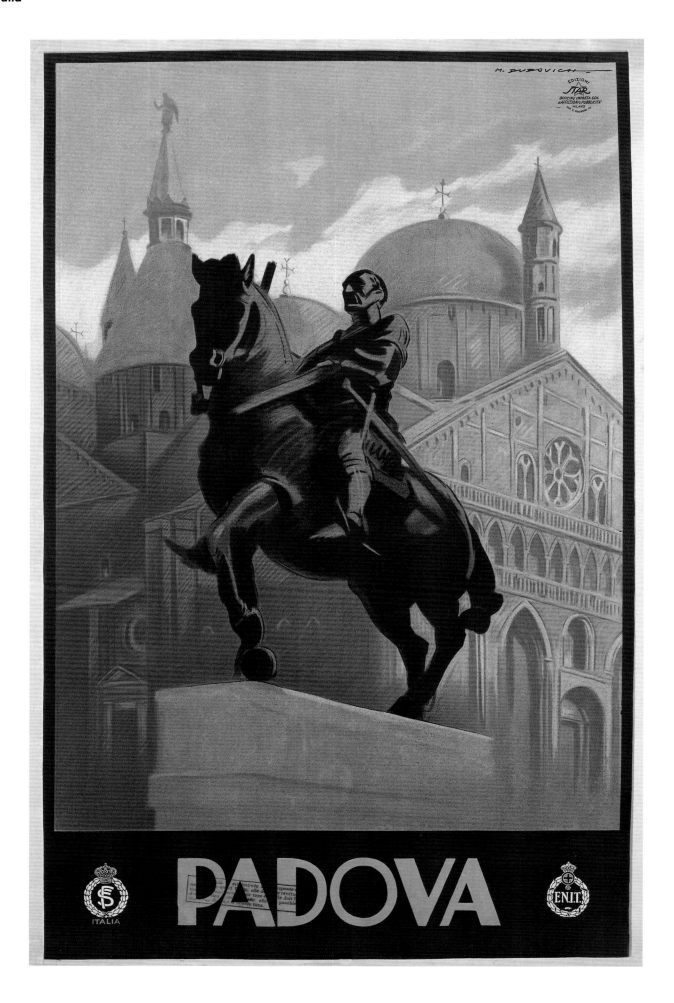

Verona, ca. 1928

Anonymous

24 x 38 ⁹⁄₁₆ in.
(61 x 98 cm.)
Lithograph
ENIT, FS
Pizzi & Pizio, Milan

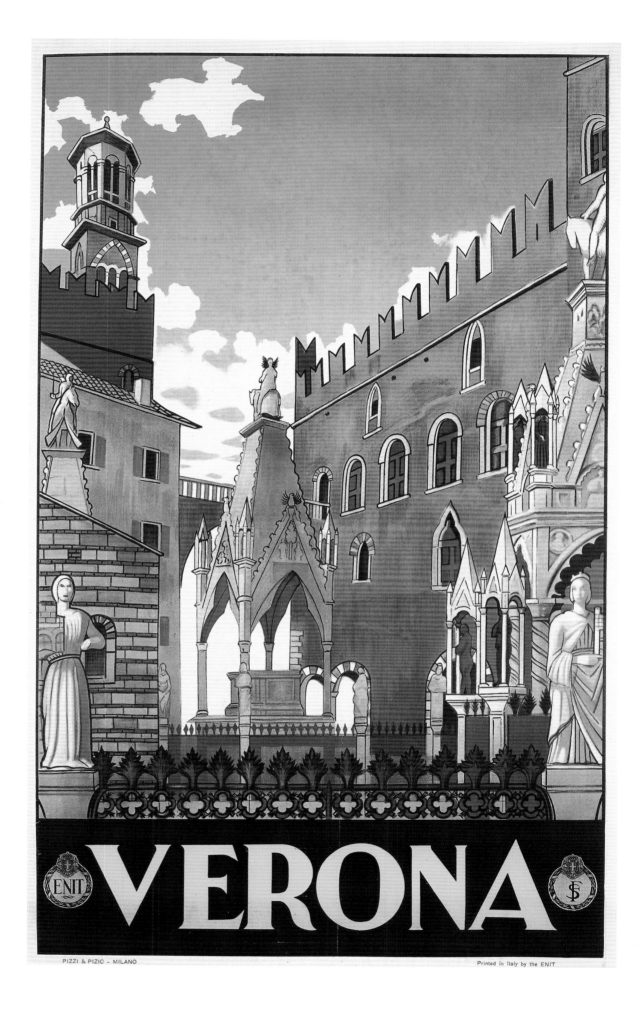

PIZZI & PIZIO - MILANO

Printed in Italy by the ENIT

Venezia, 1928
Anonymous
23 ¹³⁄₁₆ x 39 ³⁄₁₆ in.
(60.5 x 99.5 cm.)
Lithograph
ENIT, FS
Novissima, Rome

Venezia Lido, 1948
Edmondo Bacci
24 ⁵⁄₁₆ x 37 ⅞ in.
(61.7 x 96.2 cm.)
Offset
ENIT
Ommassini & Pascon, Venice

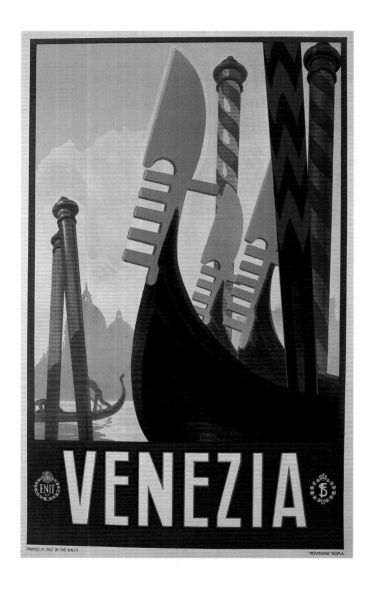

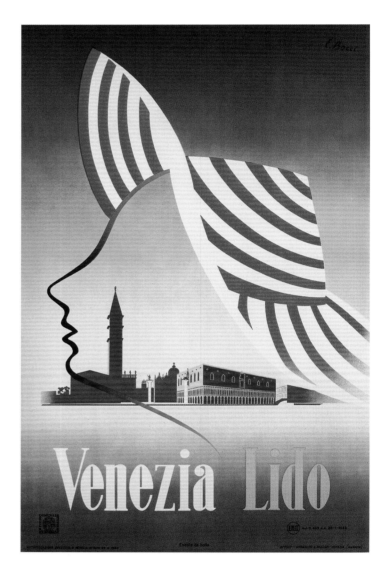

Venezia, 1951
A. M. Cassandre
24 ⅝ x 39 ½ in.
(62.5 x 100.3 cm.)
Offset
ENIT
Calcografia e
Cartevalori, Milan

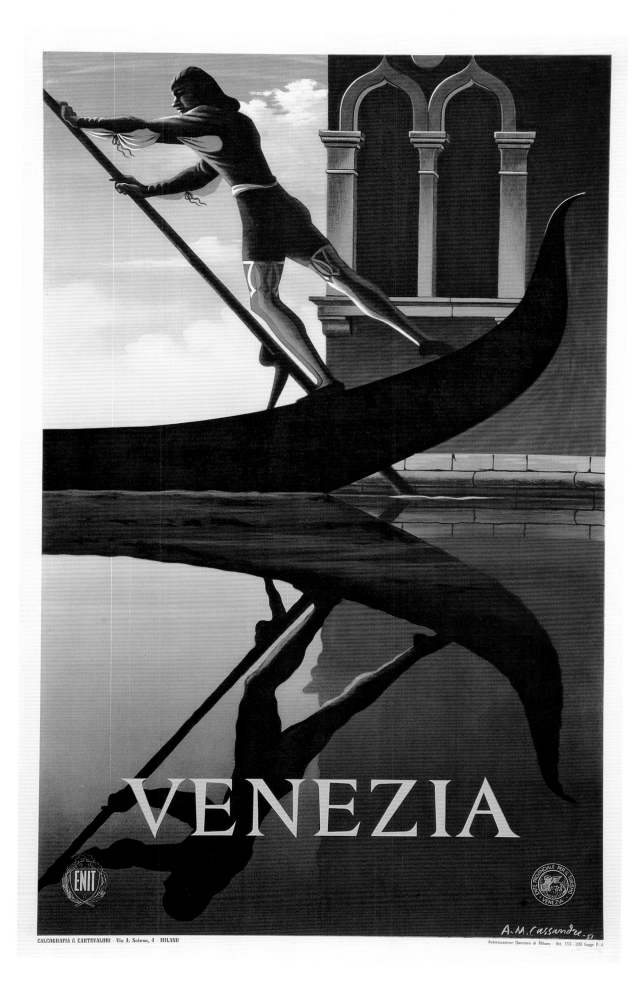

Lido di Jesolo, 1949
Dinon-Pellarin
26 ⁹⁄₁₆ x 39 ³⁄₁₆ in.
(67 x 99.5 cm.) Lithograph
ENIT
A. Pizzi S.A., Milan

Grado, 1948
Mario Puppo
27 x 39 ³⁄₁₆ in.
(68.6 x 99.6 cm.) Lithograph
Azienda di Soggiorno di Grado
SAIGA, già Barabino &
Graeve, Genoa

Friuli Venezia Giulia
Region

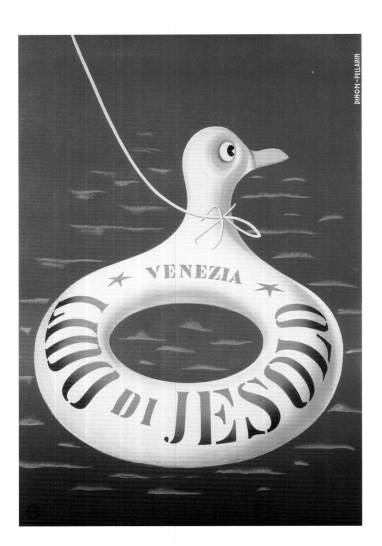

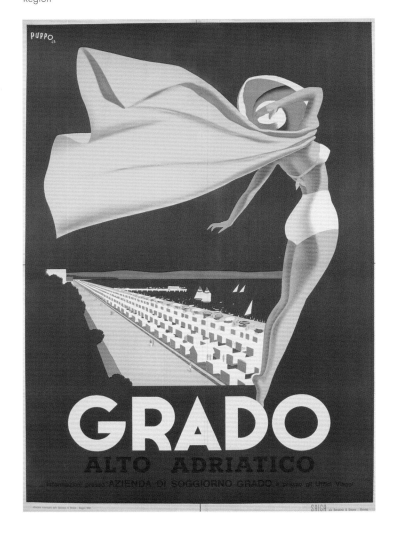

Grado, 1933
Marcello Dudovich
24 ³/₁₆ x 39 ³/₁₆ in.
(61.5 x 99.6 cm.)
Lithograph
ENIT, FS
Studio Editoriale
Turistico, Milan

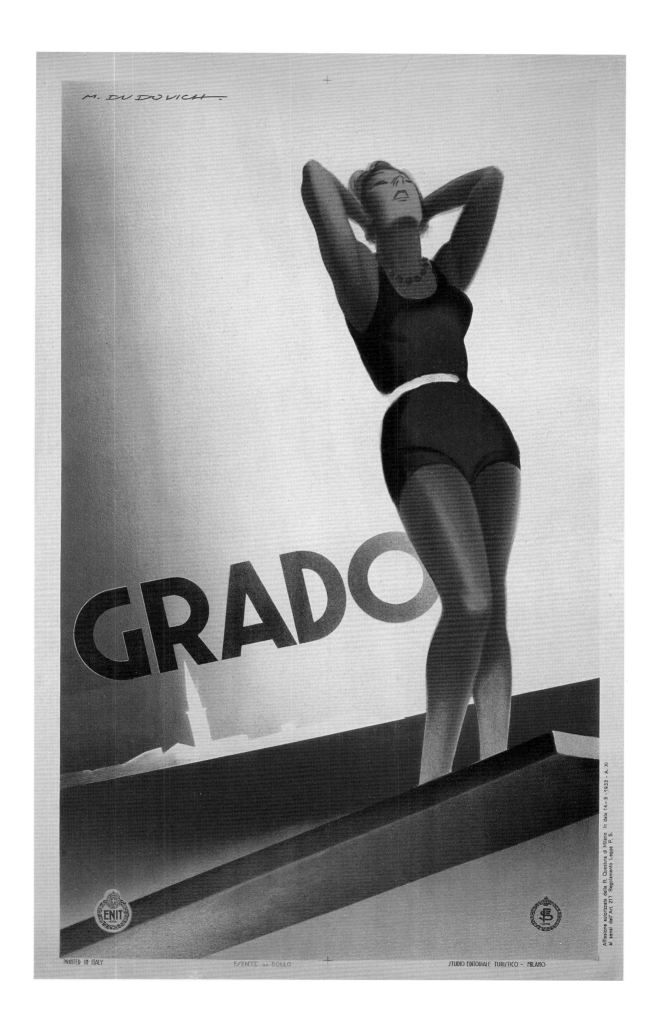

Trieste, ca. 1930
Giorgio Viola
25 ³/₁₆ x 39 ³/₈ in.
(64 x 100 cm.)
Lithograph
ENIT, FS
Grafiche Modiano,
Trieste

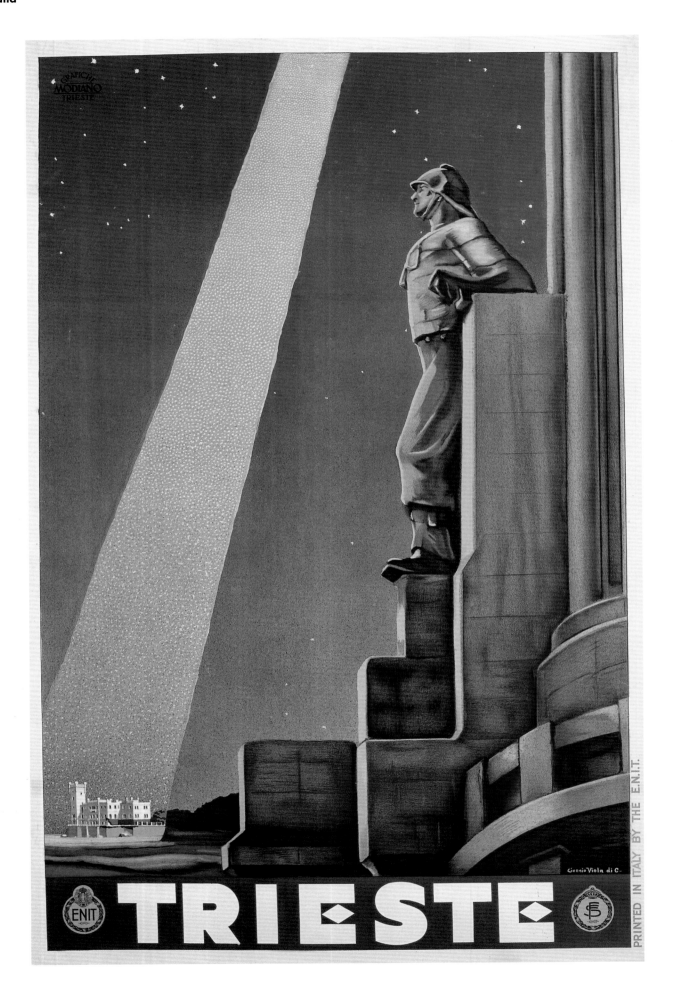

**Battaglia di Fiori
Ventimiglia, 1957**

Filippo Romoli

26 ½ x 38 ¾ in.
(67.4 x 98.5 cm.) Offset
ENIT
SAIGA, già Barabino &
Graeve, Genoa

Liguria Region

Sanremo, ca. 1928

Vincenzo Alicandri

27 x 39 in.
(68.7 x 99 cm.) Lithograph
ENIT, FS
Barabino & Graeve,
Genoa

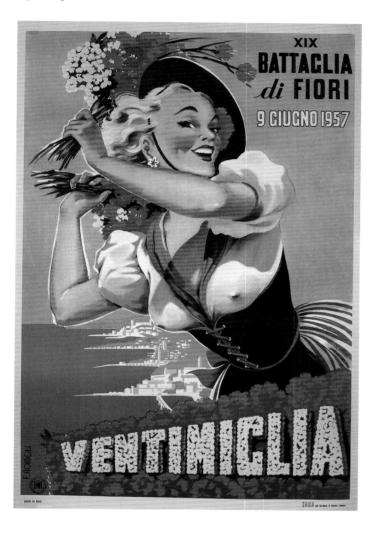

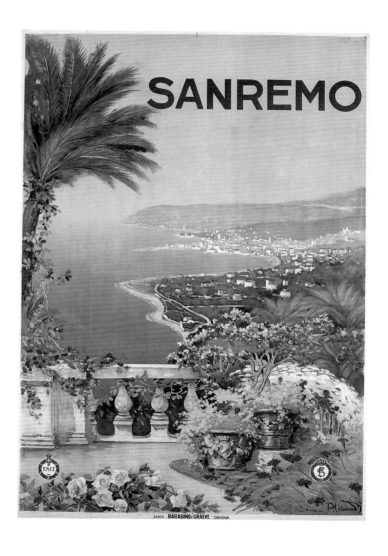

Varazze, 1927
Aurelio Craffonara
26 ½ x 38 ¾ in.
(68 x 99 cm.)
Lithograph
ENIT, FS
Barabino & Graeve,
Genoa

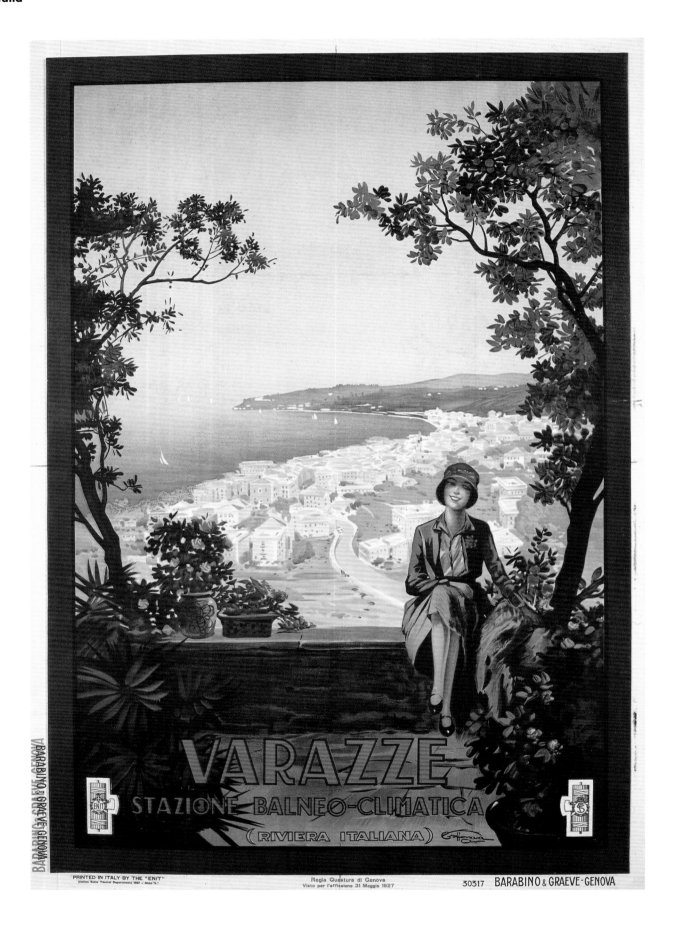

Alassio, 1929

Aurelio Craffonara

27 ⅜ x 39 ¼ in.
(69.5 x 99.7 cm.)
Lithograph
ENIT, FS
Barabino & Graeve,
Genoa

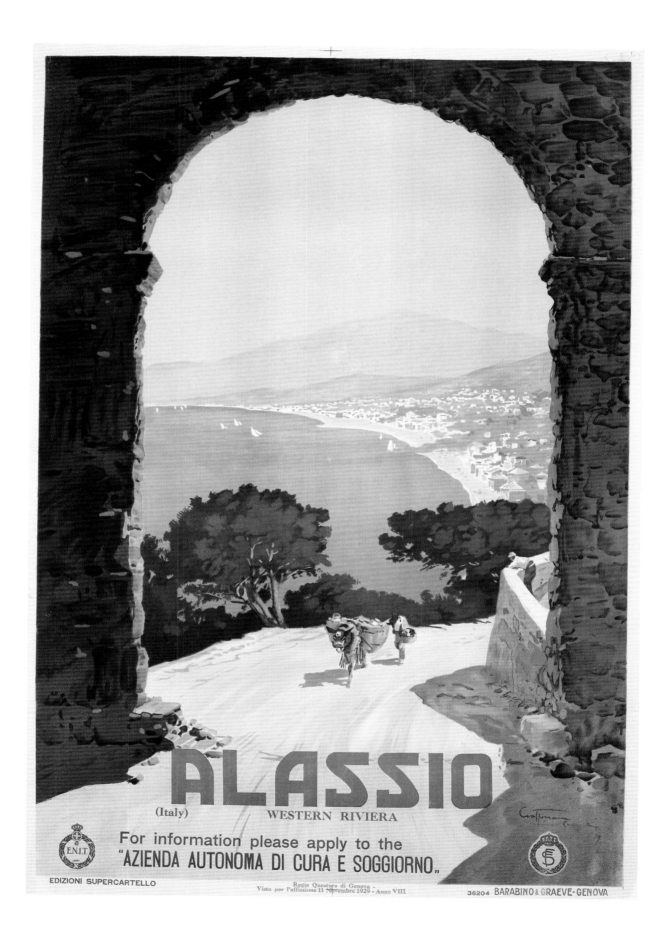

Loano, 1929
Aurelio Craffonara
27 1/16 x 38 7/8 in.
(68.8 x 98.8 cm.)
Lithograph
ENIT, FS
Barabino & Graeve,
Genoa

**Genoa and the
Italian Riviera, 1931**
Aurelio Craffonara
26 7/8 x 39 1/16 in.
(68.2 x 99.2 cm.)
Lithograph
ENIT, FS
Barabino & Graeve,
Genoa

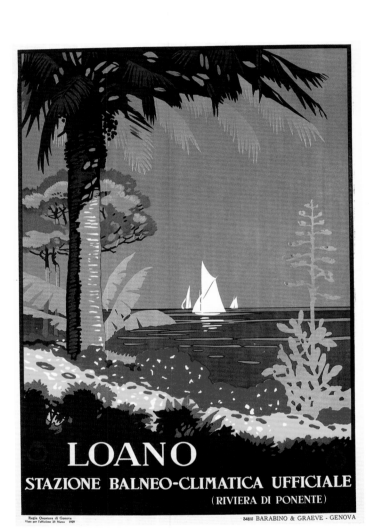

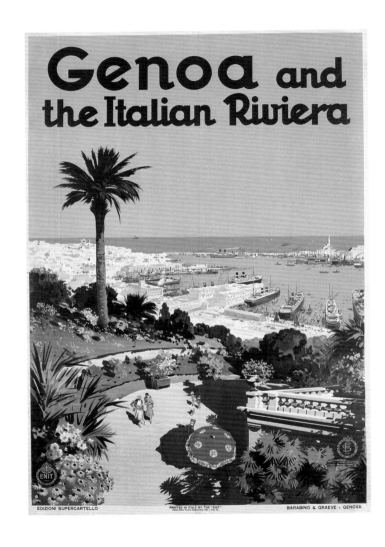

Genova, 1947
Guido Zamperoni
24 ¼ x 39 ³/₁₆ in.
(61.5 x 99.6 cm.)
Offset
ENIT, FS
A.G.I.S., Genoa

Nervi, 1948
Aldo Cigheri
27 ⅛ x 39 ⅜ in.
(69 x 100 cm.)
Lithograph
ENIT
SAIGA, già Barabino &
Graeve, Genoa

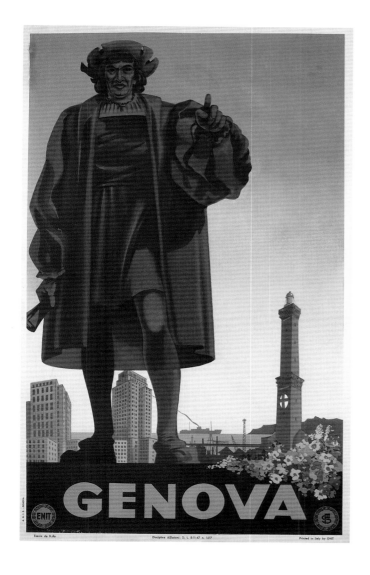

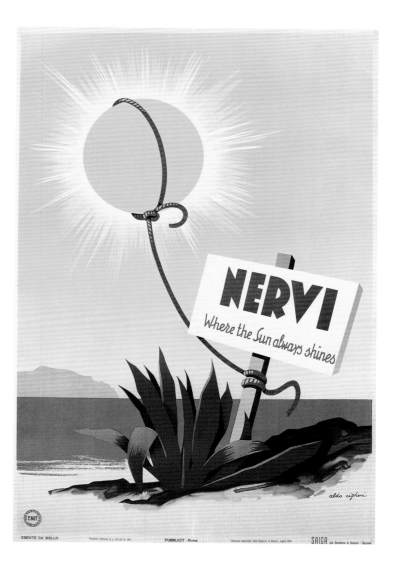

**La Riviera Italienne,
ca. 1927**

Mario Borgoni

25 ⅜ x 40 ⅛ in.
(64.5 x 102 cm.)
Lithograph
ENIT, FS
Richter & C., Naples

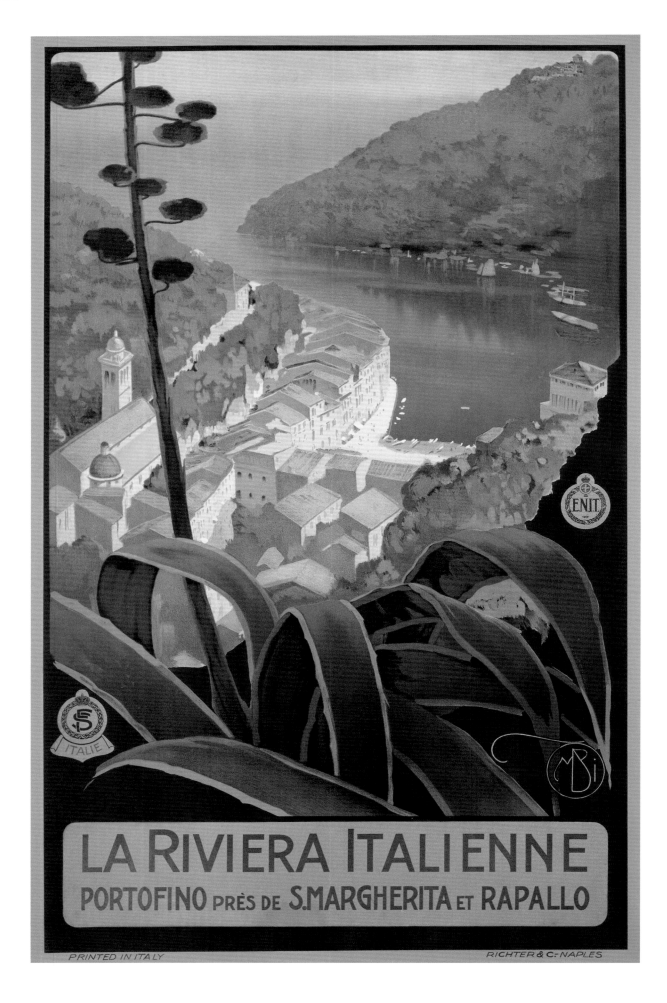

**Santa Margherita
Ligure, 1934**

Viero Migliorati
24 ½ x 39 ⅛ in.
(62,3 x 99,4 cm.)
Lithograph
ENIT, FS
Barabino & Graeve, Genoa

Rapallo, 1928

Vincenzo Alicandri
27 ⅜ x 39 ¼ in.
(69.5 x 99.6 cm.)
Lithograph
ENIT, FS
Novissima, Rome

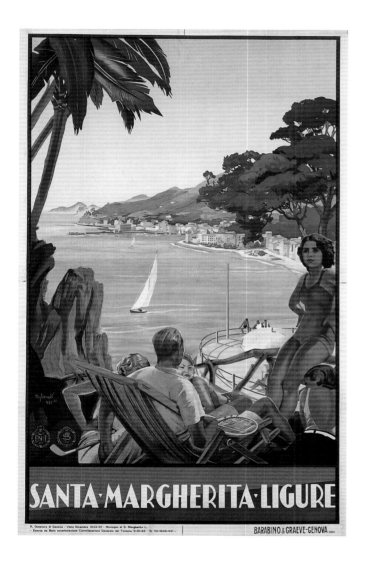

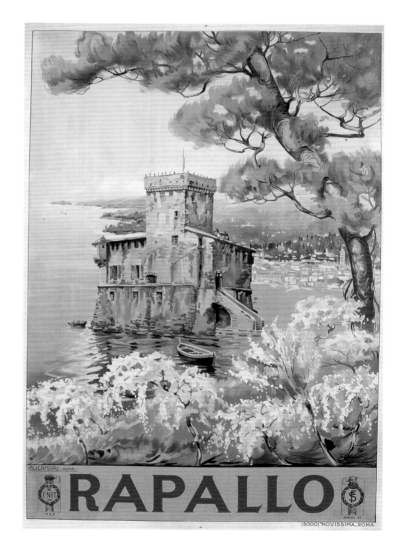

**Salsomaggiore,
ca. 1926**
Anonymous
24 ⅝ x 39 ½ in.
(62.5 x 100.4 cm.)
Lithograph
ENIT, FS
Grafia, Rome

.............................
Emilia-Romagna Region

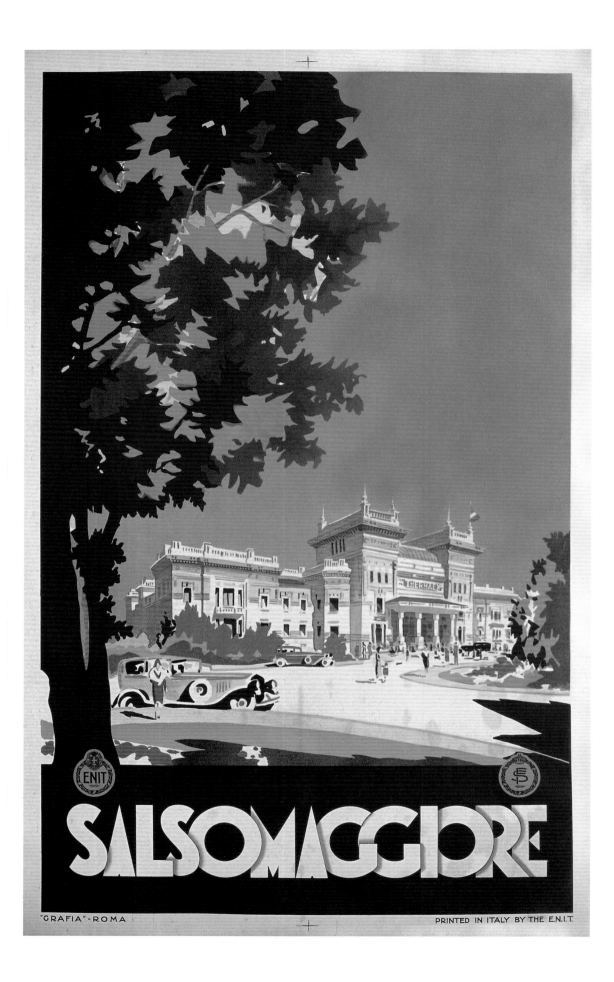

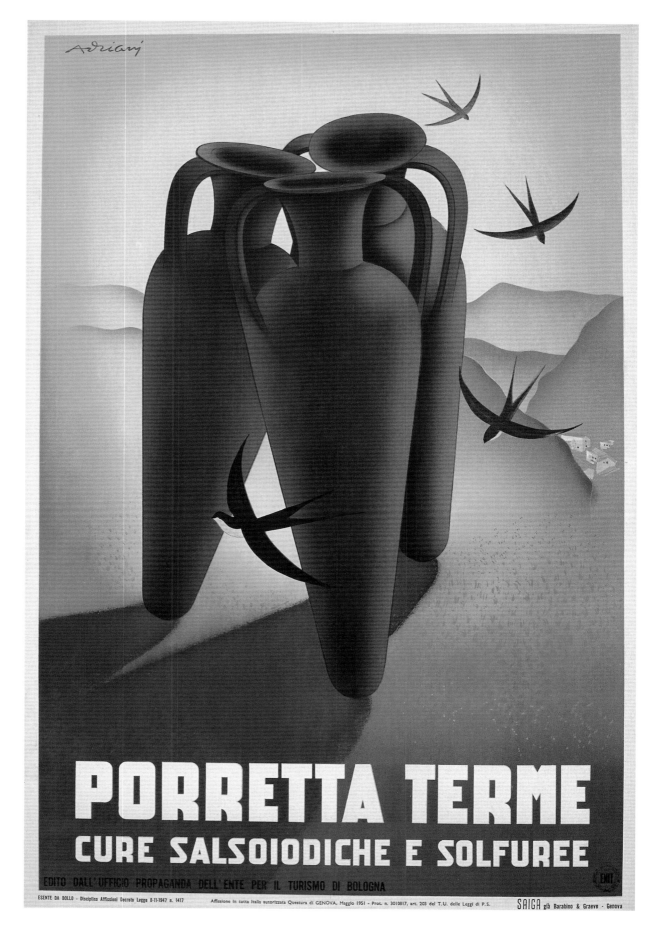

Ferrara, ca. 1927
Mario Borgoni
26 ¾ x 38 ³⁄₁₆ in.
(68 x 97 cm.)
Lithograph
ENIT, FS
Richter & C., Naples

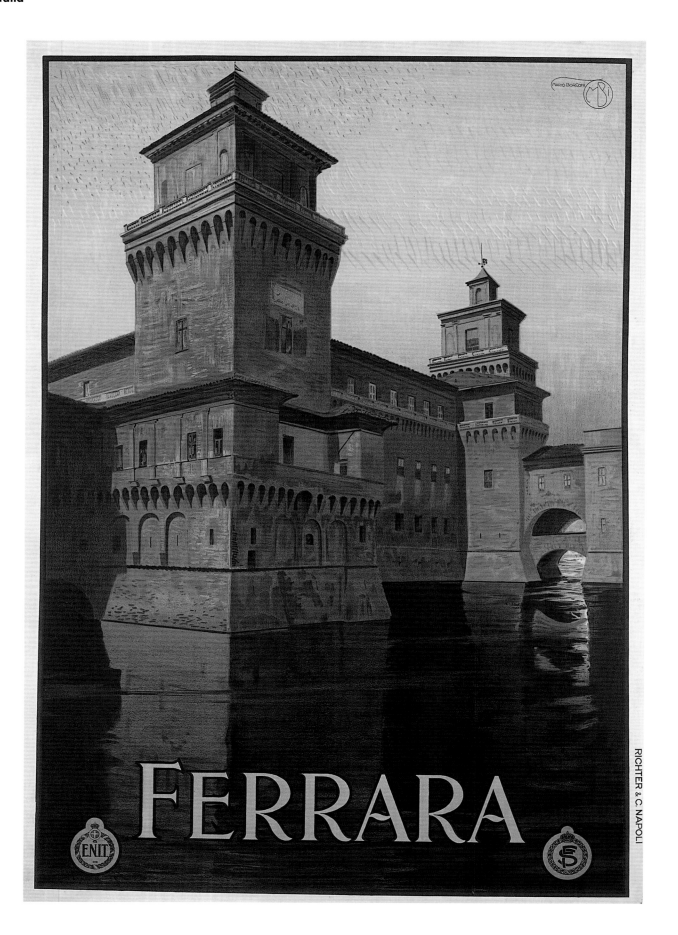

Visitate Parma, 1937
Carlo Mattioli
25 ⅜ x 38 ¾ in.
(64.5 x 98.5 cm.)
Lithograph and Offset
ENIT, FS
Grafiche I.G.A.P., Rome

Ravenna, ca. 1928
Giovanni Guerrini
26 ¾ x 39 ³⁄₁₆ in.
(68 x 99.5 cm.)
Lithograph
ENIT, FS
Novissima, Rome

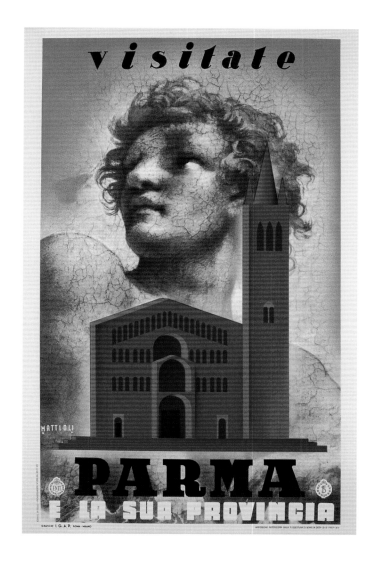

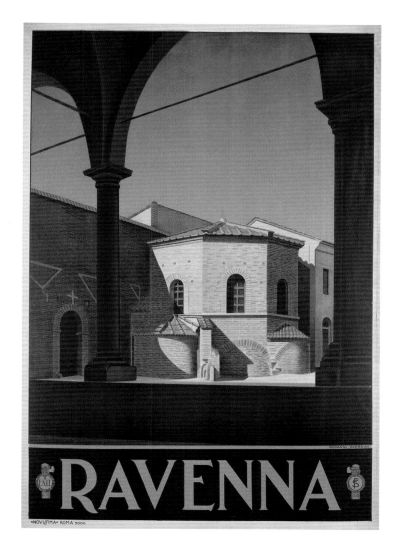

Bologna, ca. 1928
Severino Trematore
27 ³/₁₆ x 39 ³/₁₆ in.
(69 x 99.5 cm.)
Lithograph
ENIT, FS
Barabino & Graeve,
Genoa

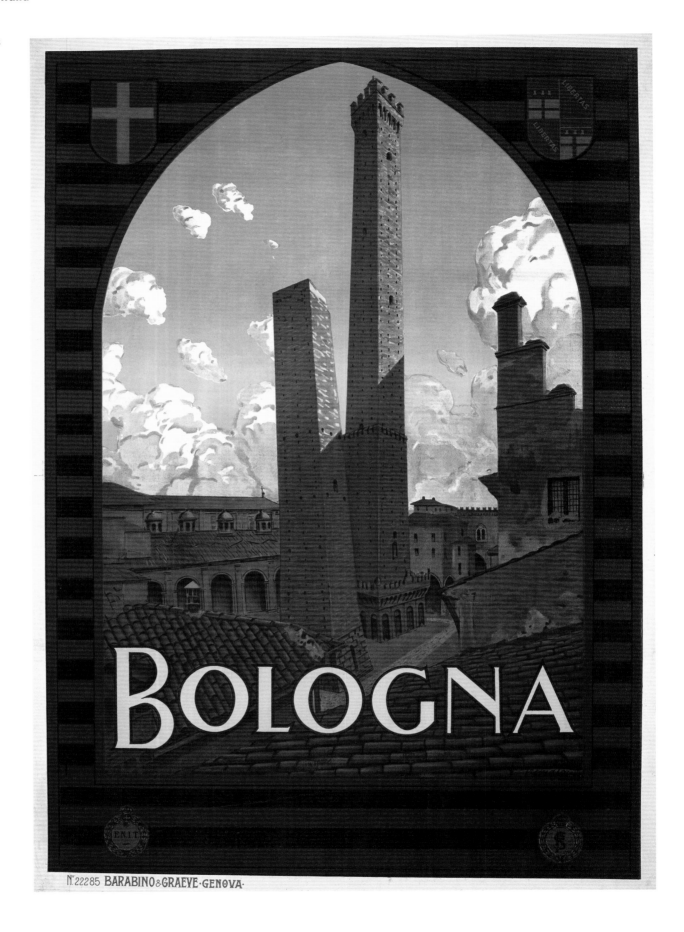

Cattolica, 1939
Gogliardo Ossani
26 ⅝ x 39 in.
(67.7 x 99 cm.)
Lithograph
ENIT, FS
Studio Ossani, Rimini

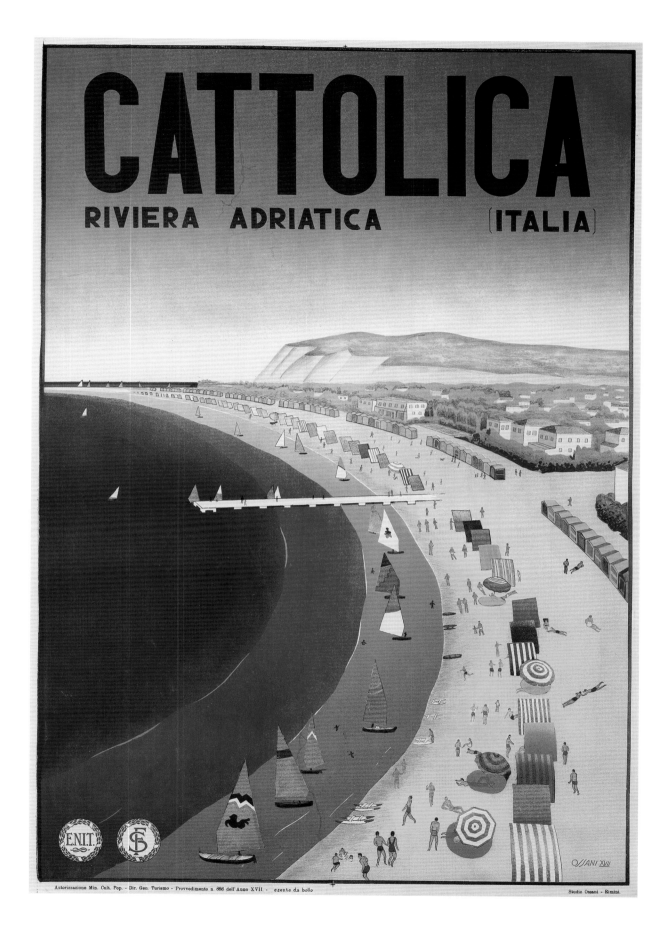

Riviera di Rimini, 1950
Nazzareno Tognacci
27 ½ x 39 ⅝ in.
(70 x 100.7 cm.)
Lithograph
ENIT, FS
Ind. Graf. Art. Galvan,
Bologna - Alessandria

Cervia Pineta, ca. 1950
Baldo Guberti
18 ⅞ x 27 ³⁄₁₆ in.
(47.9 x 69 cm.)
Offset
ENIT, FS
Litografie Artistiche Faentine

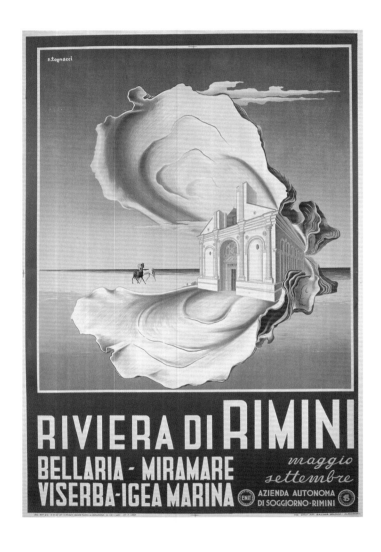

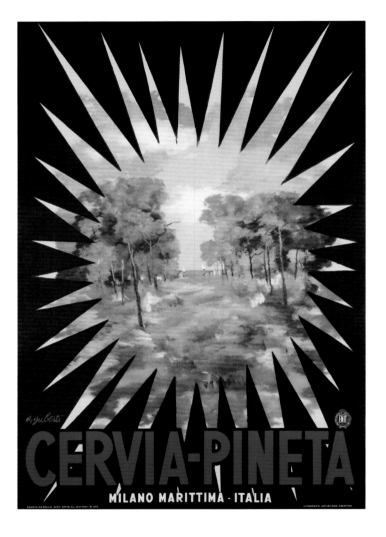

Riviera di Romagna, 1948

Mario Puppo
24 ⅜ x 39 in.
(62 x 99 cm.)
Lithograph
ENIT, FS
SAIGA, già Barabino &
Graeve, Genoa

Cesenatico, 1927

Giovanni Guerrini
27 ⁹⁄₁₆ x 39 ¾ in.
(70 x 101 cm.)
Lithograph
ENIT, FS
Novissima, Rome

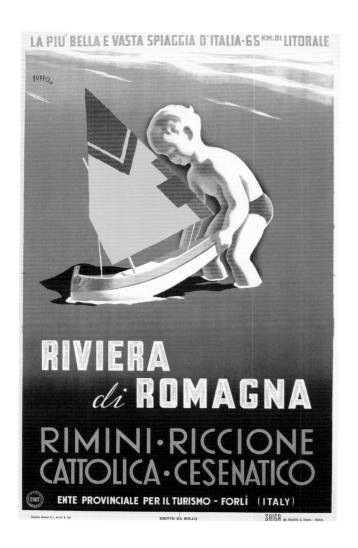

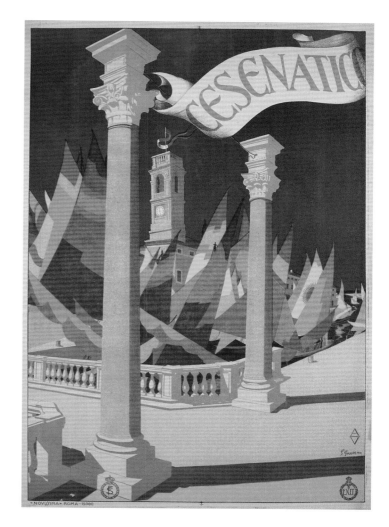

Siena, ca. 1925
Anonymous
27 ¾ x 38 ³⁄₁₆ in.
(70.5 x 97 cm.)
Lithograph
FS, ENIT
Richter & C., Naples

Tuscany Region

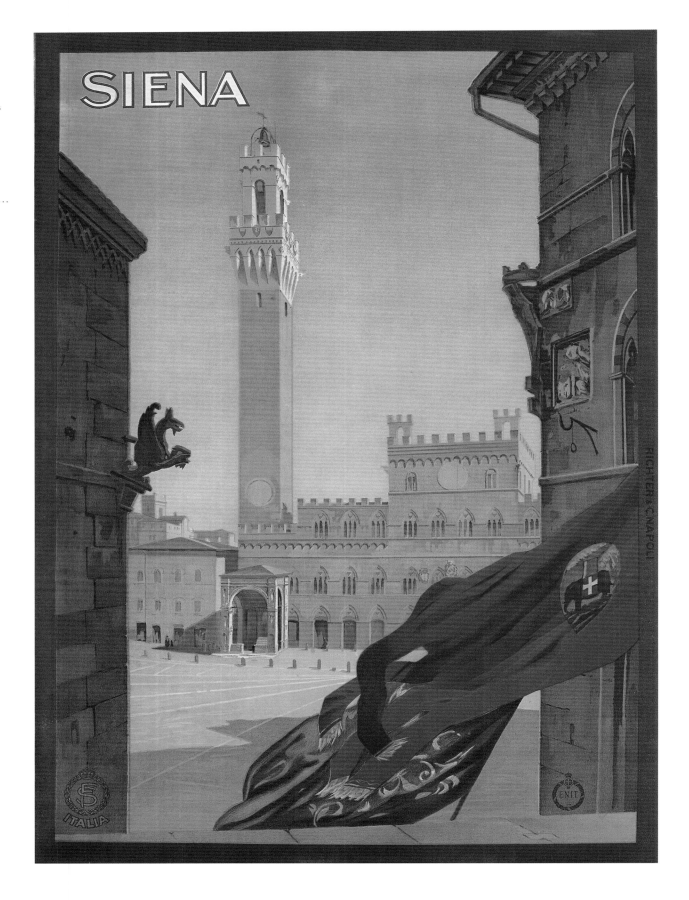

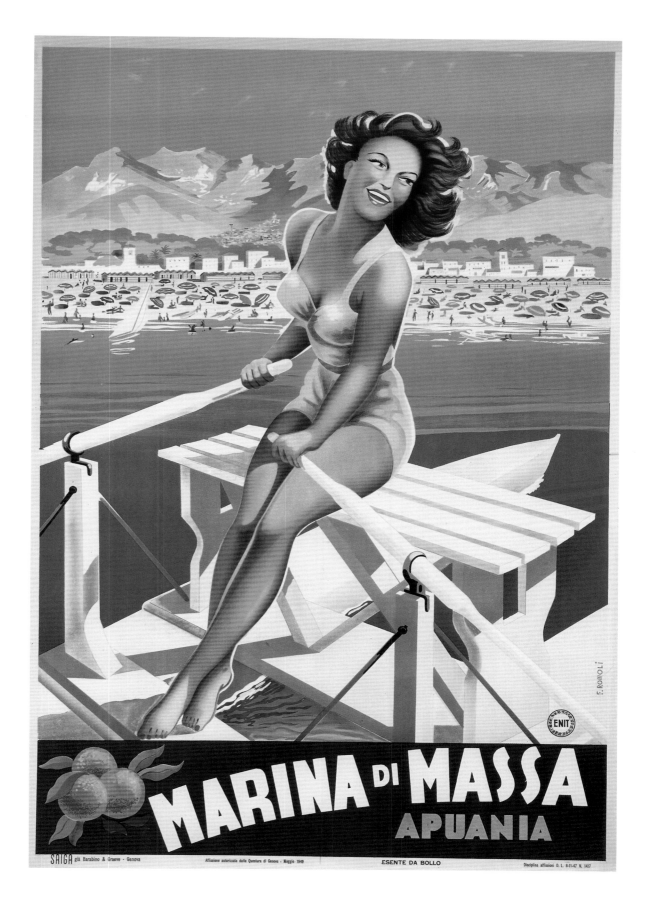

Viareggio Carnevale, 1950

Uberto Bonetti

25 ⁹⁄₁₆ x 39 ⅜ in.
(65 x 100 cm.)
Offset
ENIT
Artero, Rome

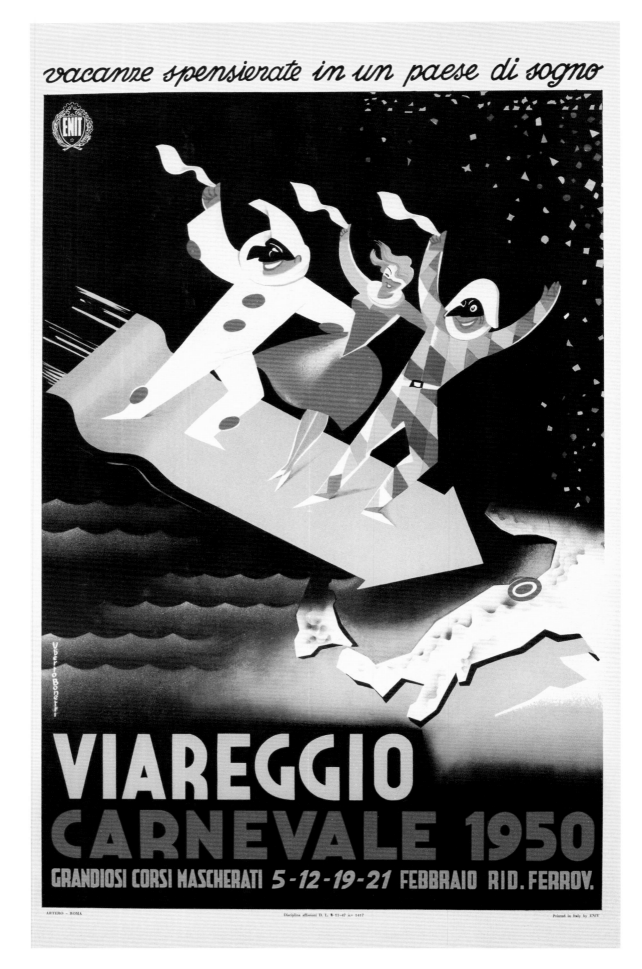

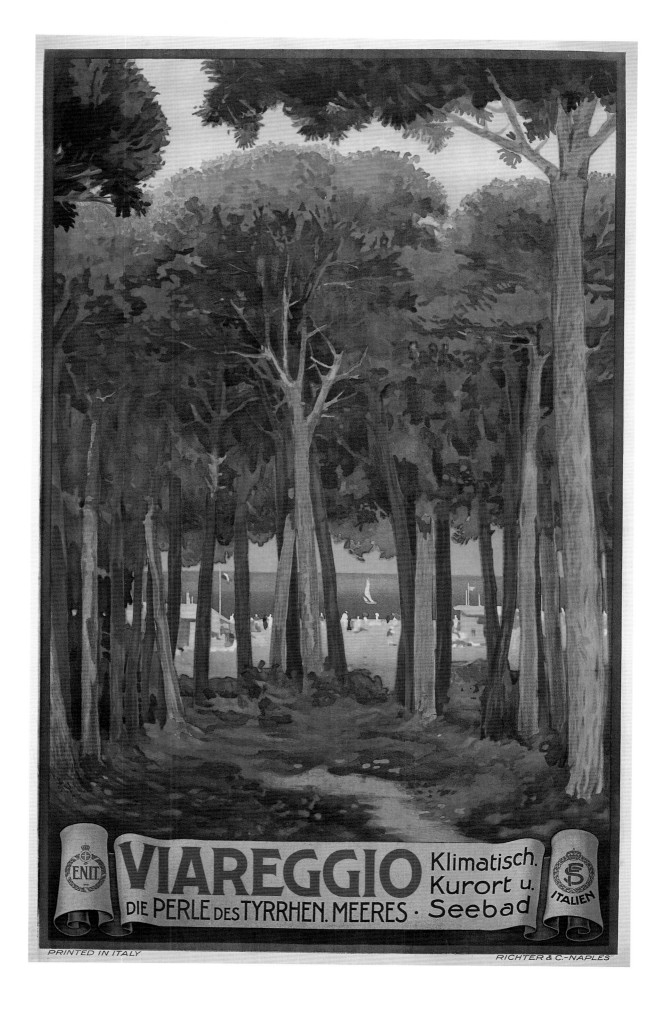

Riviera della Versilia, 1934
Gino Boccasile
24 ³⁄₁₆ x 38 ⁷⁄₈ in.
(61.5 x 98.8 cm.)
Lithograph
ENIT, FS
Off. Graf. Coen & C., Milan

Vallombrosa Saltino, ca. 1928
Anonymous
25 ³⁄₁₆ x 39 in.
(64 x 99 cm.)
Lithograph
ENIT, FS
Novissima, Rome

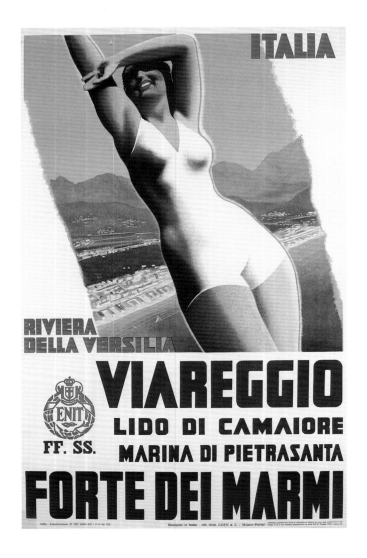

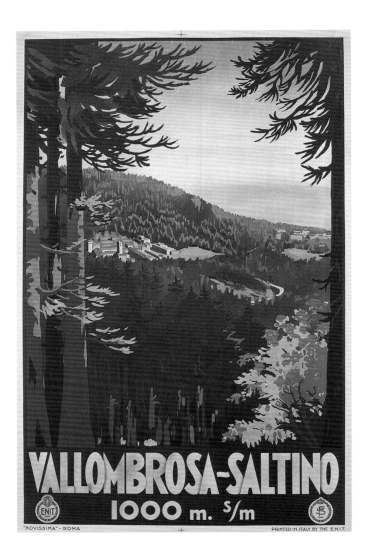

Pisa, ca. 1928
Livio Apolloni
27 ⁹⁄₁₆ x 39 ¾ in.
(70 x 101 cm.)
Lithograph
ENIT, FS
Novissima, Rome

Lucca, 1952
Guglielmo Ghini
24 ½ x 39 ⅜ in.
(62.3 x 100 cm.)
Offset
ENIT, FS
A.G.A.F., Florence

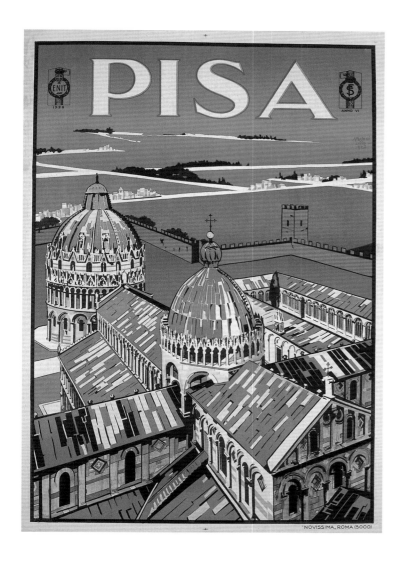

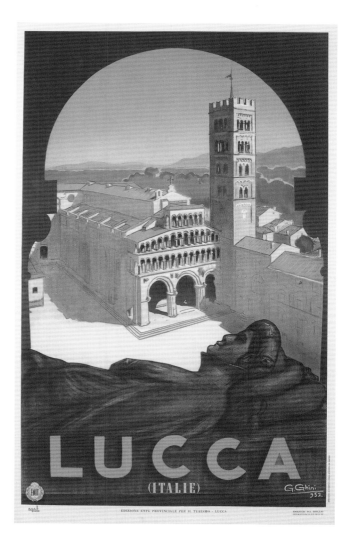

Montecatini, ca. 1930
Anonymous
24 ⅝ x 39 ⅜ in.
(62.6 x 100 cm.)
Lithograph
ENIT, FS
Studio Editoriale Turistico,
Milan

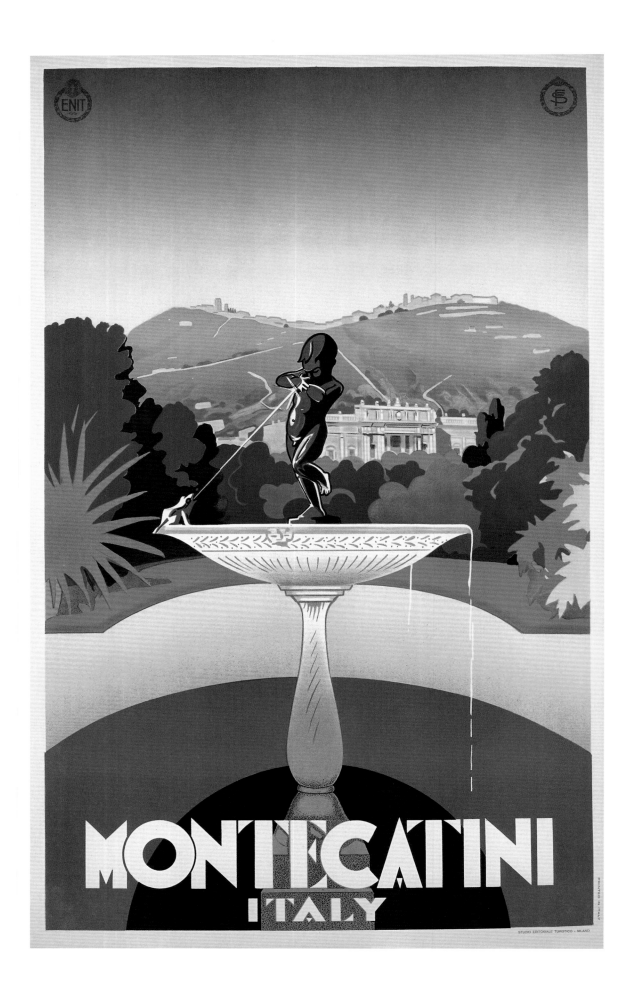

Firenze, ca. 1935
Anonymous
25 ¾ x 38 ¹¹/₁₆ in.
(65.4 x 98.3 cm.)
Offset
ENIT, FS
Gros-Monti & C., Turin

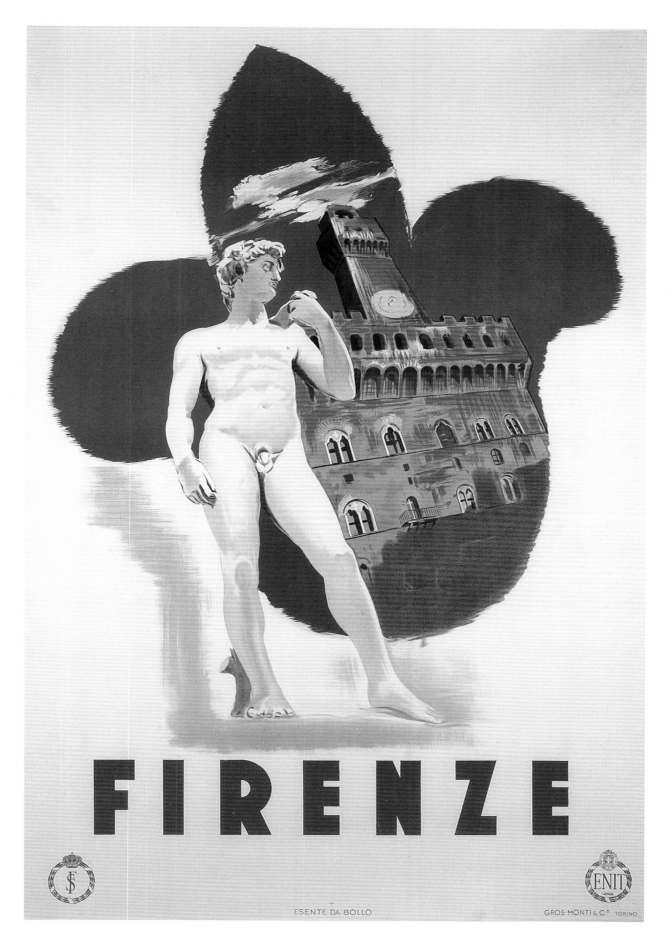

Firenze, ca. 1926
Livio Apolloni
27 9/16 x 39 1/2 in.
(70 x 100.4 cm.)
Lithograph
ENIT, FS
Novissima, Rome

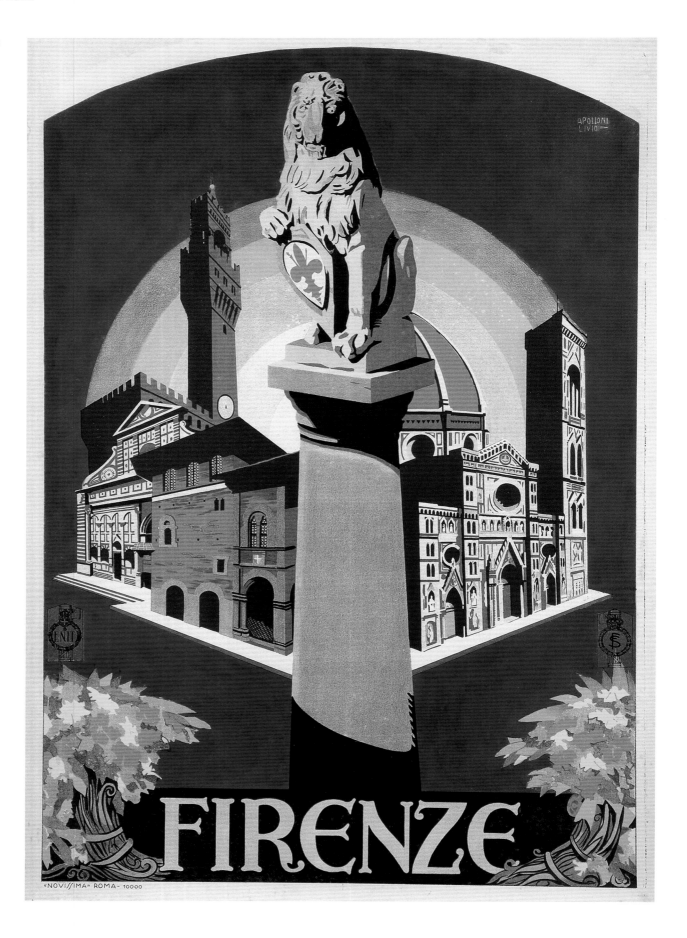

Firenze, ca. 1938

Anonymous
26 ⅝ x 38 ¾ in.
(67.7 x 98.5 cm.)
Offset
ENIT, FS
Stab. Luigi Salomone, Rome

Firenze, ca. 1930

Anonymous
23 ⁷⁄₁₆ x 39 ⅜ in.
(59.5 x 100 cm.)
Lithograph
ENIT, FS
Stab. Tipo-Litografico
del Littorio, Rome

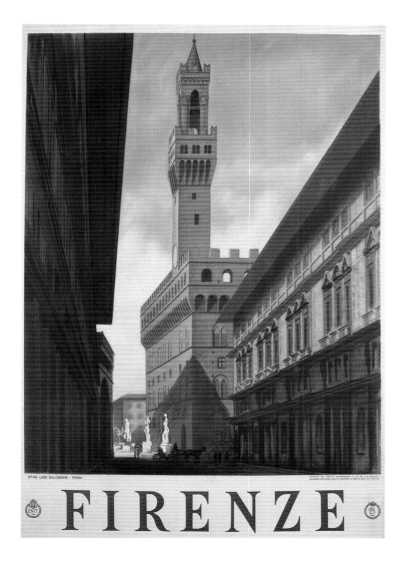

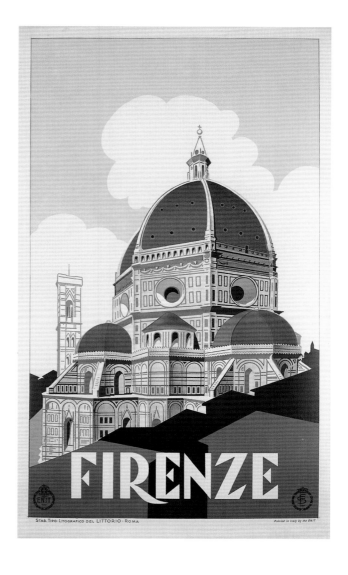

Spoleto, 1927
Simonetti
27 $^{11}/_{16}$ x 40 $^{7}/_{16}$ in.
(70.4 x 102.7 cm.)
Lithograph
ENIT, FS
Stab. L. Salomone, Rome

.............................
Umbria Region

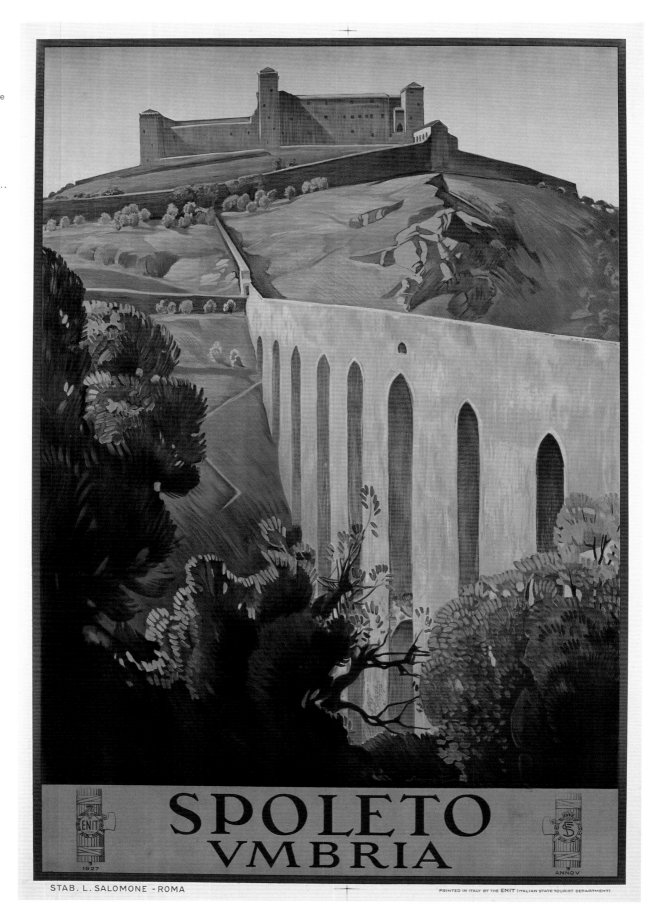

Perugia, ca. 1928

A. Traci
24 x 39 ⅛ in.
(61 x 99.4 cm.)
Lithograph
ENIT, FS
Richter & C., Naples

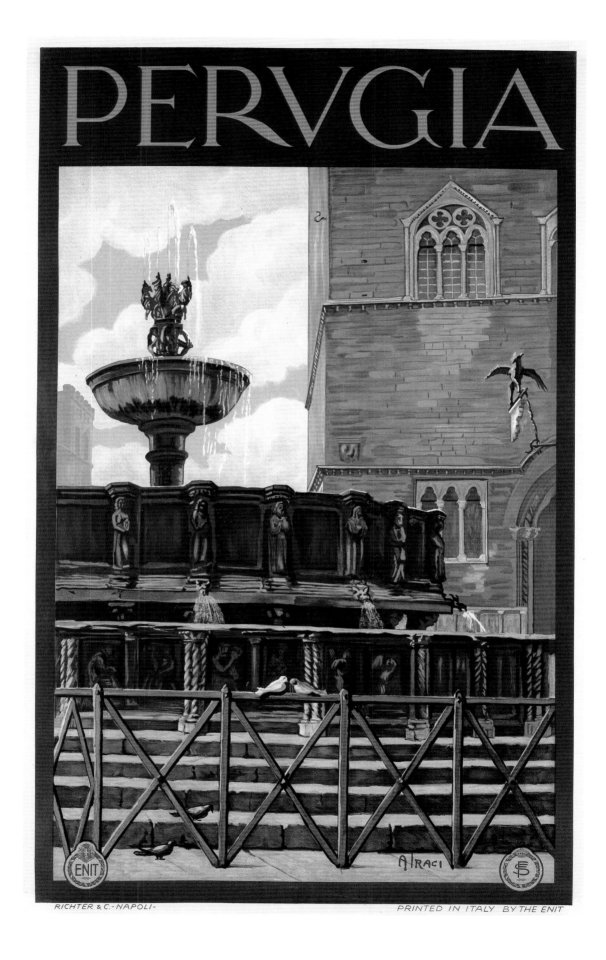

Ascoli Piceno, 1932
Anonymous
24 ⅜ x 39 ⅜ in.
(62 x 100 cm.)
Lithograph
ENIT, FS
Grafiche I.G.A.P., Rome

Marches Region

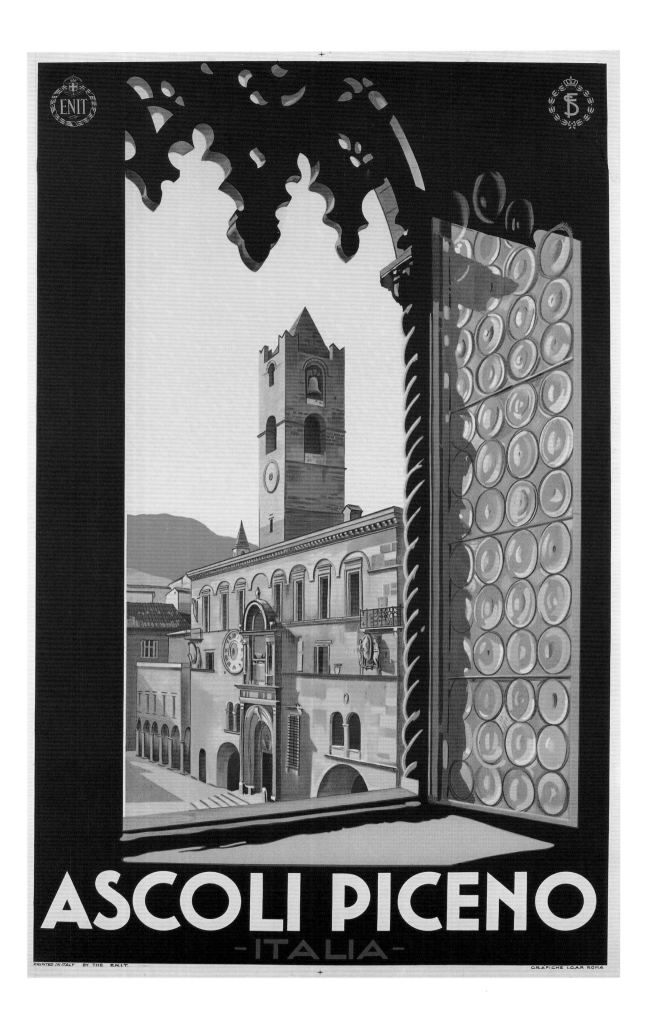

Pesaro, 1941
Luigi Piffero
24 ¹¹/₁₆ x 39 ¹/₁₆ in.
(62.7 x 99.2 cm.) Lithograph
ENIT, FS
La Pressa S.A., Milan

L'Aquila, 1934
Umberto Noni
24 ³/₈ x 39 ³/₄ in.
(62 x 101 cm.) Lithograph
FS, ENIT
Ind. Graf. Succ. Besozzi, Milan

Abruzzo Region

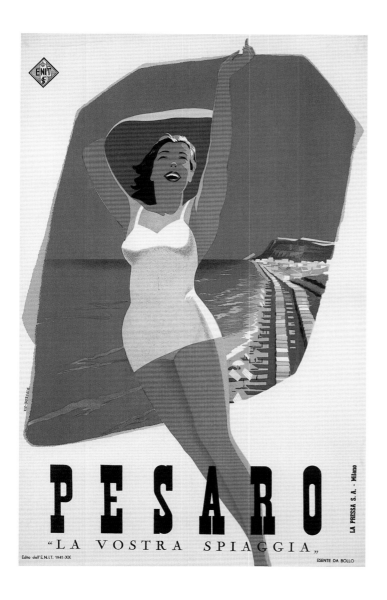

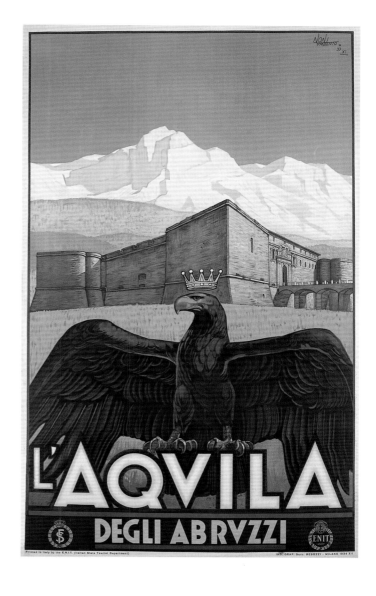

Abruzzo, ca. 1930
Giulio Ferrari
27 ¼ x 39 in.
(69.3 x 99 cm.)
Lithograph
ENIT, FS
Gros-Monti & C., Turin

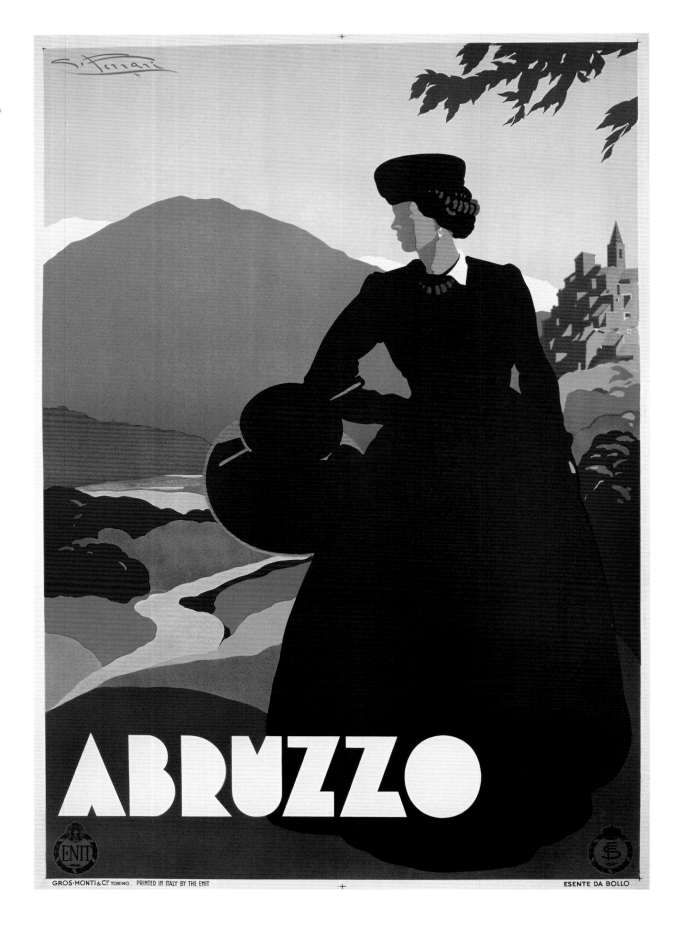

Abruzzo, 1926
Vincenzo Alicandri
26 ¾ x 38 ⁹⁄₁₆ in.
(68 x 98 cm.)
Lithograph
ENIT, FS
Grafia S.A.I.I.G., Rome

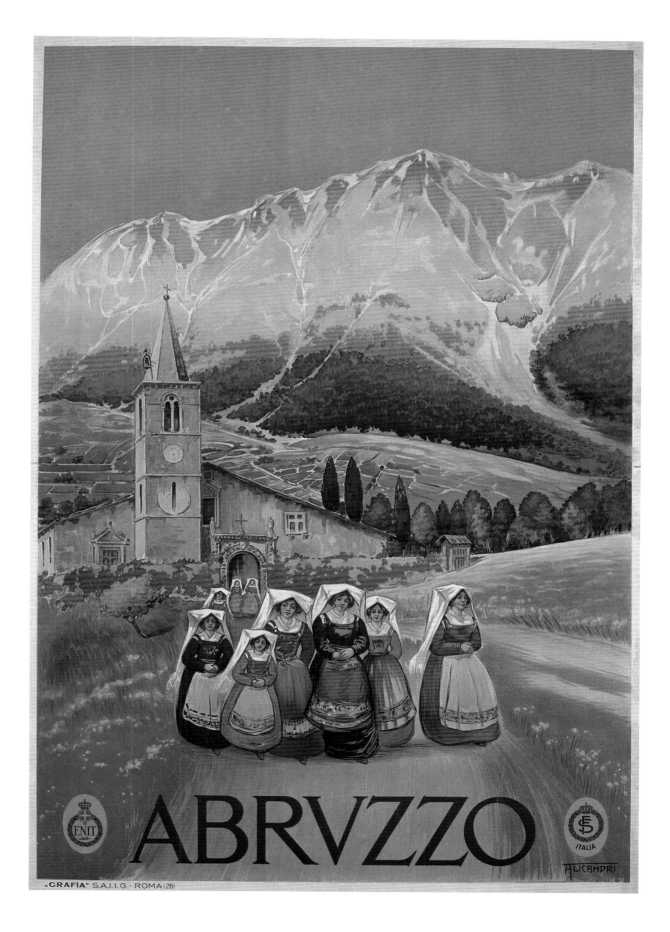

Rieti, 1951
Arrigo Pezzini
26 ¼ x 38 ½ in.
(66.7 x 97.7 cm.)
Offset
ENIT
SAIGA, già Barabino &
Graeve, Genoa

Latium Region

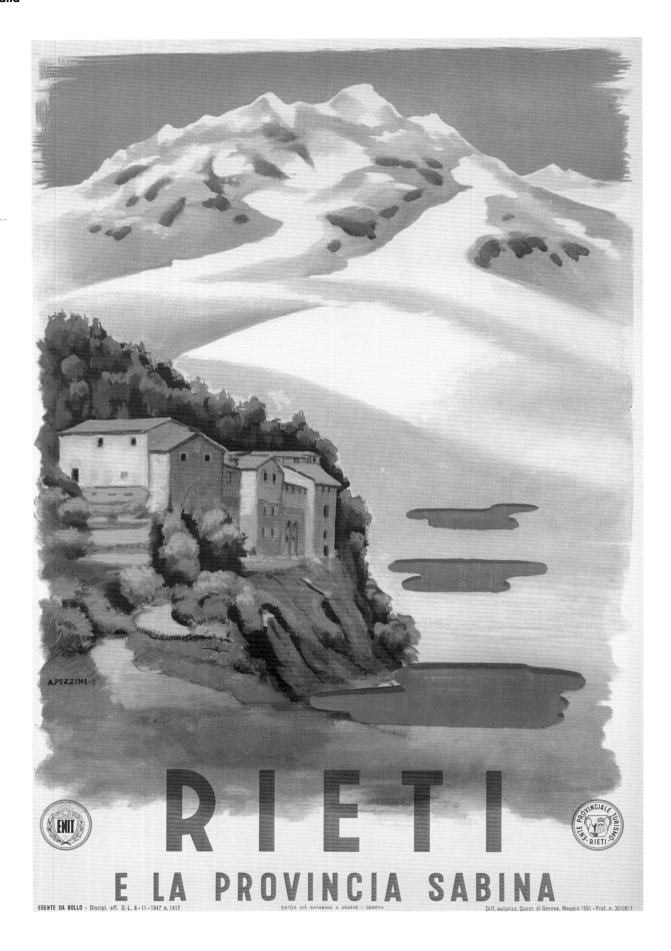

Roma, ca. 1935

Anonymous
26 ¾ x 39 ³⁄₁₆ in.
(67 x 99.5 cm.)
Offset
ENIT, FS
Pizzi & Pizio,
Milan - Rome

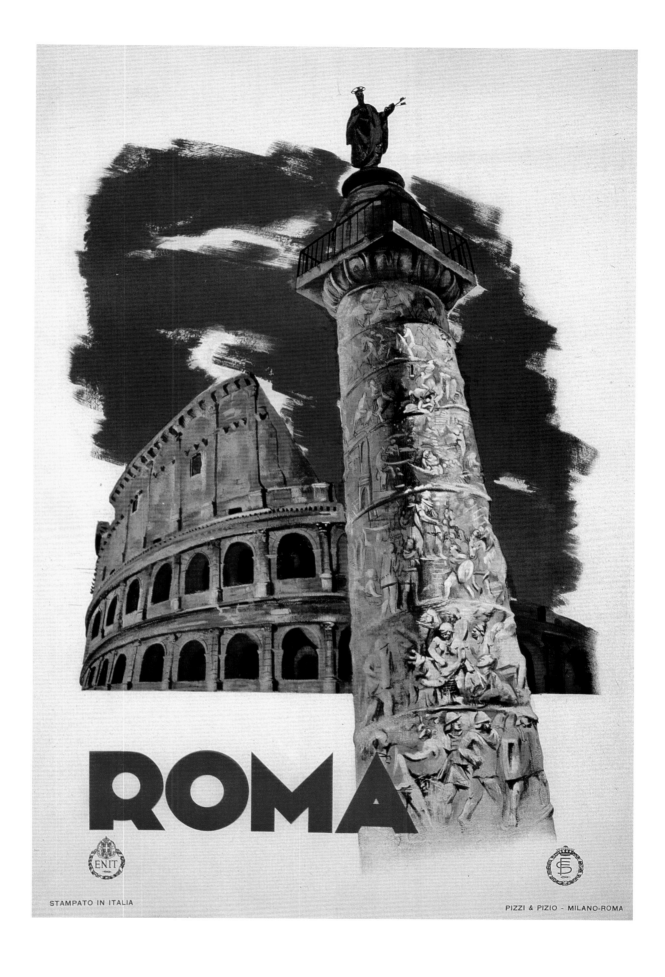

ROMA

STAMPATO IN ITALIA

PIZZI & PIZIO - MILANO-ROMA

Roma, ca. 1930

Virgilio Retrosi

24 ⅜ x 39 ⅟₁₆ in.
(62 x 99.3 cm.)
Lithograph
ENIT, FS
Novissima, Rome

**Roma Mercato di Traiano,
ca. 1928**

Vittorio Grassi

25 ⅛ x 39 ⅜ in.
(64.3 x 100 cm.)
Lithograph
ENIT, FS
Stab. A. Marzi, Rome

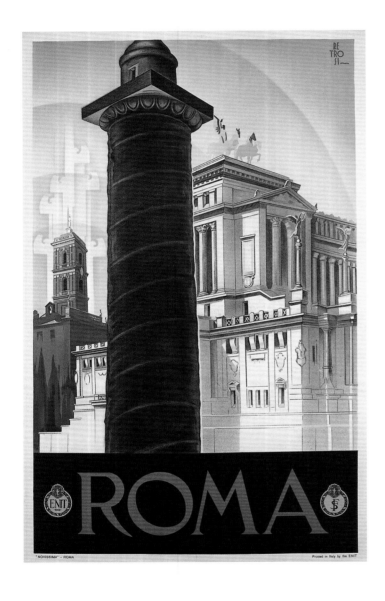

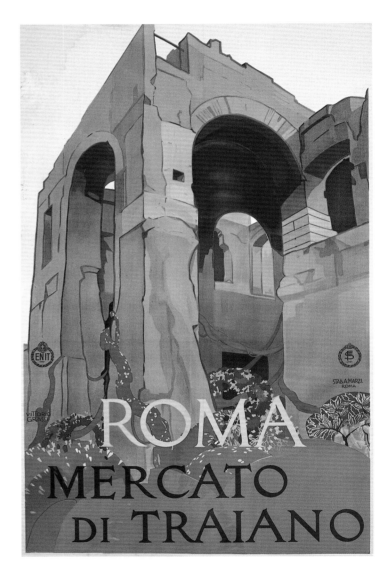

**Roma, Giro Turistico
Tramviario, 1927**

Anonymous

27 x 39 ⅛ in.
(68.7 x 99.4 cm.)
Lithograph
ENIT
Barabino & Graeve,
Genoa

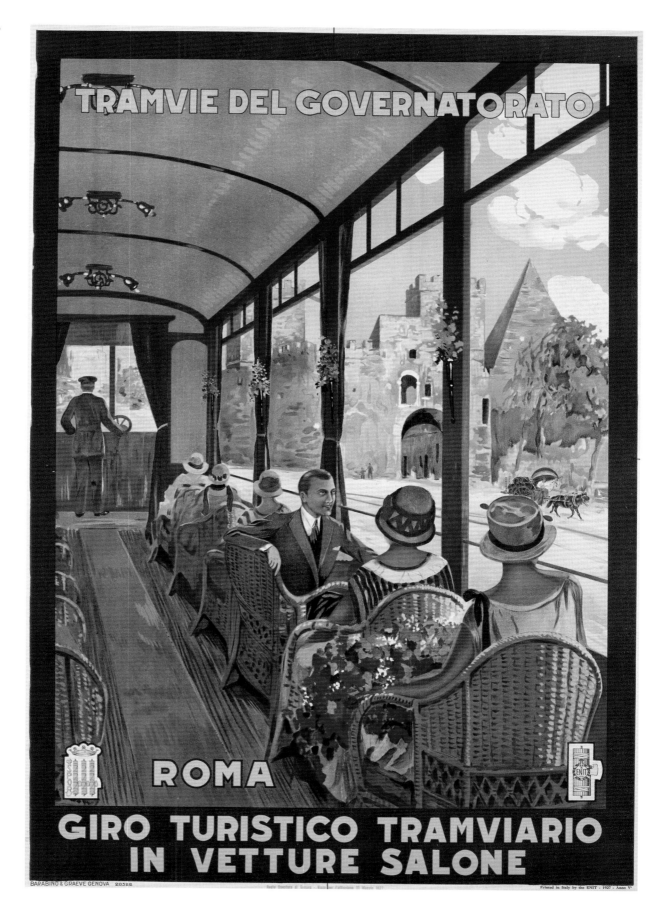

Detail from:
Roma, Giro Turistico Tramviario, 1927
(Featured on page 101)

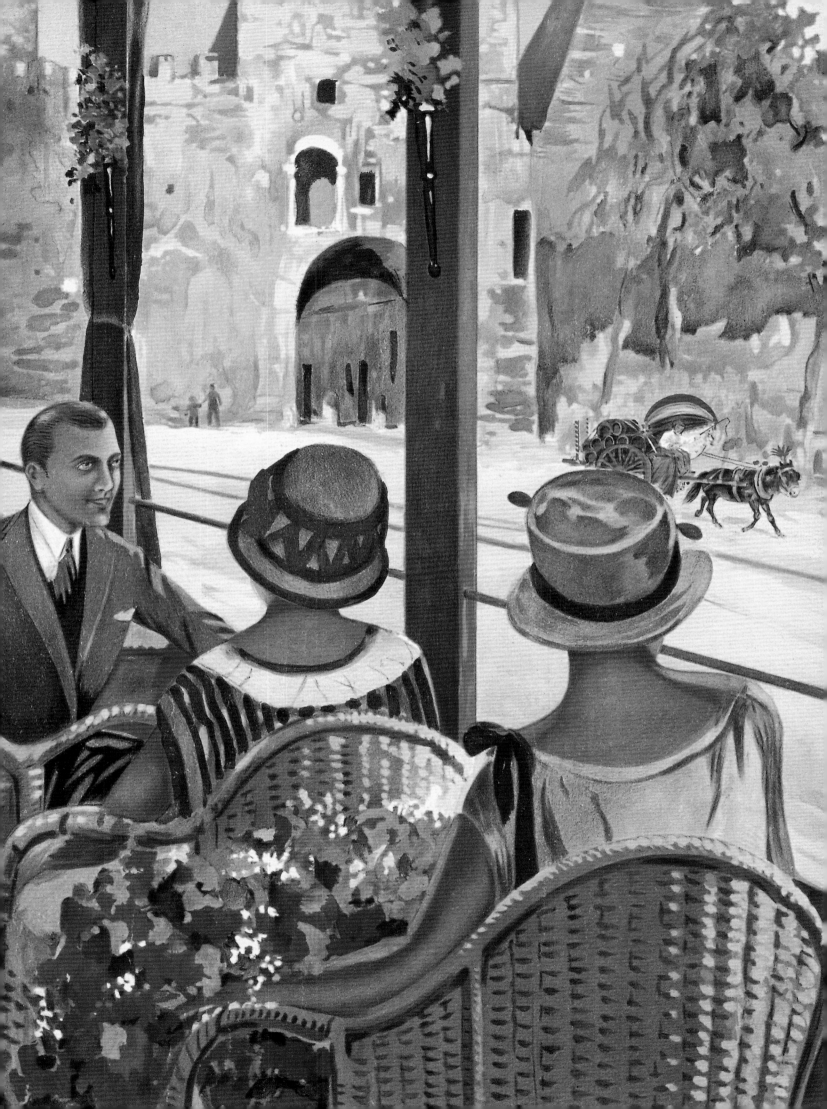

**Tivoli, Villa d'Este,
ca. 1925**

Anonymous

27 ⅛ x 39 ¾ in.
(69 x 101 cm.)
Lithograph
FS, ENIT
Stab. L. Salomone,
Rome

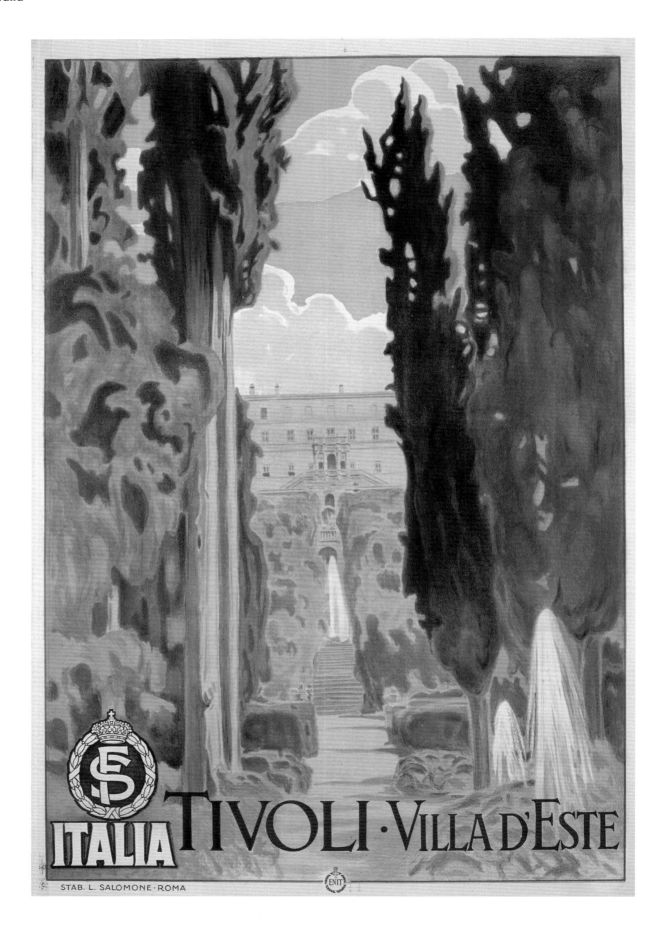

Fiuggi, 1928

Tito Corbella

27 %16 x 39 in.
(70 x 99 cm.)
Lithograph
ENIT, FS
Off. Grafiche
I.G.A.P., Rome

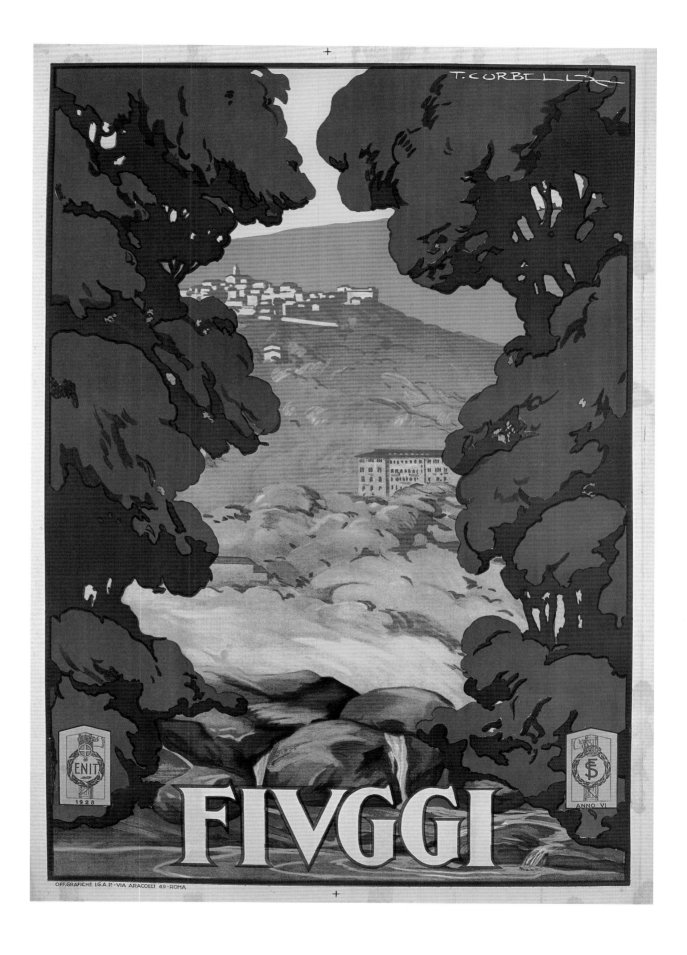

Spiagge di Latina, 1947
Virgilio Retrosi
24 ⅜ x 39 ⅜ in.
(62 x 100 cm.) Offset
ENIT
Grafiche Gigli, Rome

Caserta, 1951
Mario Puppo
27 x 39 ⅜ in.
(68.5 x 100 cm.) Lithograph
ENIT, FS
SAIGA, già Barabino &
Graeve, Genoa

..............................
Campania Region

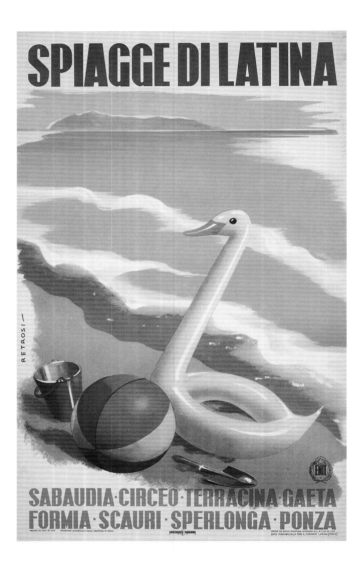

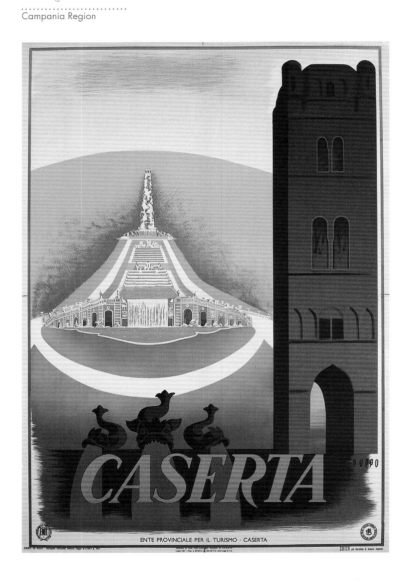

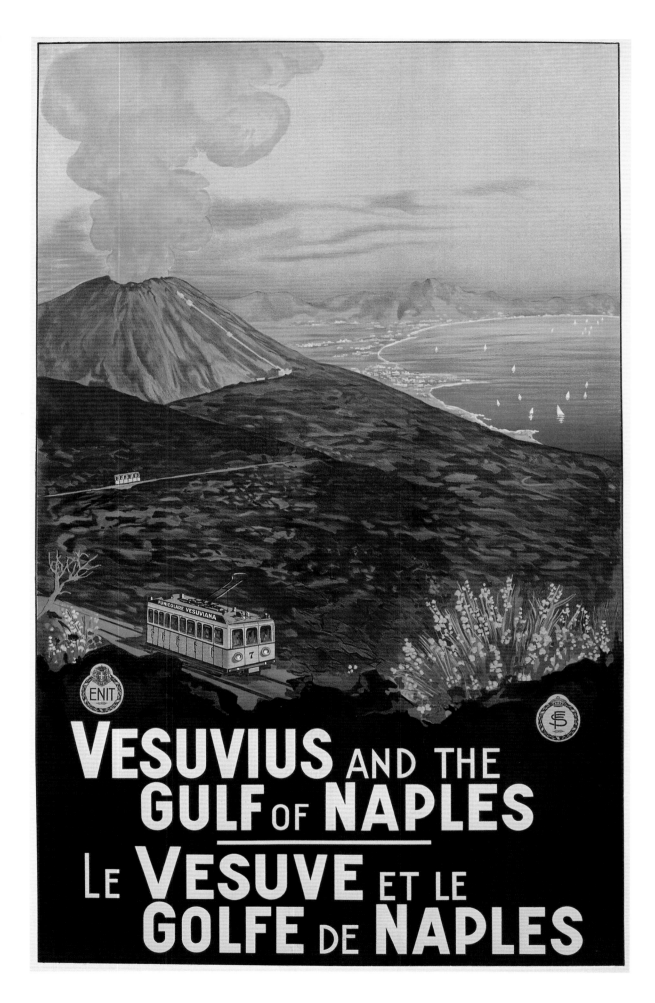

Napoli, ca. 1930
Anonymous
23 ¹⁵⁄₁₆ x 39 ¹⁄₁₆ in.
(60.8 x 99.3 cm.)
Lithograph
ENIT, FS
Richter & C., Naples

Napoli, 1942
Mario Puppo
25 x 39 in.
(63.5 x 99 cm.)
Lithograph
ENIT
SAIGA, già Barabino &
Graeve, Genoa

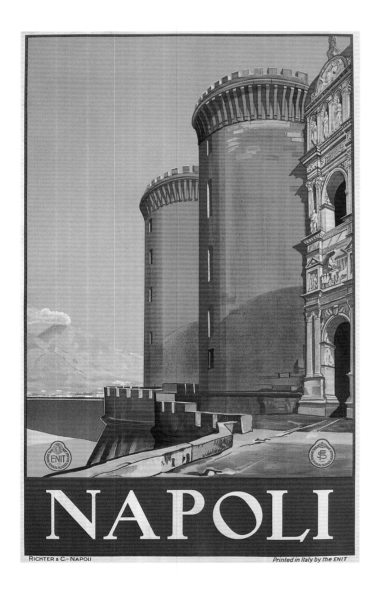

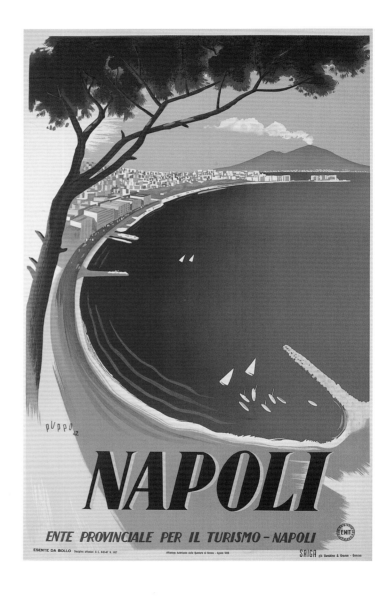

Napoli, ca. 1960

Mario Puppo
27 ⁷⁄₁₆ x 39 ⁷⁄₈ in.
(69.7 x 101.3)
Offset
ENIT
Lito Scarpati, Casoria

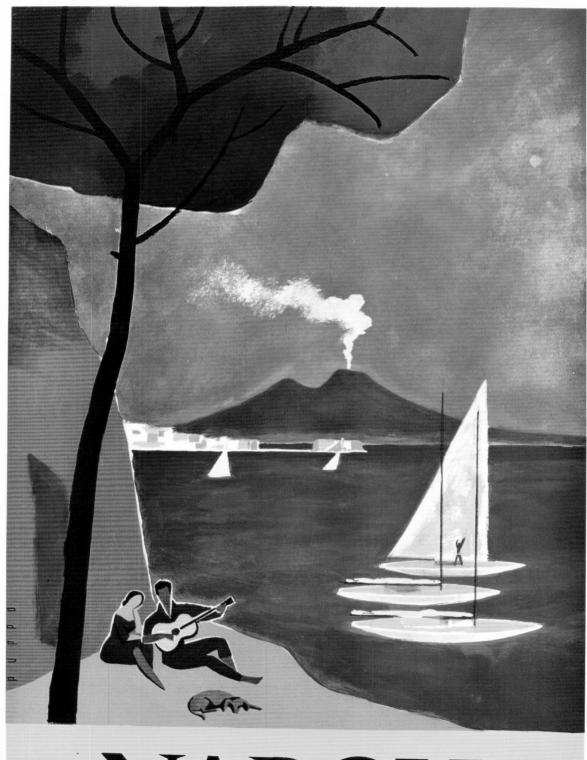

Sorrento, 1927
Mario Borgoni
27 ³/₁₆ x 38 ¹¹/₁₆ in.
(69 x 98.2 cm.)
Lithograph
ENIT, FS
Richter & C., Naples

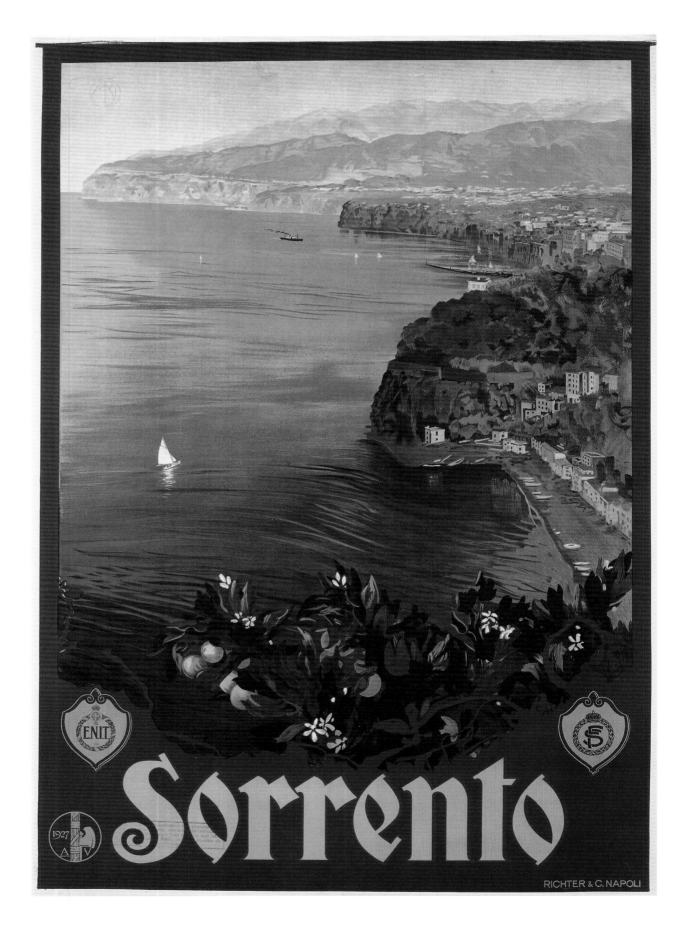

Sorrento, 1942

Mario Puppo

25 ⅛ x 39 ⁹⁄₁₆ in.
(63.8 x 100.5 cm.)
Lithograph
ENIT
SAIGA, già Barabino &
Graeve, Genoa

Sorrento, 1955

Mario Puppo

24 ⅜ x 38 ³⁄₁₆ in.
(62 x 97 cm.)
Lithograph
ENIT
S.p.A. Richter & C., Naples

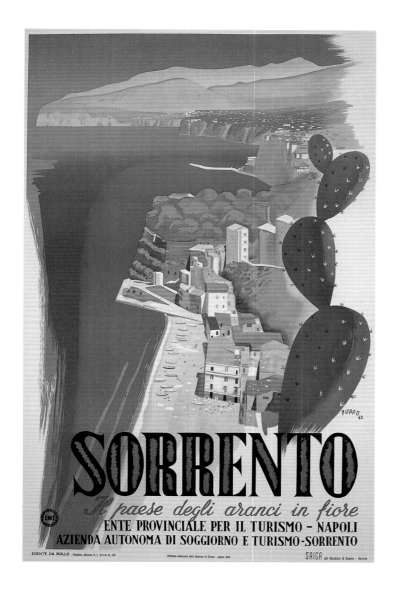

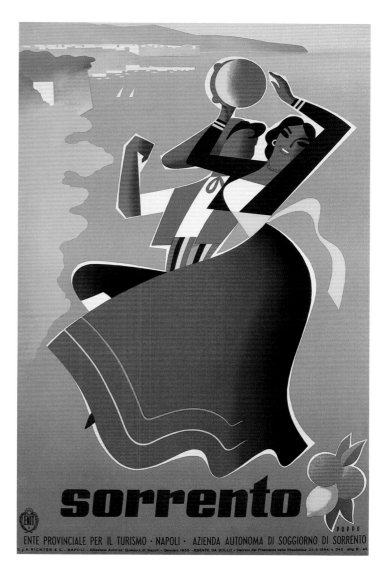

Pompei La Nuit, 1938
Giuseppe Riccobaldi
27 ⅜ x 39 ⁹⁄₁₆ in.
(69.5 x 100.5 cm.)
Lithograph
FS, ENIT
S.A.I.G.A. già Barabino &
Graeve, Genoa

**Pompei La Città
Dissepolta, 1952**
Mario Puppo
24 ⅛ x 39 in.
(61.3 x 99 cm.)
Offset
ENIT
A. Pizzi S.A., Milan

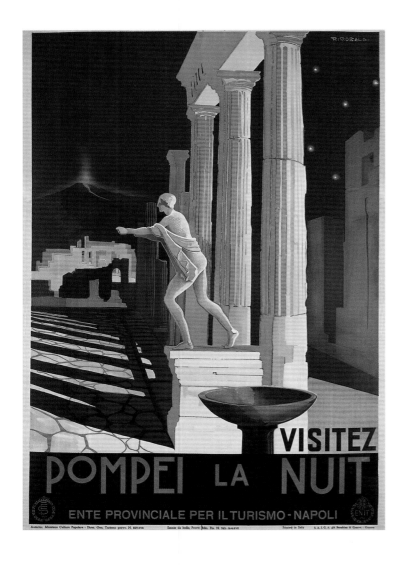

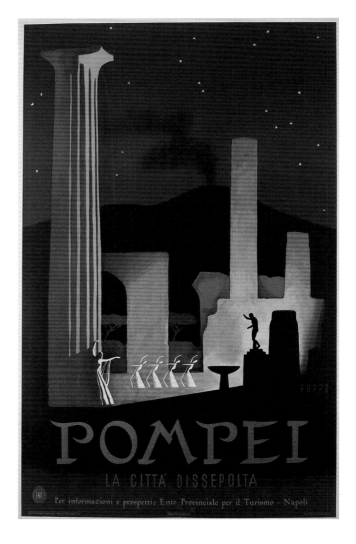

Pompei, 1955
Mario Puppo
25 ¾ x 39 in.
(65.5 x 99 cm.)
Lithograph
ENIT
S.p.A. Richter & C.,
Naples

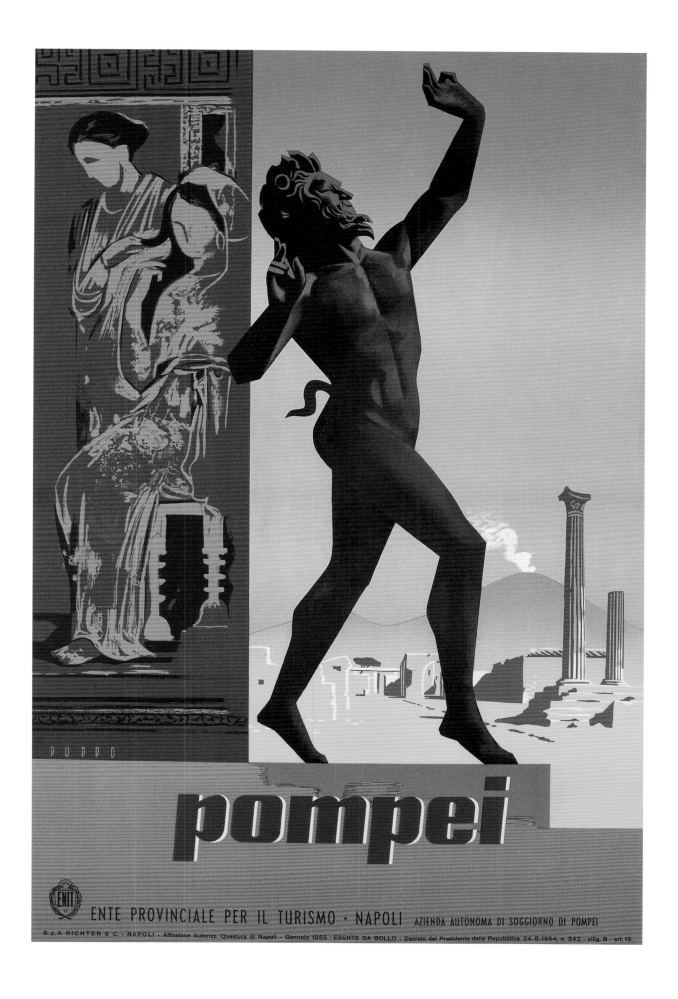

Capri, ca. 1927
Mario Borgoni
25 ⅜ x 39 ⅜ in.
(64.5 x 100 cm.)
Lithograph
ENIT, FS
Richter & C., Naples

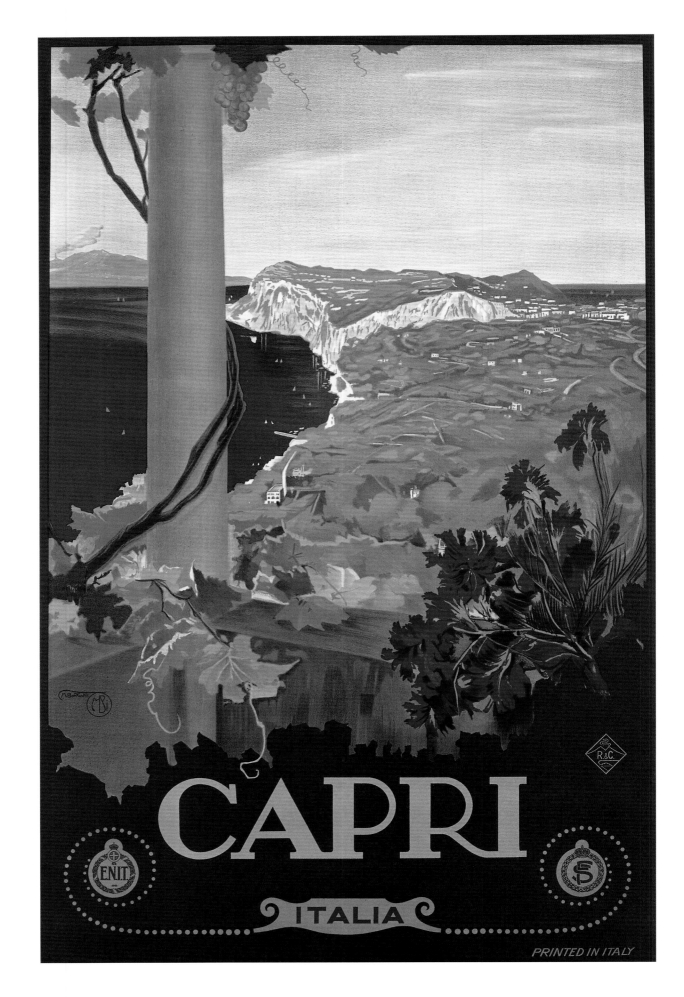

Capri, 1948
Giuseppe Riccobaldi
25 x 39 ⅜ in.
(63.5 x 100 cm.)
Lithograph
ENIT
SAIGA, già Barabino &
Graeve, Genoa

Capri, 1952
Mario Puppo
24 ³/₁₆ x 39 ³/₁₆ in.
(61.5 x 99.6 cm.)
Offset
ENIT
A. Pizzi S.A., Milan

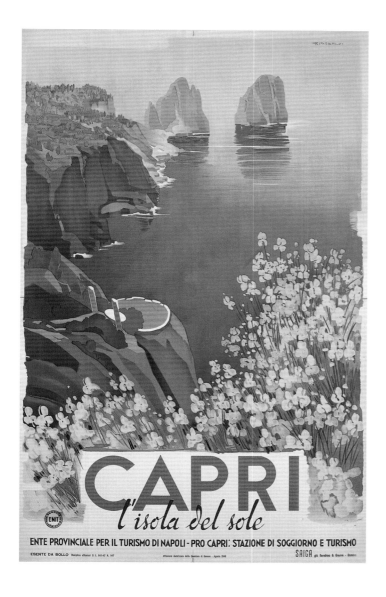

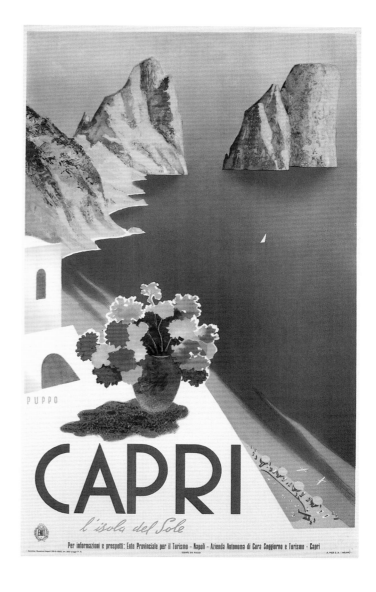

**Procida l'isola
di "Graziella", 1952**
Mario Puppo
24 ⁵/₁₆ x 39 ³/₁₆ in.
(61.7 x 99.5 cm.)
Offset
ENIT
A. Pizzi S.p.A. Milan

Procida, 1954
Mario Puppo
26 ³/₈ x 39 ¹/₁₆ in.
(67 x 99.2 cm.)
Offset
ENIT
Lito F.lli Manzoni, Naples

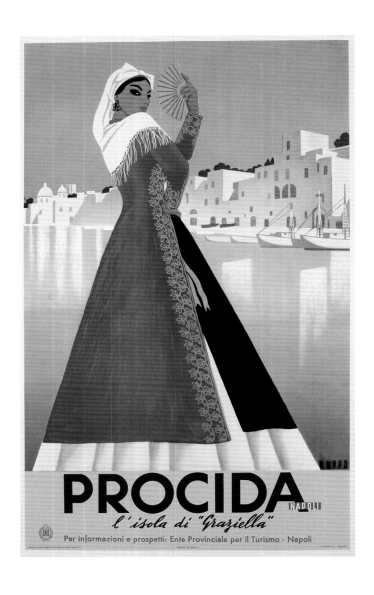

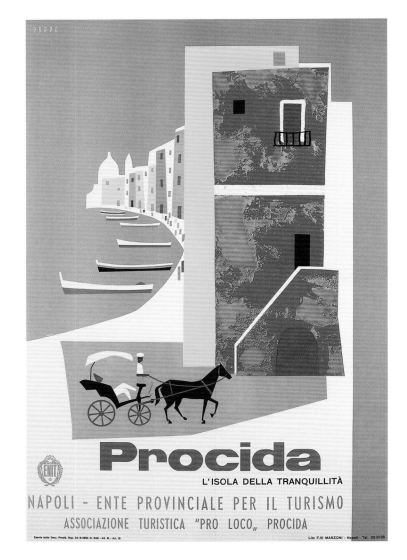

Procida, ca. 1960

Mario Puppo
27 ⁹/₁₆ x 39 ⅞ in.
(70 x 101.3 cm.)
Offset
FS, ENIT
Lito Scarpati, Casoria

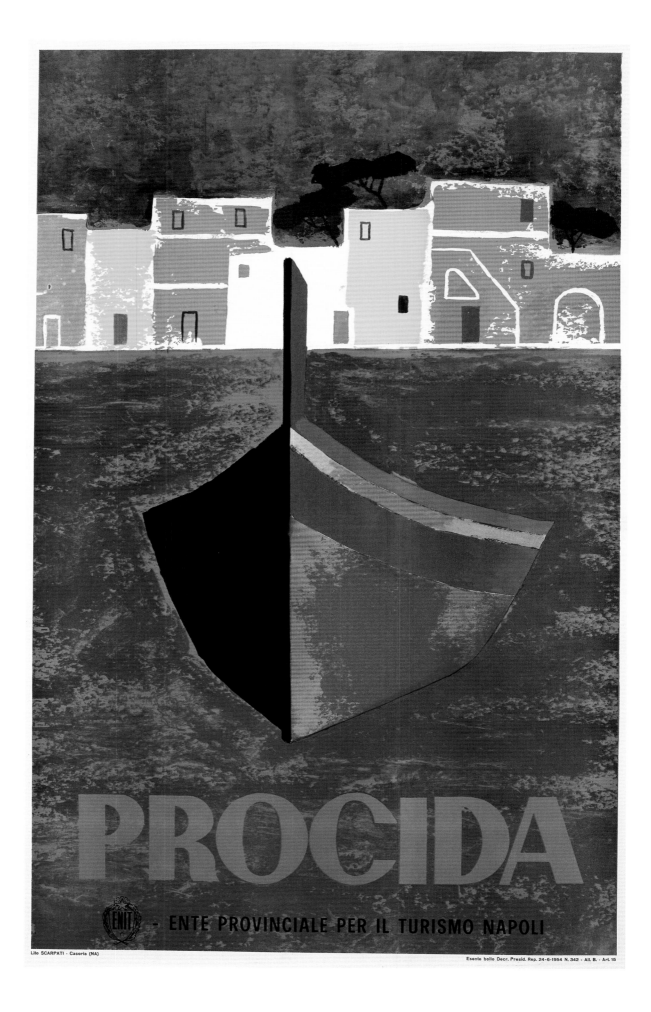

Paestum, ca. 1925
Vincenzo Alicandri
27 ⅜ x 39 ⁵⁄₁₆ in.
(69.6 x 99.8 cm.)
Lithograph
ENIT, FS
Ind. Grafiche Moneta,
Milan

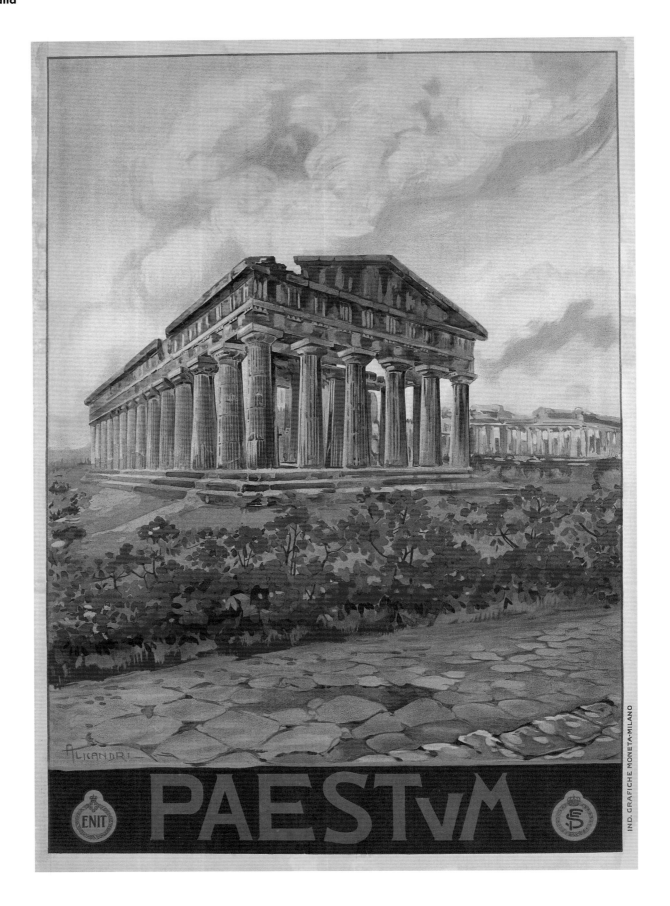

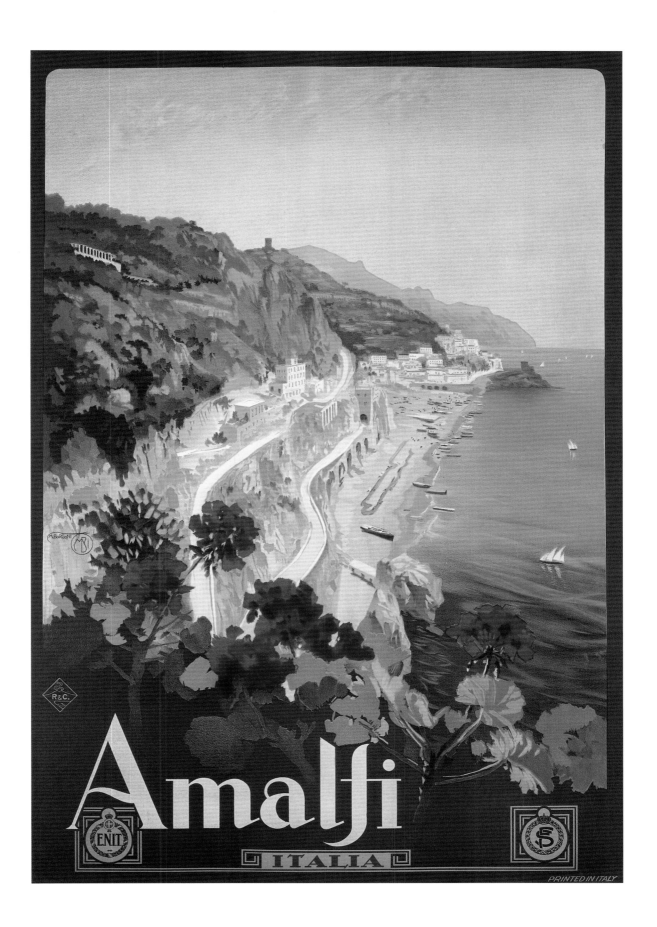

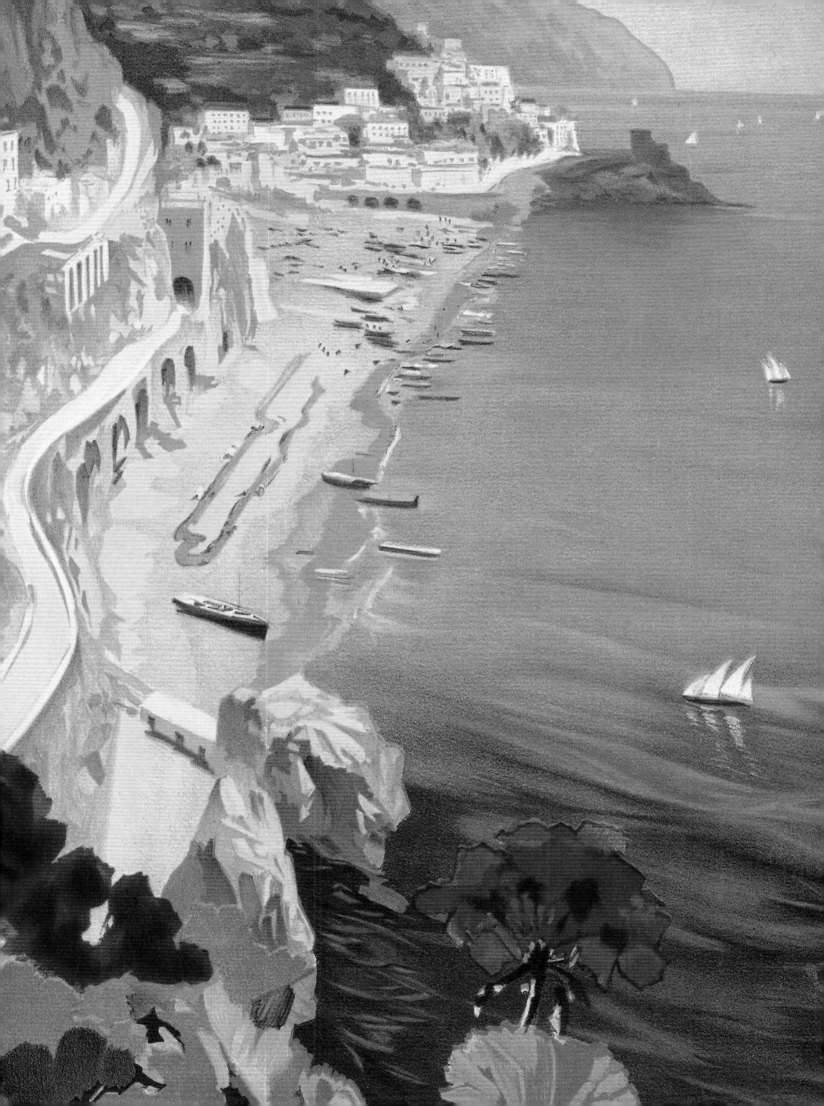

Ischia, 1948
Giuseppe Riccobaldi
25 ¹/₁₆ x 39 ³/₈ in.
(63.7 x 100 cm.)
Lithograph
ENIT
SAIGA, già Barabino &
Graeve, Genoa

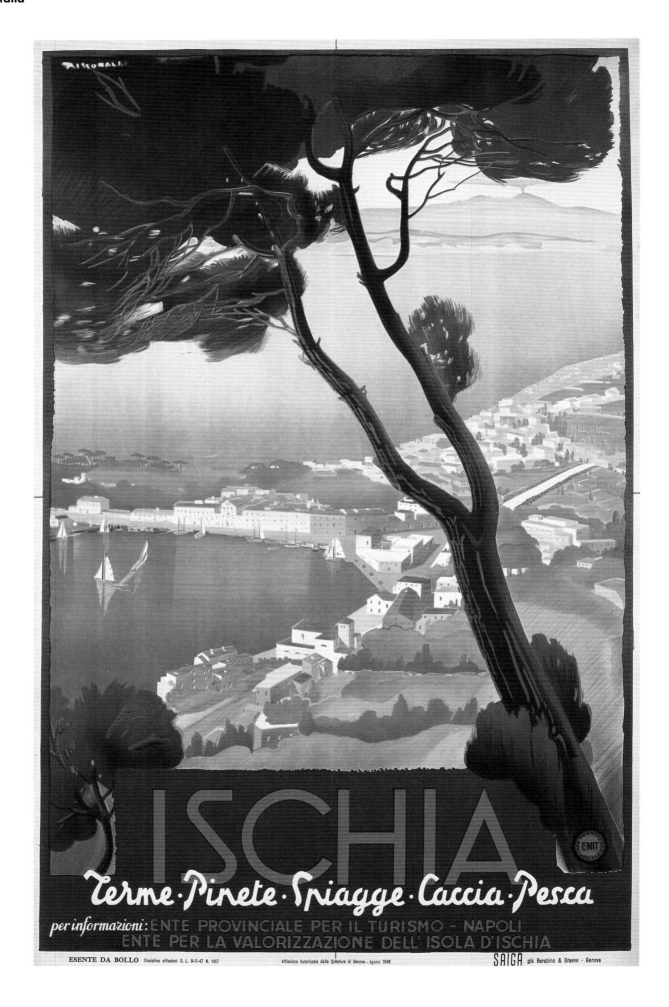

**Castellammare
di Stabia, 1948**

Giuseppe Riccobaldi

25 ⅛ x 39 ⅜ in.
(63.8 x 100 cm.)
Lithograph
ENIT
SAIGA, già Barabino &
Graeve, Genoa

**Castellammare
di Stabia, 1954**

Mario Puppo

27 ½ x 40 in.
(69.8 x 101.6 cm.)
Offset
ENIT
Lito Scarpati, Casoria

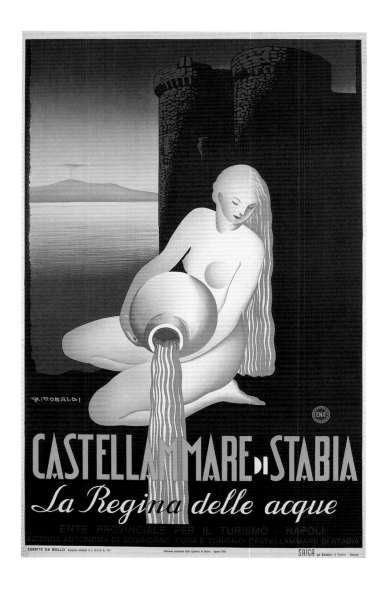

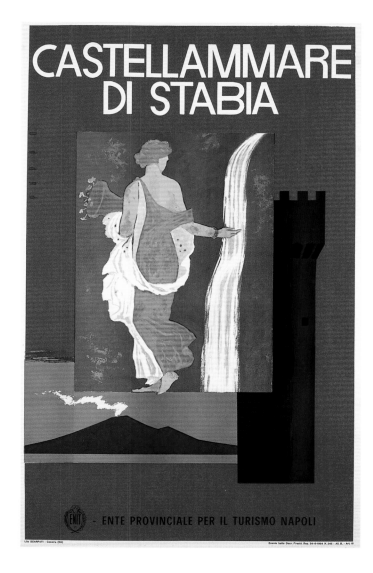

Salerno, ca. 1926
Vincenzo Alicandri
27 ¹⁵⁄₁₆ x 39 ⁹⁄₁₆ in.
(71 x 100.5 cm.)
Lithograph
ENIT, FS
Stab. L. Salomone,
Rome

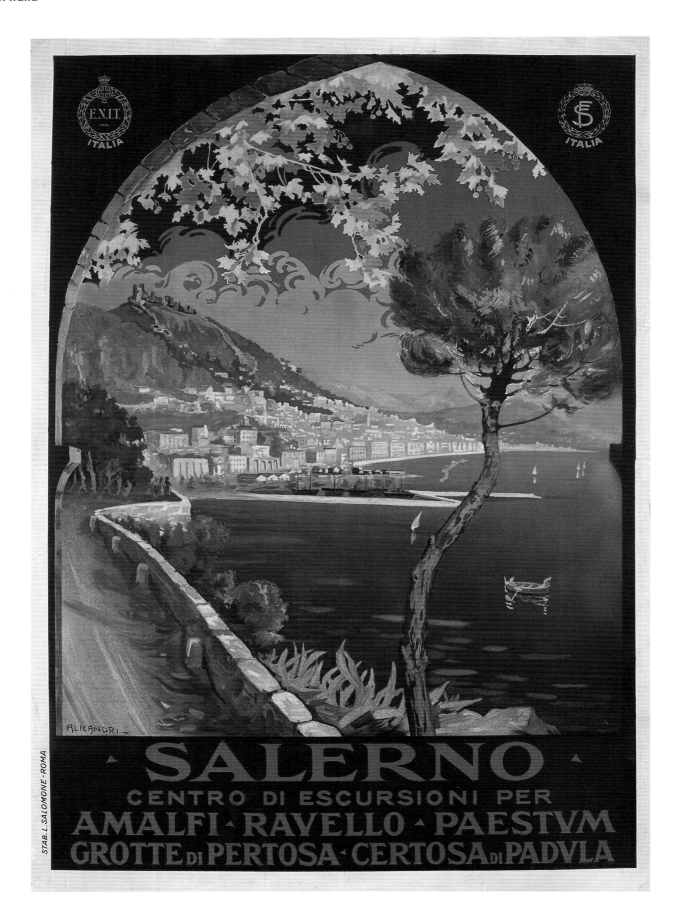

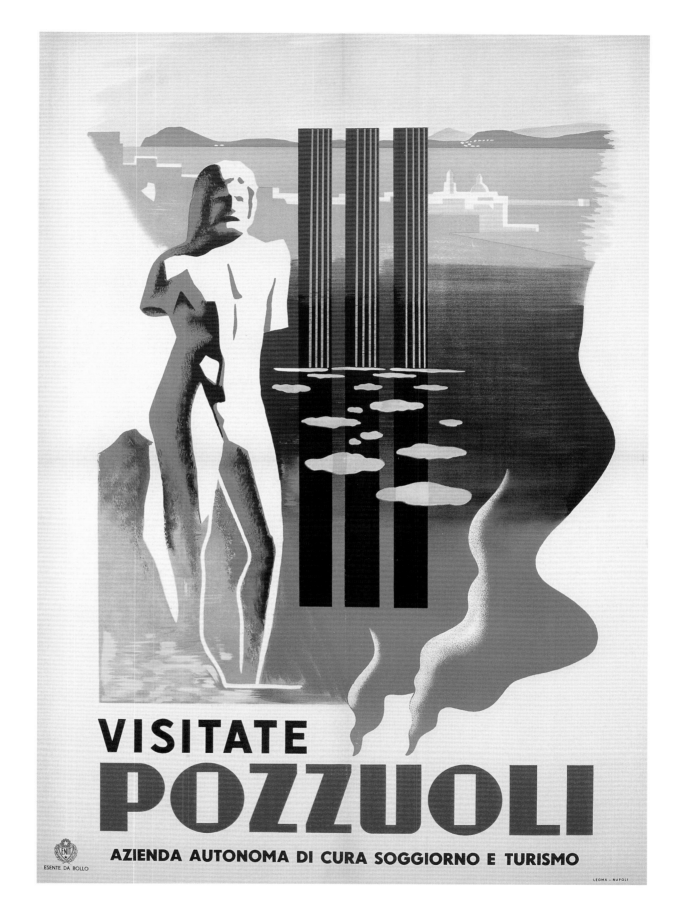

Ercolano, ca. 1928
Marcello Dudovich
24 5/16 x 39 3/8 in.
(61.8 x 100 cm.)
Lithograph
ENIT, FS
Grafiche I.G.A.P. Rome

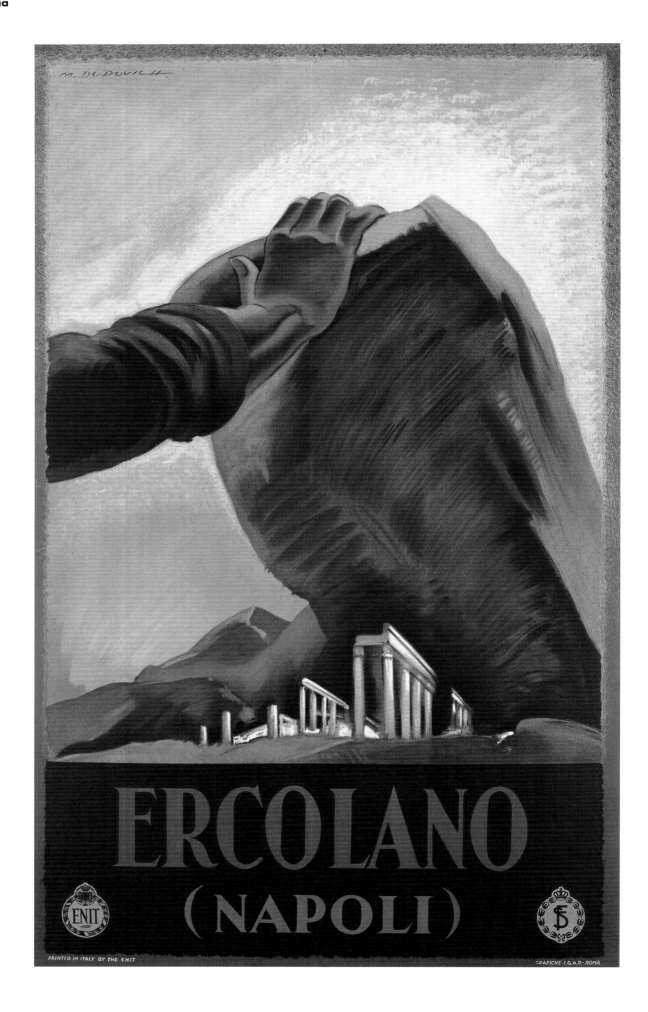

Ercolano, ca. 1960

Mario Puppo

26 ¾ x 39 ¾ in.
(68 x 101 cm.)
Offset
ENIT
Lito Scarpati, Casoria

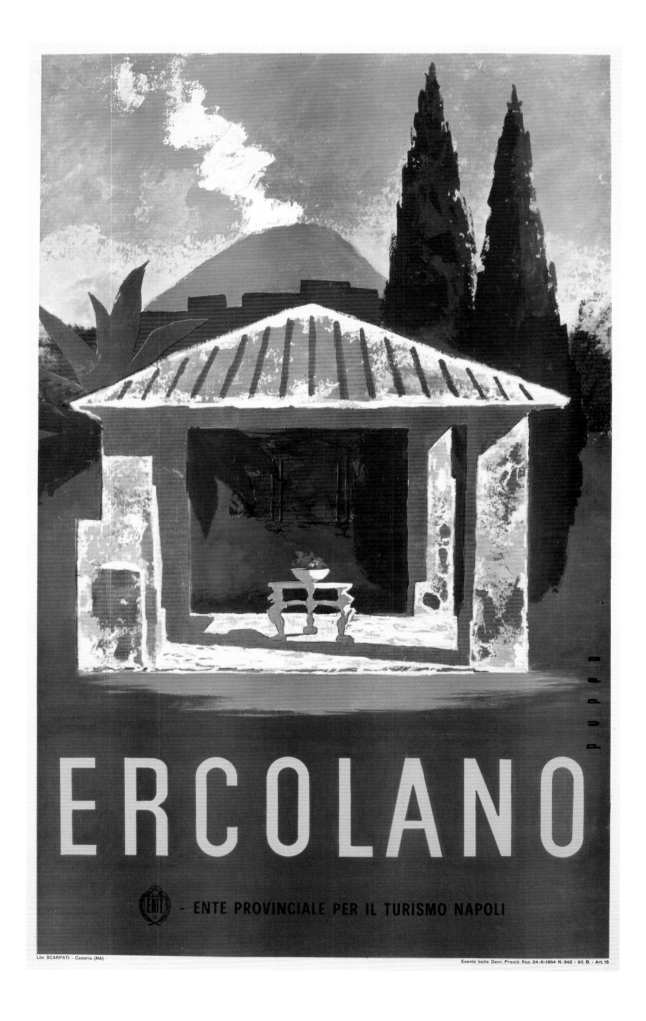

Puglie, ca. 1925
Plinio Codognato
26 ⁹/₁₆ x 39 ³/₈ in.
(67.5 x 100 cm.)
Lithograph
ENIT, FS
Edizioni Turisanda, Milan

..............................
Apulia Region

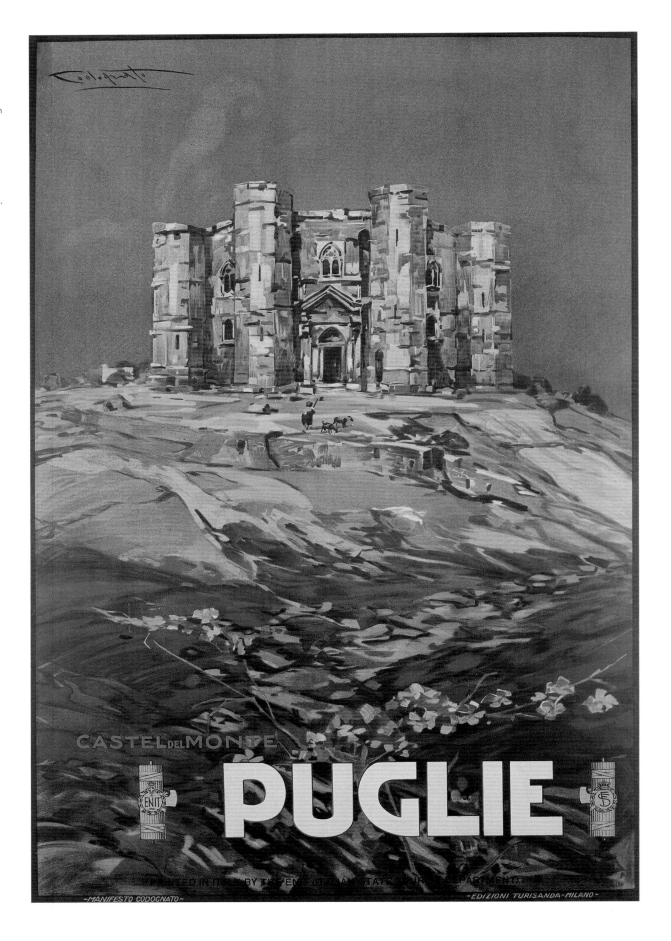

**Foggia e la sua
provincia, 1951**

Virgilio Retrosi

24 ⁵/₁₆ x 39 ⁹/₁₆ in.
(61.8 x 100.5 cm.)
Offset
ENIT, FS
G. Scarpati & Figlio, Naples

Lecce, 1947

Domenico Delle Site

27 ½ x 39 ³/₈ in.
(69,8 x 100 cm.)
Offset
Ente Provinciale Turismo
Arti Grafiche FAVIA,
Bari - Rome

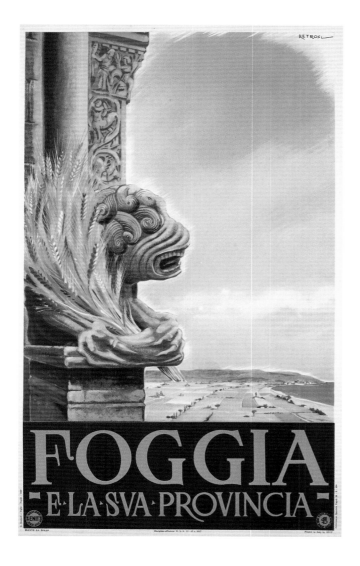

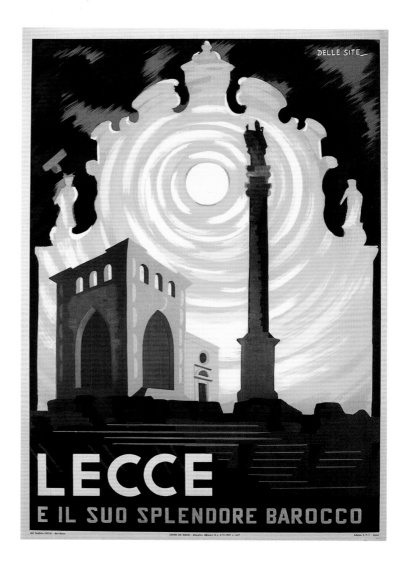

**Santa Cesarea Terme,
ca. 1927**

Anonymous

24 ⅜ x 39 ⅜ in.
(62 x 100 cm.)
Lithograph
ENIT, FS
Prem. Stab. Litografico,
Faenza

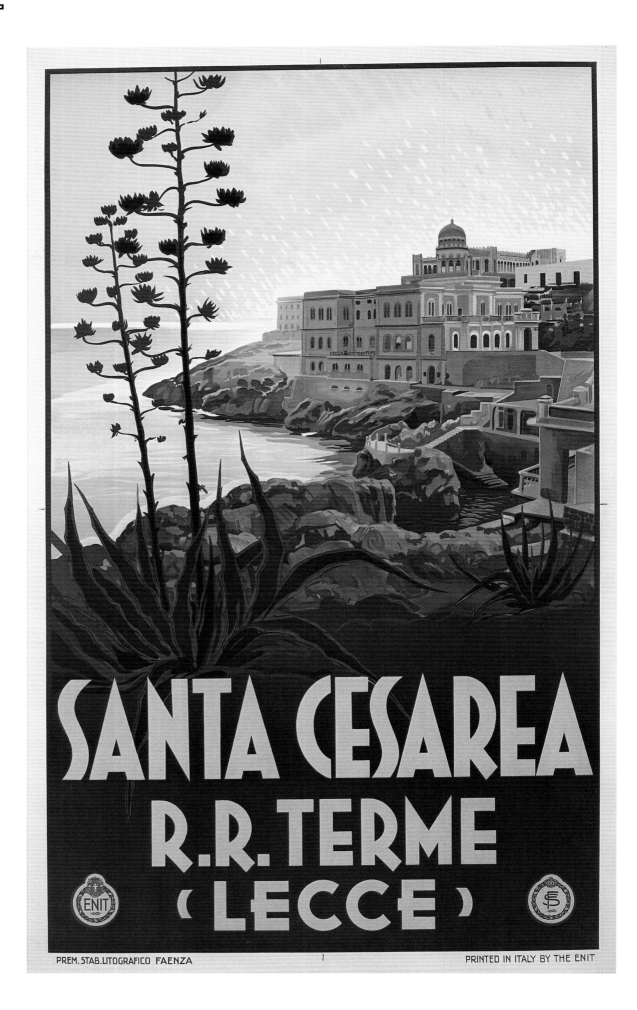

Costa Viola—Reggio Calabria, ca. 1960
Leo Pecchioni
27 x 39 ³⁄₁₆ in.
(68.5 x 99.5 cm.)
Offset
Ente Provinciale per il Turismo
Sigla Effe, Genoa

Calabria Region

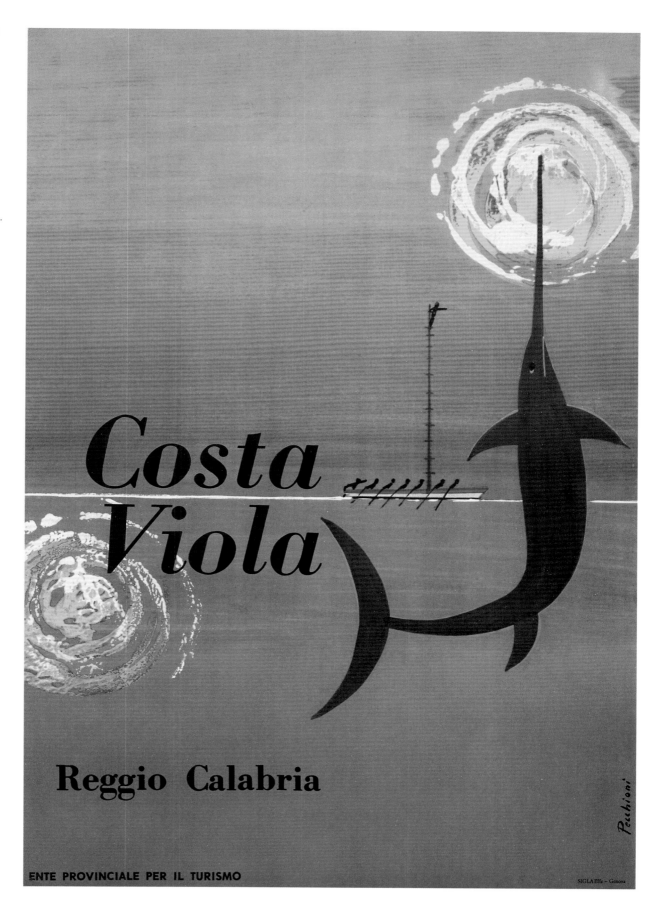

Agrigento, 1928
Marcello Nizzoli
26 ¾ x 39 ⁹⁄₁₆ in.
(68 x 100.5 cm.)
Lithograph
ENIT, FS
Edizioni STAR, Milan

Sicily Region

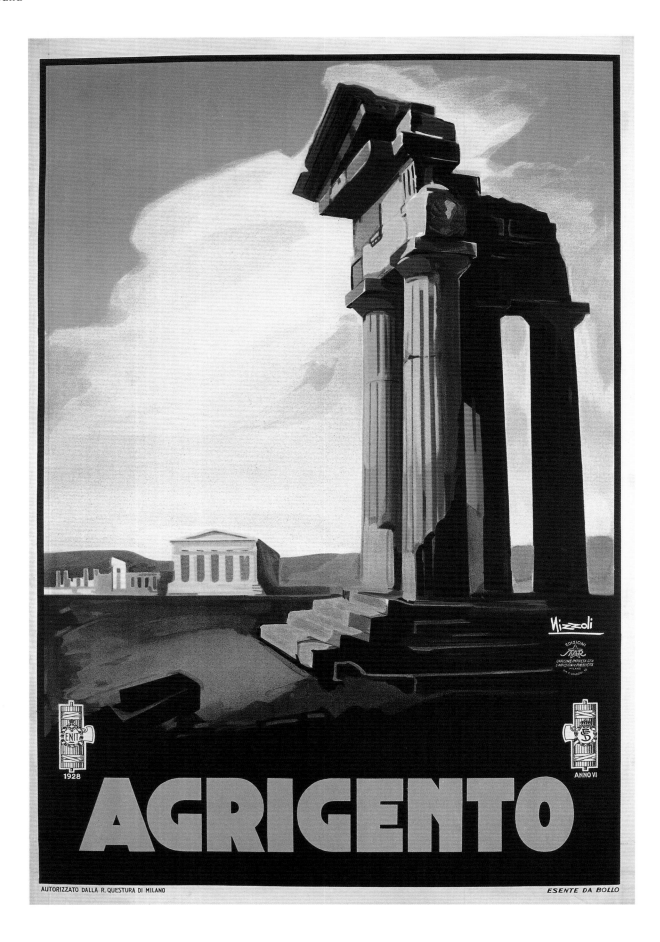

Sicilia, 1953
Mario Puppo
23 ¾ x 38 ¹³⁄₁₆ in.
(60.3 x 98.6 cm.)
Lithograph
Assessorato Turismo e
Spettacolo, Regione Siciliana
SAIGA, già Barabino &
Graeve, Genoa

**Sicilia Eterna
Primavera !, 1947**
Giulio D'Angelo
23 ¹³⁄₁₆ x 38 ¾ in.
(60.5 x 98.5 cm.)
Offset
ENIT, FS
Ind. Graf. Besozzi, Milan

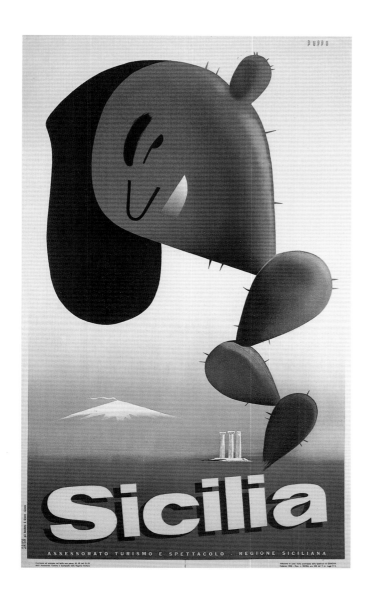

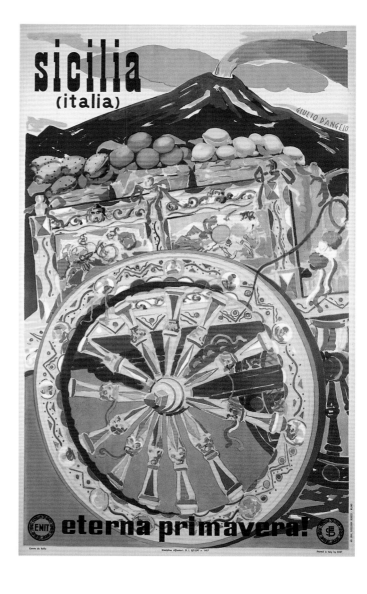

Palermo, ca. 1925
Mario Paschetto
26 ³/₁₆ x 39 in.
(66.5 x 99 cm.)
Lithograph
FS, ENIT
Stab. A. Marzi, Rome

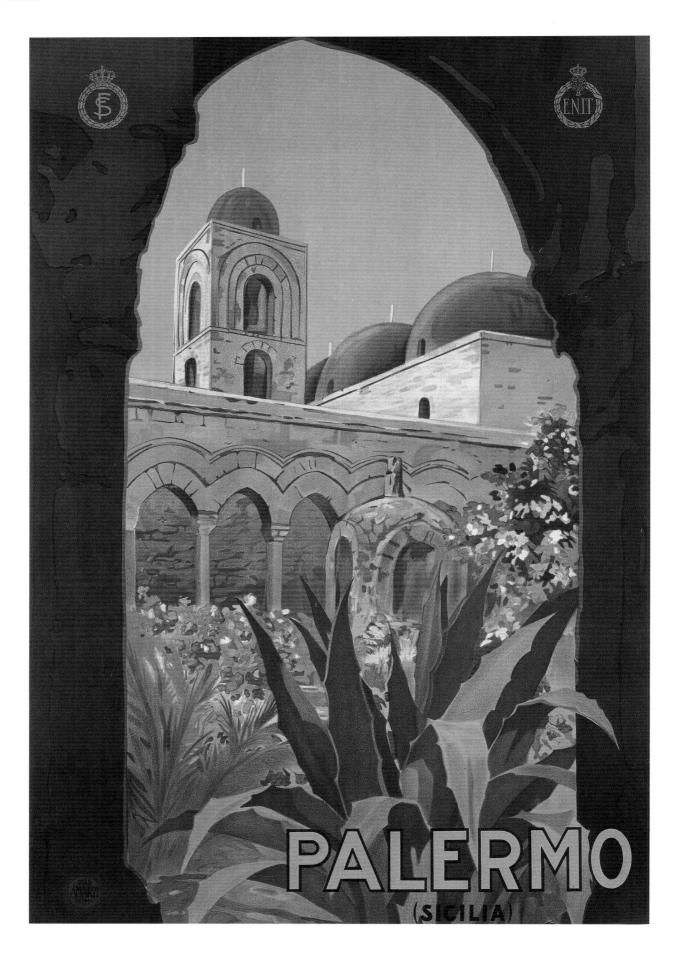

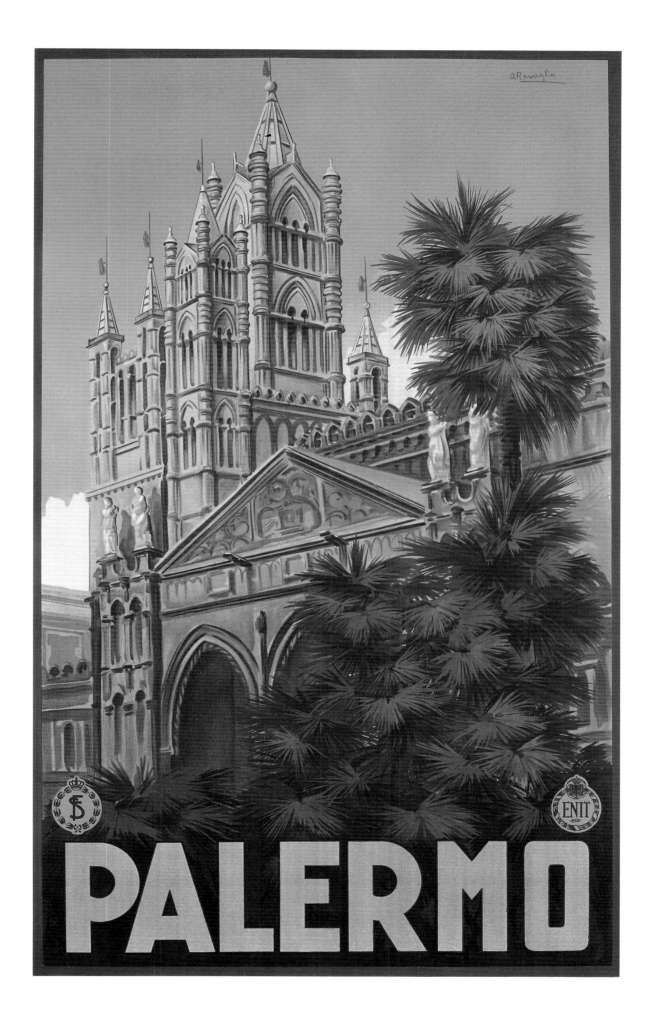

Monreale, ca. 1925
Vittorio Grassi
27 ¾ x 38 ⁹⁄₁₆ in.
(70.5 x 98 cm.)
Lithograph
ENIT, FS
Richter & C., Naples

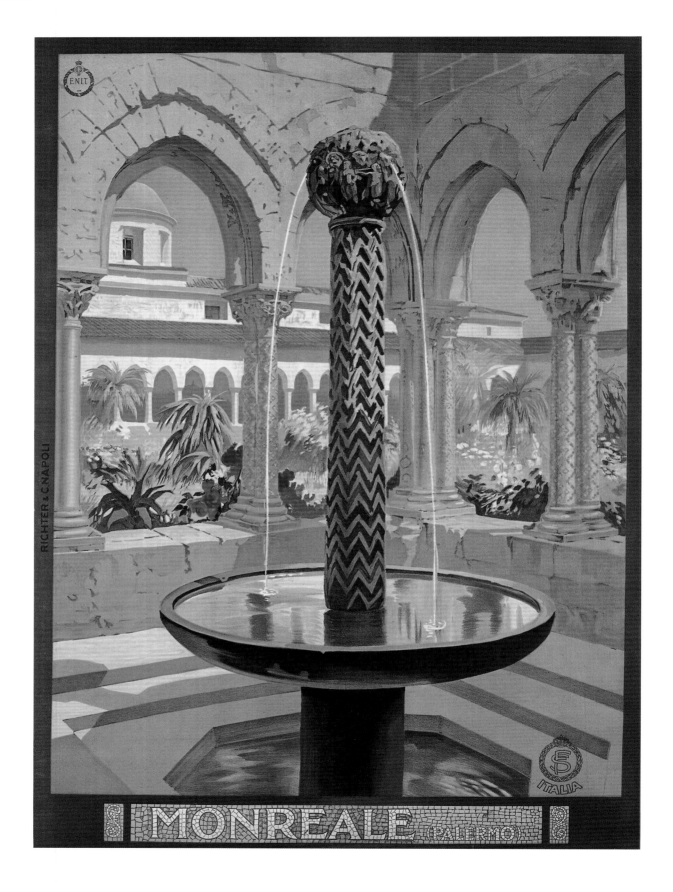

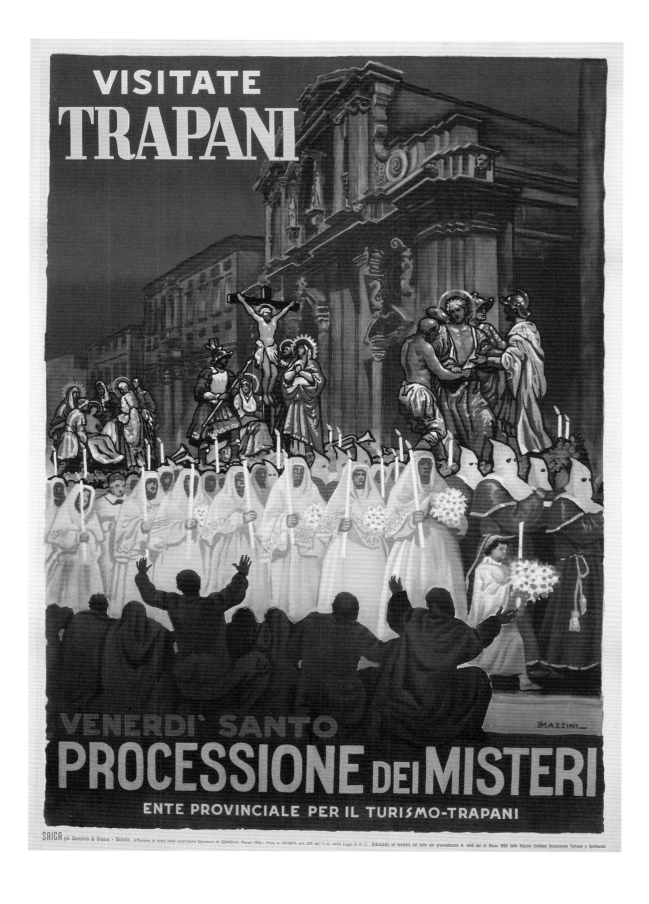

Taormina, 1933
Vittorio Grassi
24 x 39 ³/₁₆ in.
(61 x 99.5 cm.)
Lithograph
ENIT, FS
Grafiche I.G.A.P., Rome

Taormina Sicily, 1952
Mario Puppo
27 x 39 ¹/₁₆ in.
(68.5 x 99.3 cm.)
Lithograph
Azienda Autonoma Turismo
Regione Siciliana
SAIGA, già Barabino & Graeve, Genoa

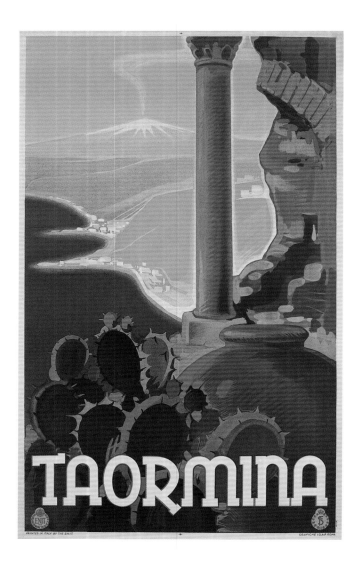

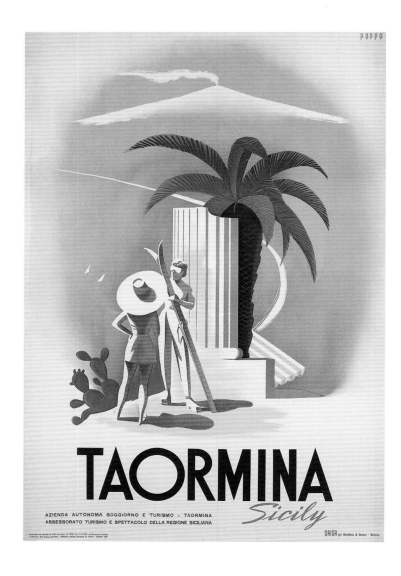

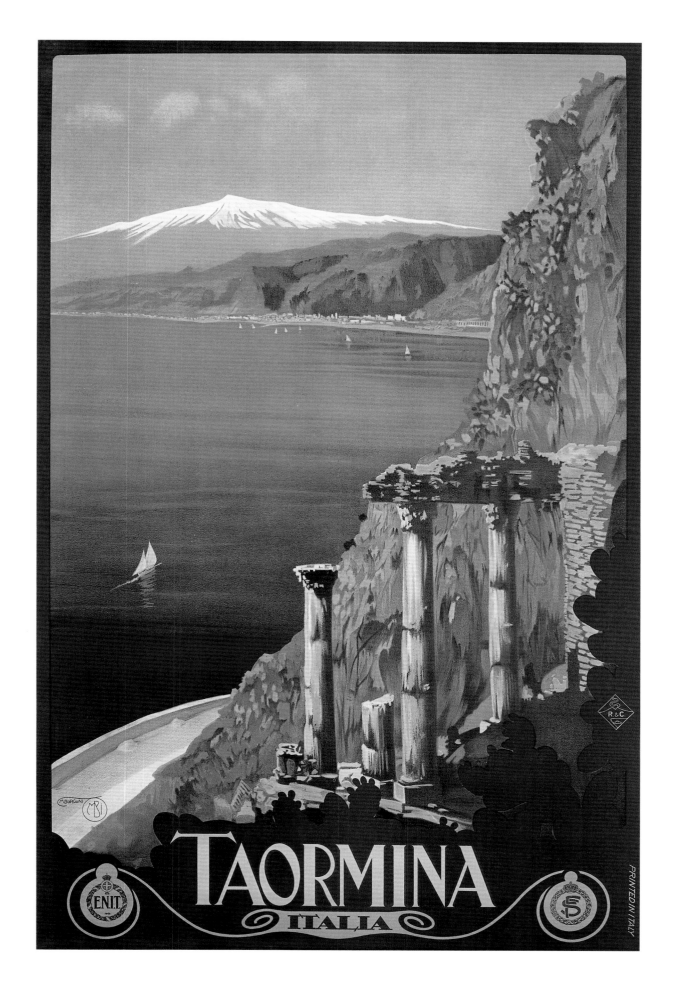

Siracusa, ca. 1935
Anonymous
26 ⁹/₁₆ x 39 ³/₁₆ in.
(67 x 99.5 cm.)
Offset
ENIT, FS
Tipo-Litografia La Presse,
Milan

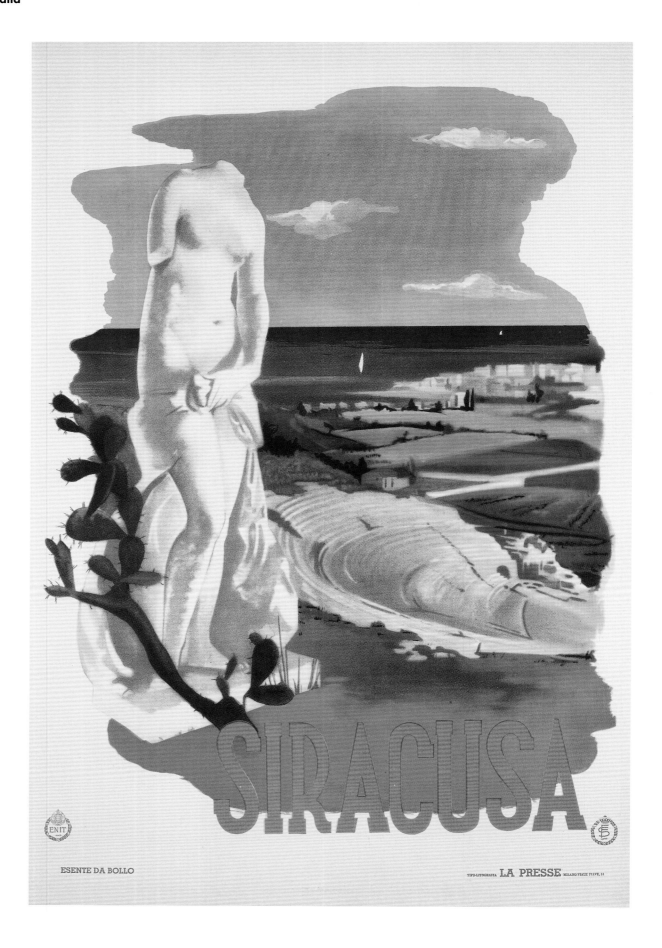

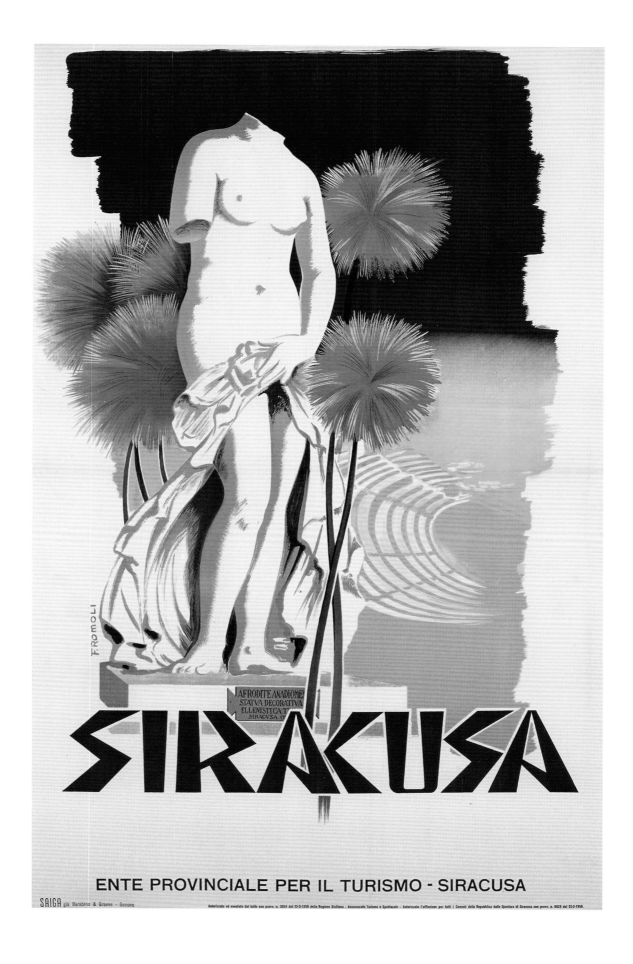

Catania, 1952
Alfredo Lalia
27 ¹⁵/₁₆ x 39 ³/₁₆ in.
(71 x 99.5 cm.)
Offset
ENIT
Grafiche Gigli, Rome

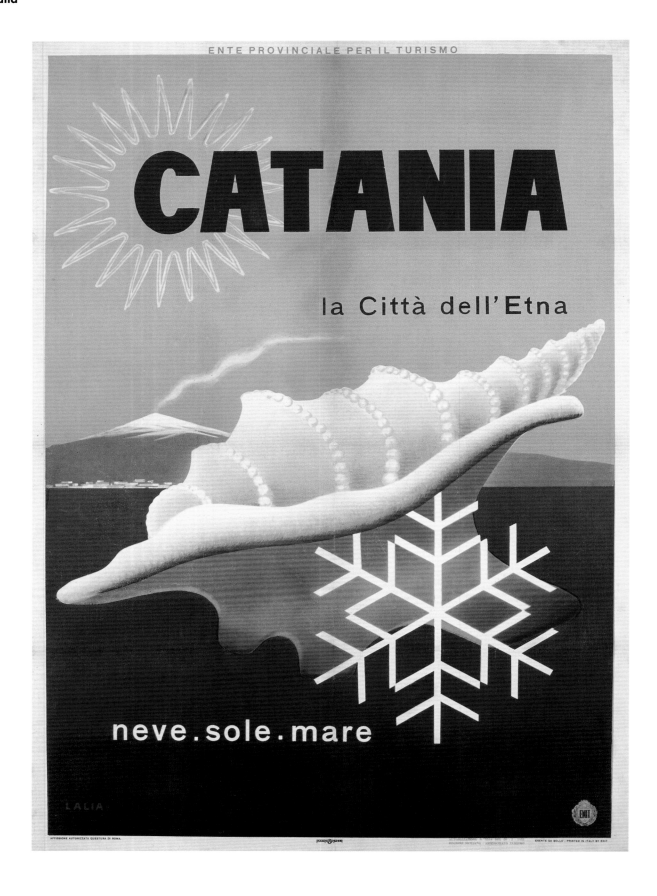

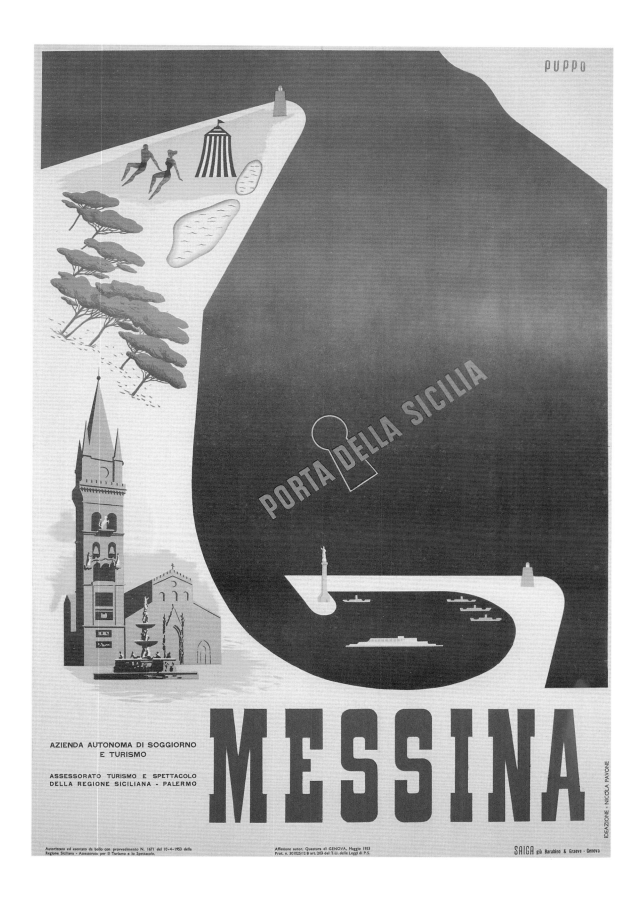

Sardegna, 1951
Domenico Delle Site
24 ⅝ x 39 ⁷/₁₆ in.
(62.5 x 100.2 cm.)
Offset
ENIT
Stab. Luigi Salomone,
Rome

Sardinia Region

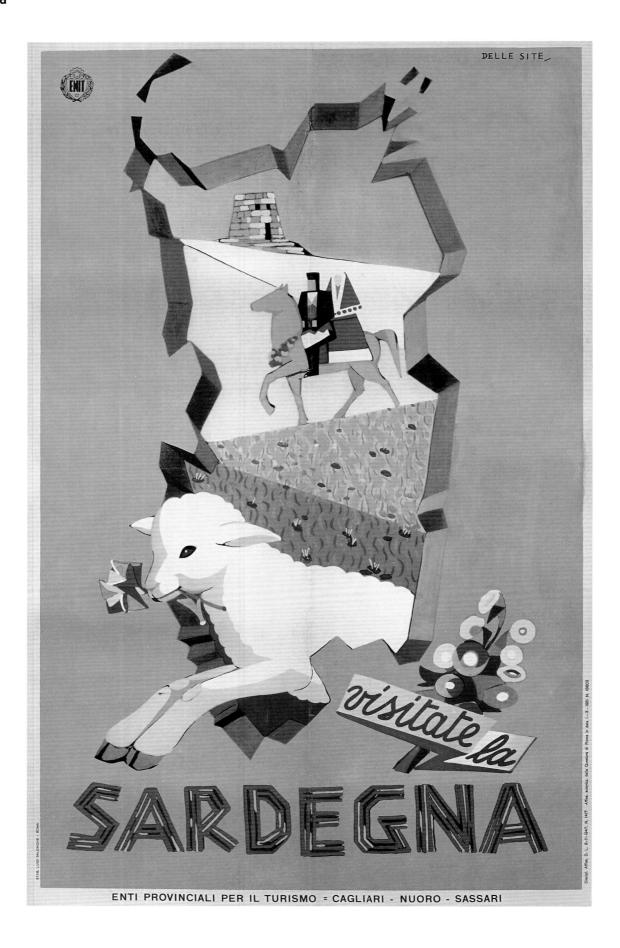

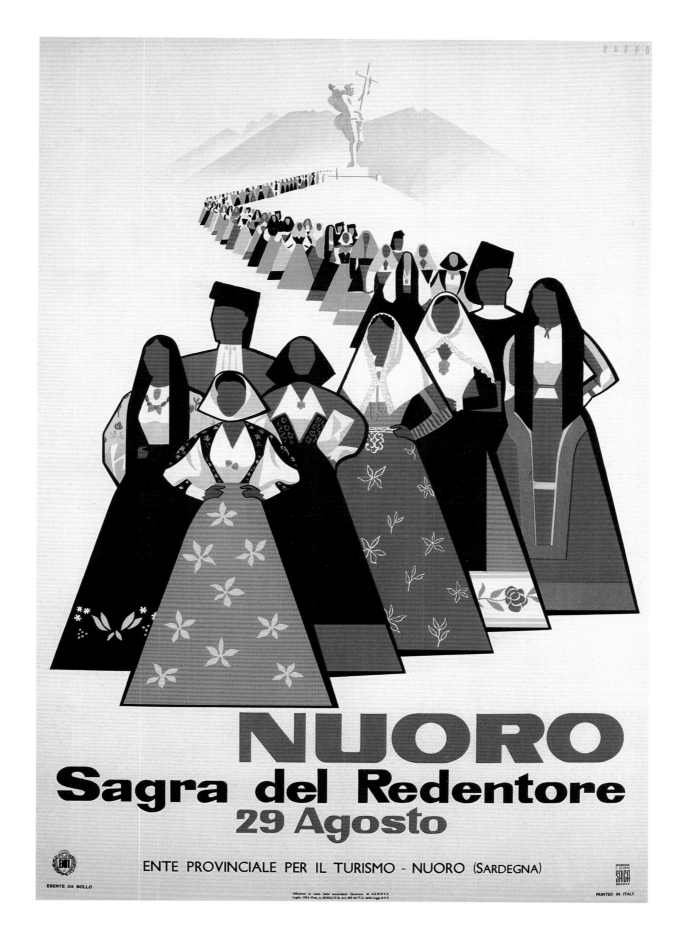

Selected Biographies

Emidio Adriani
Foligno 1897 – Bologna 1961

Adriani's work for the travel industry gave us several beautiful posters between the late-1940s and the late-1950s.

Particularly important are Adriani's posters for the resorts of Salsomaggiore and Porretta Terme in the Emilia Romagna region.

Poster
Porretta Terme | P 75

Vincenzo Alicandri
Sulmona 1871 – Turin 1955

A painter, graphic designer, and illustrator, Alicandri was part of a group of artists headed by Basilio Cascella, an eclectic painter turned lithographer. The group, whose members included the poet Gabriele D'Annunzio, designed and produced five issues of the magazine *L'Illustrazione Abruzzese.*

In the 1920s, Alicandri designed numerous travel posters for ENIT and the Ferrovie dello Stato. Alicandri had numerous art exhibitions and his frescoes can be admired in the Chiesa di Sant'Eustachio in the town of Campo di Giove in Abruzzo.

Posters
Brescia | P 38
Sanremo | P 67
Rapallo | P 73
Abruzzo | P 97
Paestum | P 118
Salerno | P 124

Livio Apolloni
Rome 1903 – 1976

Apolloni attended Genoa's Accademia di Belle Arti. In 1923, he went back to Rome where he began working as a cartoonist for the humorous publication *Serenissimo.* His satirical talent was also featured on *Il Pasquino, Il Caffe', Il Marc'Aurelio* and *Il Travaso* where he also became the director from 1943 until 1945.

Apolloni's travel posters date back to 1926 when ENIT began promoting the town of Bellagio on Lake Como. In the 1960s, Apolloni authored *Roma in Botticella,* one of several books on Roman popular culture, illustrated with 48 watercolor plates.

Posters
Bellagio | P 35
Cadenabbia - Tremezzo | P 35
Pisa | P 87
Firenze | P 90

Edmondo Bacci
Venice 1913 – 1978

Bacci attended the Scuola d'Arte of Venice and the Accademia di Belle Arti in Rome. In 1945, he had a personal show at the Galleria del Cavallino in Venice. In 1948, he participated in the Venice Biennale. Joining the Spazialismo movement, he began experimenting with light through color.

In 1955, Peggy Guggenheim took an interest in Bacci's work and introduced him to influential art collectors. In 1956, he had his first U.S. solo exhibit in New York. Back in Venice he had his own exhibit space within the Biennale of 1958. In 1959, he won the first prize of the Città di Venezia at the Terza Biennale dell'Incisione Italiana Contemporanea.

Poster
Venezia Lido | P 62

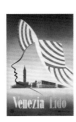

Gino Boccasile
Bari 1901 – Milan 1952

Blind in one eye due to an accident in his youth, Boccasile graduated from the Scuola d'Arte e Mestieri in Bari. At 25, he left Bari to work in Milan as an illustrator. His fame came with the more than ninety cover illustrations for the magazine *Le Grandi Firme* featuring beautiful women whose sensuality became a national phenomenon.

Boccasile's most notable poster work was done during the Fascist regime. After World War II he designed advertising posters for travel destinations and commercial products.

Posters
Val d'Aosta | P 20
Riviera della Versilia | P 86

Uberto Bonetti
Viareggio 1909 – 1993

Bonetti began his art studies at the Istituto di Belle Arti in the town of Lucca. While a student he worked as a part-time designer for architects and sculptors. A gifted caricature artist, Bonetti worked for magazines and newspapers including *La Lettura* and *La Tribuna.*

In 1930, the town of Viareggio commissioned Bonetti to create a new character for the famous Viareggio Carnival parade. Bonetti's mask of Burlamacco was a popular success. In the mid-1930s, Bonetti worked on a series of futurist paintings in the style of "Aeropittura". His later years were dedicated to teaching in Lucca, Pietrasanta, and Faenza.

Poster
Viareggio Carnevale | P 84

Previous page

Detail from:
S. Pellegrino, ca. 1928
(Featured on page 41)

Mario Borgoni
Pesaro 1869 – Naples 1936

During his lifetime, Borgoni witnessed the birth of Italian advertising. He grew up in the Stile Liberty era (Art Nouveau) and his ornate craftsmanship was rewarded with a teaching post at the Accademia di Belle Arti in Naples.

Borgoni was one of the early Italian artists who successfully made the transition from fine art to commercial art.

Borgoni's signature ornate style served not only for decoration purposes but also as a structural element used by the artist to frame and divide his beautiful compositions.

In 1905, he began a long relationship with the printing company Richter & C. based in Naples, eventually becoming its artistic director. Many of the first posters commissioned by the newly formed ENIT featured his unmistakable romantic images. The Italian State Railways (FS) also commissioned Borgoni for several posters of the most beautiful Italian locations as well as tourist destinations on the Côte d'Azur. Also worth noting is Borgoni's work for individual hotels and baths.

During the Fascist regime he was frequently hired to advertise the issuing of war bonds.

Borgoni died in Naples, shortly after he returned from New York, and before the war would damage the Italian and European sites he so beautifully immortalized in his work.

Posters
Le Linee Aeree d'Italia | P 8
Le Lac Majeur | P 31
Merano | P 49
La Riviera Italienne | P 72
Ferrara | P 76
Viareggio | P 85
Vesuvius and the Gulf of Naples | P 107
Sorrento | P 110
Capri | P 114
Amalfi | P 119
Taormina | P 139

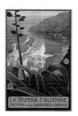

Adalberto Campagnoli
Verona 1905 – Turin 1983

Campagnoli's artistic style was influenced by the charismatic painter Felice Casorati then active in the city of Turin. He is best known for several travel posters commissioned by ENIT for Turin and other locations in the Piemonte region. Campagnoli drawings were also featured in promotional booklets for young adults such as *Le Avventure di Chiambrettino* published in 1948.

In 1953, his work was featured at the Premio Golfo della Spezia.

Posters
Torino, capitale delle Alpi | P 23
Torino e le sue valli | P 24

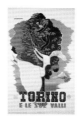

Erberto Carboni
Parma 1899 – Milan 1984

Both an architect and a graphic designer, Carboni alternated very successfully between the two professions. In the 1930s, Carboni was a pioneer together with a group of designers of the Studio Boggeri in experimenting with photomontage in his graphic work. An excellent example of his work is the poster for Rodi featured in this book.

After World War II, Carboni's career included exhibit design and the creation of numerous trademarks, including the one for the Italian State broadcasting company RAI TV.

Poster
Rodi | P 15

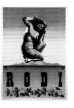

A. M. Cassandre
(Adolphe-Jean-Marie Mouron)
Kharkiv 1901 – Paris 1968

A graphic designer, type designer, painter, set-designer, and teacher, Adolphe-Jean-Marie attended the Ecole des Beaux-Arts, the Académie Julian, and studied with painter Lucien Simon in his studio in Paris.

In the early 1920s he adopted the pseudonym of A. M. Cassandre. From the late 1920s to early 1930s, Cassandre's work ranged from set design to teaching to typeface design. In 1930, Cassandre founded the Alliance Graphique with Loupot and Moyrand and produced a large number of widely acclaimed posters for French and international clients. In 1936, following a successful retrospective at the Museum of Modern Art in New York, Cassandre began designing covers for *Harper's Bazaar* where he would remain until 1939.

After returning to Paris, Cassandre's work concentrated on mostly painting and set design. In 1963, he designed the distinctive Yves Saint-Laurent's trademark. His eclectic talent and ability to design across different industries made him a leader in the field of graphic design for several decades.

Posters
Italia | P 14
Venezia | P 63

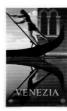

Aldo Cigheri
Genoa 1909 – Prato 1995

A prolific poster artist, Cigheri has contributed to Italy's reputation as a touristic venue. Some of his work related to tourism has become part of the permanent exhibit at the Parco Museo Quinto Martini of the Carmignano town hall.

Cigheri's long career spans from the 1930s through the 1980s. His posters are a faithful witness to the history of Italy, the two world wars, the changes in Italian society and the birth and evolution of the Italian travel industry.

Poster
Nervi | P 71

Plinio Codognato
Verona 1879 – Milan 1940

Codognato studied art at the Accademia Cignaroli of Verona. Codognato's advertising work began in his early twenties. At the onset of the new century he collaborated on a production of Arena of Verona. In 1906, Codognato won the first prize at the first Esposizione della Pubblicità.

His posters were commissioned by many of the largest Italian companies, especially Fiat the car manufacturer based in Torino. Codognato would in fact become a household name at Fiat, lending his talent to car advertising campaigns as well as serving as the art director of the company magazine.

Posters
Dall'Europa Centrale alla Riviera | P 11
Puglie | P 128

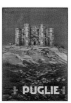

Tito Corbella
Pontremoli 1885 – Rome 1966

Corbella studied art in Venice under the tutelage of Sicilian artist Ettore Tito. A fine portrait painter, Corbella illustrated more than three hundred postcards often using his wife as a model.

Among his clients were many representatives of the high society of the time. When he moved to Rome he became fascinated with the landscapes of the Roman countryside. In 1928, ENIT and the FS commissioned him to create the poster for the town of Fiuggi.

Poster
Fiuggi | P 105

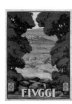

Aurelio Craffonara
Gallarate 1875 – Genoa 1945

Craffonara moved from his native Lombardia to Genoa where he attended the Accademia Linguistica di Belle Arti. He began designing posters and postcards in the early 1910s along his teaching post at the Accademia.

During the 1920s, he was a frequent collaborator with the printing company Barabino & Graeve which published many of his travel posters. An elegant and refined painter, Craffonara's posters captured the seductive beauty of the Italian Riviera.

Posters
Varazze | P 68
Alassio | P 69
Loano | P 70
Genoa and the Italian Riviera | P 70

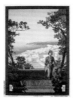

Giulio D'Angelo
Catania 1904 – Rome 1978

The son of painter Giuseppe D'Angelo, Giulio D'Angelo attended the Accademia di Belle Arti in Rome. D'Angelo spent long periods of time in France where he deepened his knowledge of Impressionism. D'Angelo's work was frequently exhibited in national and international shows such as the 1951 and 1959 Quadriennale Nazionale d'Arte in Rome.

After D'Angelo's death, his family donated a collection of his pencil drawings, to the Pinacoteca Zelantea in the town of Acireale.

Poster
Sicilia Eterna Primavera! | P 133

Domenico Delle Site
Lecce 1914 – Rome 1996

When only twelve years old, Delle Site was enrolled at the Scuola Artistica Statale di Lecce. His early talent was soon featured in the school journal. At sixteen, he moved to Rome to attend the Accademia di Belle Arti.

His first art exhibit in 1932 opened with an introduction by Prampolini. Delle Site's ties with futurism would culminate with his embrace of the "Aeropittura" style and his participation in the Venice Biennale. Delle Site's artwork was exhibited at the1950s Quadriennali Romane and in 1965 in New York. His work is part of the permanent collection of the Museo Caproni of Trento.

Posters
Lecce | P 129
Sardegna | P 144

Marcello Dudovich
Trieste 1878 – Milan 1962

After studying at the Real-Schule in Trieste, Dudovich was sent to Munich to complete his education and begin his working life. His father's connections got Dudovich a meeting at the Milano-based publishing company Ricordi, the place to be as a commercial artist. There he quickly went through the ranks under the tutelage of technical director Leopoldo Metlicovitz and the watchful eye of artistic director Adolfo Hohenstein.

At twenty-two, he won a gold medal at the Exposition Universelle of Paris.

Dudovich spent a brief but successful period in Bologna designing posters for the Chappuis Publishing Company. Following his marriage to Elisa Bucchi and a brief period in Genoa working with the printing house Armanino, Dudovich moved back to Milan.

The years of his return to Milan will consecrate Dudovich as the most celebrated artist at Ricordi with the design of beautiful posters for the Magazzini Mele, a chic department store in Naples and the iconic posters for Borsalino hats.

In 1911, he was offered the society column of the German magazine *Simplicissimus*. In 1915, the beginning of World War I forced Dudovich to return to Italy. His ties to Germany meant a difficult period in his career. In the early 1920s, Dudovich became a partner of the publishing company STAR in Milan and was nominated co-artistic director of IGAP another important publishing company. In the years up to 1936, Dudovich's posters would single-handedly define the most important brands of the period: La Rinascente, Campari, Fiat, and Pirelli to name a few.

His fine art work had appeared at the Venice Biennale of 1920 and 1922 and at the Biennale Romana in 1928.

His travels to Libya in the mid 1930s resulted in a legacy of sketchbooks with an historically important collection of drawings. Dudovich went back to Libya in 1951 a few years after the death of his wife.

Marcello Dudovich died in Milan at age eighty-four.

Posters
Padova | P 60
Grado | P 65
Ercolano | P 126

Giulio Ferrari
Potenza 1900 – Rome 1990

During the Fascist period Ferrari designed for the magazine *L'Illustrazione Fascista*. In the 1930s Ferrari designed travel posters for Italian destinations as well as the Italian colonies.

Abruzzo, the poster featured in this book, shows Ferrari's exquisite creativity and non-conformist approach to design.

Poster
Abruzzo | P 96

Sergio Franciscone
Turin 1912

Franciscone began his career when the Italian advertising industry was already established. Franciscone collaborated with the some of the largest printing companies in Turin, Florence, and Milan.

Franciscone's signature poster is for the 1939 Rabarbaro Zucca campaign. It featured a kneeling geisha, her arms stretched forward forming a distinctive letter "Z". It is still used by the liqueur company to this day. In the 1950s, Franciscone co-founded the ad agency ULTRA.

Poster
Merano | P 50

Guglielmo Ghini
Florence 1901 – 1982

Born into an aristocratic family, Ghini attended the Accademia delle Belle Arti in Florence while studying in the ateliers of Florentine painters. A fine portrait artist, Ghini had his first solo exhibit in Livorno in 1928 followed by many others in Rome, Milan, Pavia and Genoa.

His work is part of the permanent collection of the Galleria D'Arte Moderna in Pavia and in other private collections in the United States, Germany, and Italy.

Poster
Lucca | P 87

Vittorio Grassi
Rome 1878 – 1955

Grassi was active in the art circles of Rome at the beginning of the 20th century. He was a friend of many influential artists including the futurist Balla. He co-founded the Facoltà di Architettura at the University of Rome where he also taught.

Grassi's cross-disciplinary talent can be seen in his glass window designs at the Church of St. Peter and St. Paul in Rome. He designed travel posters for ENIT and designed covers for several magazines.

Posters
Roma Mercato di Traiano | P 100
Monreale | P 136
Taormina | P 138

Enrico Grimaldi
1879 – 1966

Little information exists about this artist. Grimaldi's travel posters include subjects for Solda in the Italian Alps, Sestri Levante, and Riviera Ligure.

Poster
Solda | P 52

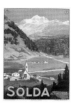

Baldo Guberti
Ravenna 1907

Guberti's artistic inspiration can be found in the Cubist and Metaphysical art movements.

He designed some covers for the magazine *L'Ufficio Moderno*.

Guberti's known poster designs include the 1934 Esposizione d'Arte Italiana and Cervia Pineta in the 1950s. His fine art work was featured in 1945 in Riva del Garda and in 1948 at the Venice Biennale.

Poster
Cervia Pineta | P 80

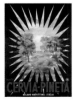

Giovanni Guerrini
Faenza 1887 – Rome 1972

After his artistic studies were completed between Faenza, Bologna, and Florence, Guerrini began teaching at the Accademia di Belle Arti in Ravenna. While his natural talent made him a successful engraver, his artistic curiosity encouraged his experimentation with other media such as ceramics, wrought iron, and textile design.

In 1925, Guerrini's poster design won the first prize at the Monza Exposition. He then began a fortunate relationship with ENIT and Ferrovie dello Stato designing travel posters and postcards. Guerrini will also be remembered for his numerous magazine covers and book illustrations.

Posters
Ravenna | P 77
Cesenatico | P 81

Alfredo Lalia
Genoa 1907

Lalia taught at the Istituto Superiore di Pubblicità in Rome and wrote the textbook *La Tecnica del Cartellone* (Poster Design Technique). He worked mainly for Italian state agencies including ENIT and FS, designing numerous travel posters. He collaborated with fellow artist Duilio Cambellotti.

Lalia designed the mausoleum of Agostino Trabalza in Rome's monumental cemetery.

Posters
En Italie | P 6
Winter in Italy | P 10
Catania | P 142

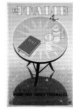

Franz Lenhart
Bad Haring (Austria) 1898 – Merano 1992

Lenhart had just enrolled at the Vienna Academy of Fine Arts when World War I began. In 1922, Lenhart moved to Florence to complete his studies at the Accademia di Belle Arti and began working as an apprentice poster designer at a local shop.

Once Lenhart earned his diploma he moved to Merano, where he began teaching and working as an artist.

A gifted portrait artist Lenhart was a master in capturing the light and atmosphere of the Italian Alps and Dolomites as demonstrated in his famous travel posters.

Posters
Bozen-Gries | P 51
Dolomiti | P 53
Cortina | P 56

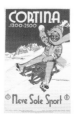

Giuseppe Magagnoli
Bologna 1878 – Milan 1933

Magagnoli was an artist and a businessman. In the 1920s, he founded his own advertising agency, MAGA. The agency was successful both in Italy and France, where Magagnoli had many contacts and a satellite office. MAGA had both commercial and government clients such as the National Fascist Association of Italian Steel Industrialists.

Magagnoli's agency was able to recruit some of the best known artists operating in Italy such as Nizzoli, Mauzan, and the Pozzati brothers.

Poster
The Valley of Aosta | P 18

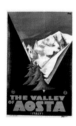

Carlo Mattioli
Modena 1911 – Rome 1994

Mattioli completed his artistic education at the Istituto D'Arte of Parma. In the early 1930s his work was influenced by the new tendencies of the Stile Novecento and the work of Italian master Giorgio Morandi. In 1940, his work was featured in the Venice Biennale.

Mattioli was also a fine illustrator often working on important books of Italian and foreign literature. In 1966, he was named into the prestigious Accademia Clementina (established in 1711 in Bologna) and in 1968 became a member of the Accademia di S. Luca.

Poster
Visitate Parma | P 77

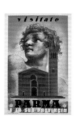

Aldo Mazza
Milan 1880 – Gavirate 1964

Mazza entered the Accademia di Pittura di Brera at a very young age. He began his career as an illustrator for the books published by Vallardi. In 1908, he illustrated a well known poem by Giovanni Visconti-Venosta "La Partenza del Crociato" which was a popular success.

For twenty years between 1904 and 1924 he collaborated with the weekly *Guerin Meschino* and became its director until the publication was acquired by the *Corriere della Sera*. He then joined another newspaper and continued his career as illustrator and caricaturist with Ricordi, Chappuis, and Bertarelli.

Poster
Stresa-Borromeo | P 30

Ettore Mazzini
Genoa 1891 – Rome 1960

Mazzini completed his artistic studies at the Accademia Linguistica di Belle Arti in Genoa where he also taught. He was a skilled painter and engraver, often working on classical and religious themes.

Mazzini collaborated with the Genovese publishing company Barabino & Graeve where he created several posters including *Torrefazione Caffè Pernigotti of Novi Ligure* in 1923 and *Visitate Trapani* in 1950.

Poster
Visitate Trapani | P 137

Leopoldo Metlicovitz
Trieste 1868 – Ponte Lambro 1944

Born in Trieste, Metlicovitz completed a printing apprenticeship in the town of Udine. His career blossomed at the music publishing company G. Ricordi & C. in Milan, where he served as Technical Director and eventually as the Artistic Director. At Ricordi, Metlicovitz designed posters for Puccini's operas *Madama Butterfly* and *Tosca*, and Mascagni's *Iris* among others. Metlicovitz recruited and trained an entire generation of new artists, including Dudovich.

Metlicovitz's design for the 1906 International Exposition of Milan, which marked the opening of a railroad tunnel through the Alps, was awarded the first prize.

Metlicovitz designed advertising posters for Mele, Fiat, and La Rinascente, and travel posters for Venice, Pola, and Zara.

Poster
Pola | P 12

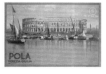

Ruggero Alfredo Michahelles
Florence 1898 – 1976

The young brother of futurist artist Ernesto (aka Thayaht), Michahelles studied art with Filippo Martori-Savini. At nineteen, Michahelles earned his first art commission by doing caricatures for the newspaper *La Nazione*. After his graduation Michahelles won the set design competition for the opera *Aida*.

Michahelles continued his studies abroad in the ateliers of influential Parisian and London artists. In his travel posters, Michahelles successfully integrates photographic elements, exploring the relationship between the realism of photography and the interpretation of the artist.

Posters
Italy | P 7
Italy This Winter | P 9
Kennst du das land? Italien | P 10

Viero Migliorati

Migliorati was very active in the 1930s and 1940s, when he collaborated with the publishing company Barabino & Graeve of Genoa.

His drawings were often featured in the magazine *L'Eroica*. In 1941, Migliorati illustrated the book *Ceriu'* by Ettore Cozzani.

Poster
Santa Margherita Ligure | P 73

Walter Molino
Reggio Emilia 1915 – Milan 1997

At the young age of fifteen Molino collaborated with the fascist newspaper *Libro e Moschetto*. Praised by Mussolini himself, Molino was hired to design cartoons for the newspaper *Il Popolo d'Italia*. While producing illustrations for fashion and advertising he also illustrated the comic book *Il Monello*. From 1936 he designed for satirical publications *Il Bertoldo* and *Marc'Aurelio*. In 1938, Molino illustrated the Italian editions of *Mickey Mouse* and *Donald Duck*.

Molino's crowning achievements are the thirty years of illustrations for the magazine *Domenica del Corriere* including many memorable covers. Under the pseudo name JW Symes he designed comic strips for the magazine *Grand Hotel*.

Poster
Abbazia | P 14

Arnaldo Musati
Roccapietra 1916 – 1988

Musati began working for various publishing companies in Milan often collaborating with fellow artist Gino Boccasile. After World War II he established his advertising studio in Aosta where he developed advertising campaigns for the ski resorts of the area.

His travel posters of the 1950s featured iconic female figures closely underscoring Boccasile's artistic influence in Musati's work.

Posters
Vallée d'Aoste | P 21
Mera | P 28

Marcello Nizzoli
Boretto 1887 – Nervi 1969

After having completed his architectural studies in Parma, Nizzoli moved to Milan. There he came in contact with the new groups exploring abstract art and became acquainted with futurist architect Antonio Sant'Elia. His cross-disciplinary design sense allowed him to design buildings as an architect, design advertising campaigns for MAGA's and Boggeri's design studios, and even product design.

In 1938, Nizzoli joined Olivetti as a designer and architect and in 1954 he won the coveted Compasso D'Oro prize for his Olivetti typewriter designs now part of the permanent collection of MoMA.

Posters
Milano | P 38
Bergamo | P 40
Agrigento | P 132

Umberto Noni
Trieste 1892 – Rome 1971

Noni was active during the 1920s and 1930s in Trieste where he was also a teacher. In Trieste, he collaborated with Studio Stuart as an interior designer and decorator for the bustling shipyards of the Adriatic port town.

In 1928, he worked on the decoration of the grand halls of the famous trans-Atlantic ship *Conte Verde*. A skilled classical artist he painted large decorative maps such as the 1936 oil on canvas *I Continenti*.

In 1962, Noni left Trieste and moved to Rome where he would spend the rest of his life.

Poster
L'Aquila | P 95

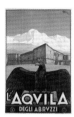

Michele Ortino
Catania 1914

Ortino attended the Accademia Linguistica di Belle Arti of Genoa. In Genoa he collaborated with the publishing company Barabino & Graeve, designing travel posters for tourist destinations such as Cortina in 1938.

Poster
Cortina | P 58

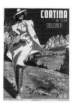

Gogliardo Ossani
Piacenza 1908 – Rimini 1984

Ossani completed his studies in Piacenza. He designed and built furniture and interior decors. He invented a new composite material, Lincreo, which was economical and easy to carve. A follower of futurist artist Fortunato Depero, Ossani used the new material to create a series of painted panels for the first Futurist Exhibit in Rome in 1934.

In the 1930s, Ossani contributed to ENIT's advertising campaigns by designing several travel posters and collateral materials for tourist destinations along the Adriatic coast. In 1939, Ossani designed the decorative panels for the interior of the Zanarini Bar in the town of Riccione.

Poster
Cattolica | P 79

Paolo Paschetto
Torre Pellice 1885 – Turin 1963

Born into a Valdese family in Piedmont, Paschetto earned his art diploma at the Accademia di Belle Arti of Rome, where he would teach between 1914–1948. His long teaching commitment did not limit his fine art and graphic design productions.

Paschetto's crowning achievement is the splendid decorations and glass windows of the Valdese Church in Rome. His graphic career included the winning design of the symbol for the newly born Italian Republic in 1948.

During the 2006 Winter Olympics, the town of Torre Pellice dedicated a comprehensive exhibit to this Valdese artist.

Poster
Sports Invernali in Italia | P 27

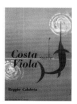

Leo Pecchioni
Camogli 1926

Pecchioni was born in Camogli in the area of Golfo del Paradiso, the splendid coast line between Bogliasco and Portofino. He attended the prestigious Accademia Linguistica di Belle Arti in Genoa. At nineteen he began his collaboration with Industria Grafica Sigla Effe where he became an art director and would remain until 1967.

Pecchioni designed numerous tourist guides depicting landscapes from above with a breathtaking "bird's eye view". He also created several travel and commercial posters.

Poster
Costa Viola—Reggio Calabria | P 131

Arrigo Pezzini
Genoa 1893 – 1975

Pezzini was an accomplished illustrator and fine watercolorist, a technique often used in landscape paintings and advertising posters.

In the 1950s, Pezzini collaborated with the printing company SAIGA-Barabino & Graeve in Genoa.

Poster
Rieti | P 98

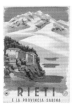

Luigi Piffero
Milan, 1907 – Sant'Agata di Cannobio 1978
..

Piffero's education took place at the Accademia di Brera. From 1931 to 1937, he was a teacher at a renowned art school in Milan.

During the period 1933–1943, Piffero participated in numerous national and international art shows, including the V and VI Triennale of Milan.

In 1937, he became ENIT's artistic director where he supervised the creation of travel posters until 1943.

Poster
Pesaro | P 95

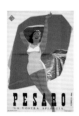

Armando Pomi
Filottrano 1895 – Milan 1950
..

When his mother died, Pomi (then 14 years old) and his father moved to Milan. Pomi's interest in art pushed him to attend evening art classes and afterwards he graduated from the Scuola Superiore d'Arte Applicata all'Industria. Attracted by the commercial aspect of advertising, Pomi left his teaching job and became a full-time artist. His clients included Indian and Zundapp motorcycles, Bayer's aspirin, and Thermogen.

In 1937, he co-founded, with his friend Gino Boccasile, the advertising agency ACTA and founded the movie magazine *Cinemalia*.

Poster
Milano | P 39

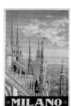

Carlo Prandoni
Turin 1919
..

A self-taught artist, Prandoni worked mostly in the Piemonte region. After World War II, Prandoni was hired by Mario Donadei, a journalist and founder of the advertising agency Publineon.

At Publineon, renamed Publinova a few years later, Prandoni designed several posters for businesses of the Cuneo area such as Balocco and Arione as well as for tourist destinations such as Limone Piemonte and Fabrosa. Prandoni's hyper-realistic style of portraying women was influenced by Gino Boccasile.

Poster
Limone Piemonte | P 29

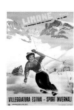

Mario Puppo
Levanto 1905 – Chiavari 1977
..

An uncommon artistic intuition and graphic versatility earned Puppo a successful and prolific career. In 1930 while in Paris, Puppo was asked to create the movie poster for *All Quite on the Western Front*. The same year the British musician Jack Hylton commissioned Puppo for a poster of his very popular jazz band.

From 1930 to 1960, his graphic work is almost entirely concentrated in designing travel brochures and posters for ENIT and FS. Puppo was able to create many memorable posters across a long and complex period of time that included Fascism and the Second World War. Nevertheless Puppo's never ending creativity and experimentation lead him through Art Deco, Futurism, Cubism, Abstract Art, and Surrealism.

This book features a significant selection of his work during the 1950's along with the prized Cortina poster from 1938.

Posters
Finale Ligure | P 16
Valle d'Aosta | P 19
Sports Invernali in Val d'Aosta | P 20
Baveno | P 32
Riva Torbole | P 46
Cortina | P 57
Grado | P 64
Riviera di Romagna | P 81
Caserta | P 106
Napoli | P 108
Napoli | P 109
Sorrento | P 111
Sorrento | P 111
Pompei La Città Dissepolta | P 112
Pompei | P 113
Capri | P 115
Procida | P 116
Procida L'isola di "Graziella" | P 116
Procida | P 117
Castellammare di Stabia | P 123
Visitate Pozzuoli | P 125
Ercolano | P 127
Sicilia | P 133
Taormina Sicily | P 138
Messina | P 143
Nuoro, Sagra del Redentore | P 145

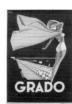

Aldo Raimondi
Rome 1902 – Erba 1998
..

A son of painter Roberto Raimondi, Aldo attended the Accademia di Belle Arti of Rome. A talented watercolor artist, Raimondi moved to Milan. His excellent work from those years won him the Professorship of watercolor painting at the Accademia di Brera.

Raimondi's work was the subject of many exhibits in Italy and abroad. He was chosen as a portrait artist by kings, emperors, three Popes and by the celebrities such as Arturo Toscanini and Guglielmo Marconi. The Italian Postal Service celebrated his work with a series of stamps in the late 1980s.

Poster
Gardone | P 42

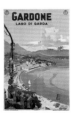

Virgilio Retrosi
Rome 1892 – 1975
..

Retrosi studied at the Accademia di Belle Arti in Rome with Duilio Cambellotti. During World War I, he designed an anti-Austrian series of postcards which was widely popular at the time.

A fine ceramist, Retrosi became Cambellotti's assistant at the Istituto Professionale del San Michele. His ceramic work continued in the important pottery centers of Deruta and Gualdo Tadino. His graphic work included the design of several travel posters for ENIT.

Posters
Roma | P 100
Spiagge di Latina | P 106
Foggia e la sua provincia | P 129

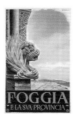

Giuseppe Riccobaldi
Florence 1887 – Genoa 1976
..

After the death of his father, Riccobaldi and his brother moved to Genoa where he attended the Accademia Ligustica di Belle Arti. In 1908, Riccobaldi collaborated with Rovescialli a renowned set designer in Milan working at La Scala.

In 1927, he designed movie posters for *Metropolis* by Fritz Lang and *Frate Francesco* by Giulio Antamoro.

His important production includes many memorable and highly collectible posters celebrating Fiat cars.

Posters
Mantova | P 41
Terme Sirmione, Lago di Garda | P 44
Riva Torbole | P 47
Terme Levico Vetriolo | P 48
Vicenza | P 59
Pompei La Nuit | P 112
Capri | P 114
Ischia | P 122
Castellammare di Stabia | P 123

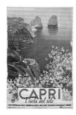

Filippo Romoli
Savona 1901 – Genoa 1969

After obtaining a technical design diploma in Savona, Romoli was hired by a utility company in Genoa. His artistic talent was soon recognized by the leading publishing company Barabino & Graeve where he would design many travel posters for the resorts of the Italian Riviera.

Romoli designed the corporate identity for the Lazzi bus lines including the logo, uniforms, the decor of the corporate headquarters and of course all advertising.

Posters
Varallo | P 26
Valsesia | P 27
Battaglia di Fiori Ventimiglia | P 67
Marina di Massa | P 83
Siracusa | P 141

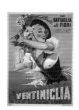

Tullio Silvestri
Venice 1880 – Trieste 1963

A self-taught painter Silvestri was a well-traveled artist. He spent time in various European capitals and in Russia. Back in Venice, Silvestri was invited to participate in group art shows in Trieste.

Silvestri became friends with author James Joyce, whom Silvestri portraited in two occasions. After his wife's death, he moved to Rome and then to Zappola in his home region of Veneto. From there he continued to paint and had numerous shows in Italy and abroad.

Poster
Vicenza | P 59

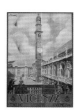

Antonio Simeoni

Simeoni collaborated in the 1930s with the printing company Barabino & Graeve in Genoa. His known advertising work includes his 1926 poster of *Lago di Garda* and in the 1930s a poster for the newspaper *Il Brennero*.

His fine art work is part of the permanent collection of the Castello del Buonconsiglio in Trento.

Poster
Lago di Garda, Riva | P 45

Pio Solero
Sappada di Cadore 1881 – 1975

Solero studied at the art academies of Munich, Germany, Venice and Rome. Between 1905 and 1915, he traveled to Vienna, Paris, Egypt and Buenos Aires. After World War I Solero and his wife went back to his hometown of Sappada where he would spend the rest of his life.

During the 1920s his work was featured and widely acknowledged in art exhibitions, both in Italy and abroad. His graphic talent and love for the Alpine landscapes of Alto Adige can be found in his travel posters designed for ENIT.

Poster
Dobbiaco | P 52

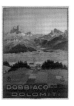

Fortunato Tami
Ovaro 1875 – Crusinallo 1942

A multi-talented artist, Tami collaborated with the Società Umanitaria, an institution founded in Milan in 1893 with the mandate to help the less fortunate by providing counseling and professional education.

After World War I, Tami's work was featured in numerous national and international shows. His advertising work includes the romantic poster *Lago Maggiore* in 1909, and in a more graphic style, his poster for the town of S. Pellegrino circa 1928.

Poster
S. Pellegrino | P 41

Nazzareno Tognacci
Rimini 1911 – 1987

Tognacci's life and work seemed to concentrate on the Adriatic coast. He attended the Liceo Artistico in Rimini and the Accademia di Belle Arti in Ravenna. A gifted sculptor and painter, he taught in various Rimini schools.

Tognacci designed the Piazza Pascoli fountain in the town of Viserba for which he also created brochures and posters. Tognacci will be remembered for his acclaimed 1950 poster of the Riviera di Rimini.

Poster
Riviera di Rimini | P 80

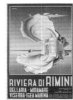

Severino Trematore
Foggia 1895 – 1940

Following his father's avocation, Trematore became an art student at the Accademia di Belle Arti of Naples. In Genoa, Trematore's landscapes and portraits were often shown in art exhibits. In the 1920s, Trematore began developing his commercial work with Barabino & Graeve.

He designed travel posters and brochures for Italian destinations and advertising for ocean liners.

At the onset of World War II, while in London, Trematore was arrested along with other foreign nationals and embarked on the *Arandora Star* to be deported to Canada. The ship left England without an escort or the Red Cross colors and was sunk in the middle of the Atlantic by a German torpedo. Trematore was among the victims.

Posters
Le Lac de Garda | P 43
Bologna | P 78

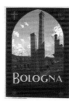

Guido Zamperoni
Milan 1912 – 2003

A self-taught artist, Zamperoni was an illustrator and comic book artist. He created illustrations for books by Salgari, Stevenson, and Jack London. He frequently collaborated on magazines for young adults including a brief collaboration with *L'Avventuroso* which was interrupted when the Fascist censorship deemed his drawings too American.

His advertising work includes ads for Rolls-Royce, Italia Navigazione, KLM, and others. In 1949, he received an award at the Mostra del Cinema of Venice for a short animated film.

Poster
Genova | P 71

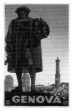

Collection Alessandro Bellenda

t is a great honor to share a part of my collection of vintage advertising posters with those who view these pages. I'm especially proud to have established such a collection in my hometown of Alassio on the Italian Riviera, a renowned travel destination.

More than fifteen years ago, I became fascinated by the beauty of the posters designed at the turn of the twentieth century, and there grew in me a desire to be surrounded by this art form and contribute to its legacy. Soon I acquired my first posters and began the collection, which became the passion of my life.

My interest extends to a variety of subjects, from commercial products such as cars and liquors to fashion and travel, and for the past ten years I've been on an eternal quest to acquire new subjects for my collection. This never-ending task has frequently led me to France, Switzerland, Germany, England, Belgium, and the U.S. My only regret is that as my collection grows I may not have enough wall space to display all of my posters.

As a collector I've taken my responsibility to heart. I spare no resources and time in ensuring that all of my posters are preserved in optimal condition. I believe that mine is a passion first and a business second.

To be fair to history we have to conclude that the poster as a medium had its pinnacle—with some exceptions—during the first hundred years after its invention. Now the remaining prints have new meaning. The product or show originally advertised reflects a society long gone. The poster's historical value has dramatically changed, morphing a colored sheet of paper—destined to spend its brief lifespan on a wall—into a true object of desire. Now that you read this marvelous book, I think you'll agree.

—Alessandro Bellenda
Collection Alessandro Bellenda
Alassio, Italy

Detail from: **Alassio, 1929** (Featured on page 69)

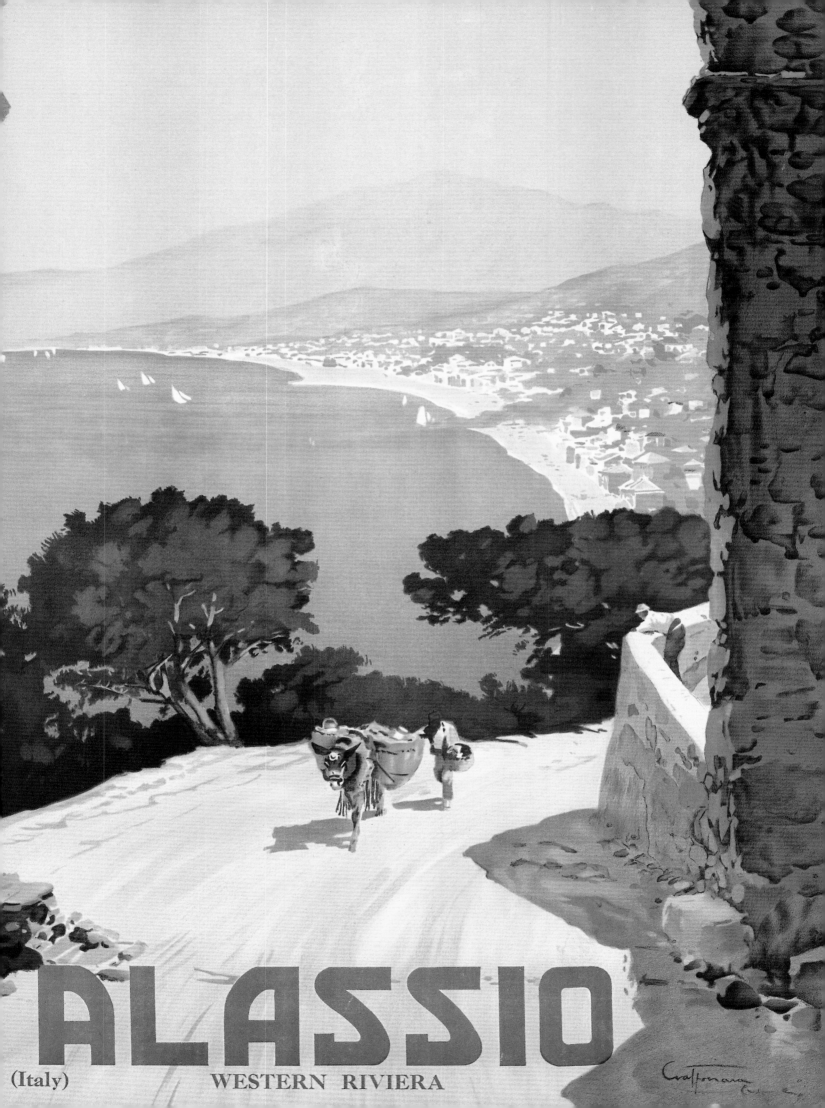

ALASSIO

(Italy) WESTERN RIVIERA

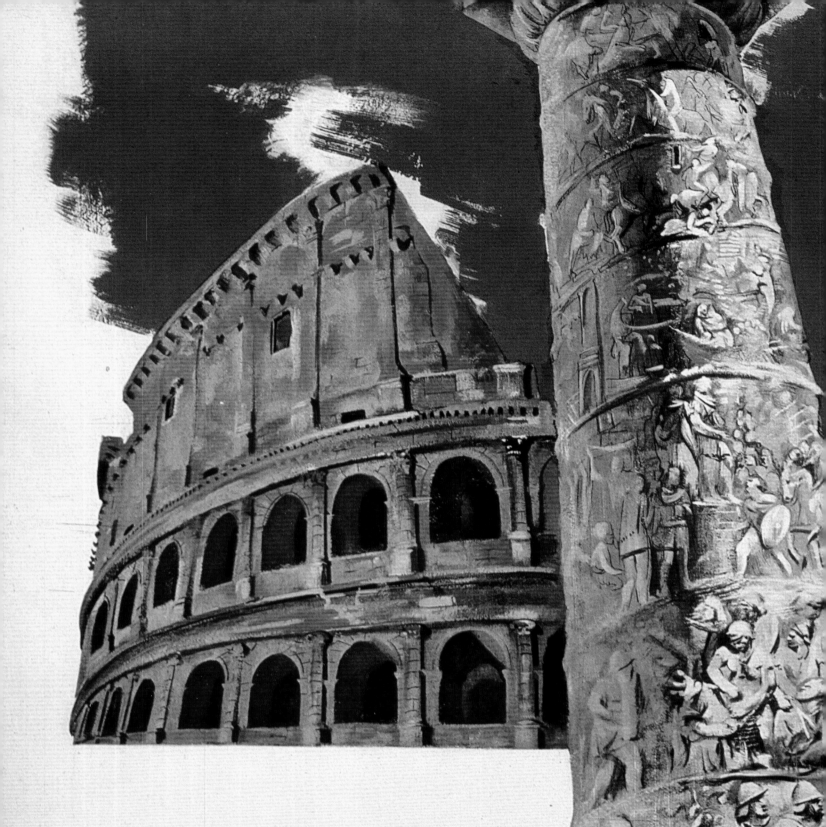

ROMA